Spectrum 13

UNDERWOOD BOOKS
Nevada City, CA • 2006

SPECTRUM 13

Leo & Diane Dillon · Bobby Chiu · Jeremy Geddes

Trade Softcover Edition ISBN 1-59929-001-4
Hardcover Edition ISBN 1-59929-002-2

10 9 8 7 6 5 4 3 2 1

Artists, art directors, and publishers interested in receiving entry information for the next Spectrum competition should send their name and address to:
Spectrum Design, P.O. Box 4422, Overland Park, KS 66204
Or visit the official website for information & printable PDF entry forms: **www.spectrumfantasticart.com**
Call For Entries posters (which contain complete rules, list of fees, and forms for participation) are mailed out in October each year.

Published by **UNDERWOOD BOOKS**, P.O. BOX 1919, NEVADA CITY, CA 95959
www.underwoodbooks.com
TIM UNDERWOOD/*Publisher*

CONTENTS

Nic Klein

Peter de Sève

Don Maitz

Photograph by Arnie Fenner

The *Spectrum 13* competition had the feeling of an episode of "American Idol" this year. Unknown to us, Virgin Records had scheduled a talent search for hip-hop and rap artists in the hotel rooms adjacent to the Spectrum judging. The hallways, elevators and corridors were filled with hopeful participants and their managers (friends/family/fans/posse). There were people sitting on the floor in the hallways, people practicing routines in the hotel lobby, and a general sense of excitement everywhere one turned. It was very apparent how seriously the performers were about their craft. There was a tension in the air that was tactile. Everyone wanted their one chance to be discovered, their chance to be the next "big thing." One expected Simon Cowell to walk around the corner any minute pursued by a crowd of hopefuls.

Watching the performing artists waiting for their chance at stardom really drove home the similarities in the two seemingly different competitions. All artists want recognition for their hard work and talent and most feel they have the potential to be movers and shakers and trend makers. On one side of the hall the medium was music, on the other side it was fantastic art. It made me think about how hard it must be for the artists to choose which of their works to enter, to decide on what they believe will stand out from all the competition and make the judges take notice. The knowledge of how tough it is to make a great impression in such a fleeting moment was sobering. Art—whether created by drawing, singing, or writing—is personal, an expression of emotion and intellect. Though it has never been lost on me that there are those who are happy and those that are disappointed by the results of their participation in *Spectrum*, watching the musical hopefuls come and go that Saturday was a reminder of the people who take a chance on making it into the book each year. Regardless of the outcome, we appreciate all of the artists who join together to make *Spectrum* what it is.

The judging took place the first weekend in March this year (a little later than usual to accommodate scheduling conflicts for several jurors) and was held again at the Hyatt Regency Crown Center. There were 60 tables covered with art for the judges to view in each round. The panel was given procedural instructions and judging began at 8:30 AM, coffee cup in one hand and cup of beans (used to cast votes) in the other. Each of the jurors moved around the room independently and all discussions of the work were discouraged during that phase: each judge could secretly vote for as many or as few works as they chose. Any work that a juror felt was worthy of award consideration was signified by their including a paperclip along with their vote. Art that received a plurality of votes was marked for inclusion in the annual. There were around 5000 entries this year (the art in the room had to be reset seven times) and every one was reviewed by the panel--entries are never pre-screened. When votes had been cast in the final category, art that had been indicated for award consideration was brought back out for debate. The judges this year dropped a *lot* of paperclips, so there were some long and lively discussions. In the end a consensus was reached and at 6:30 PM awards were determined for each category—it was the longest day of judging in *Spectrum's* history. Everyone was more than ready for martinis that evening.

Assisting Arnie and myself this year in tabulating votes, setting and resetting the room, and keeping the proceedings moving at a rapid clip were Arlo Burnett, Gillian Titus, Armen Davis, Lucy Moreno, and her daughter Lucy Moreno.

Each year presents its own set of challenges and hurdles to overcome; the cost of doing Spectrum increases a little each year, we continually chase down pirates who infringe on the artists' rights, and we're hardly oblivious to our competitors who are doing similar types of projects. But it's all worth it. I've said it for many years now, but I don't mind sounding like a broken record: this book is only made possible by the continuing participation of the artists (both those that get selected for the book and those that unfortunately don't), by the readers, and by the art directors who use it as a resource. *Spectrum* belongs to all of you. Thank you for allowing us to be part of this community.

—Cathy Fenner/Show Co-Chairman

Correction

Aren't these two concept paintings for the film *Robots* knock-outs? So wouldn't it have been nice if we had properly credited the artist responsible in *Spectrum 12*? The answer to both questions is: YES! Both pieces were created by **MICHAEL KNAPP** [mike@michaelknapp.com]. Our apologies to Michael for our bonehead error!

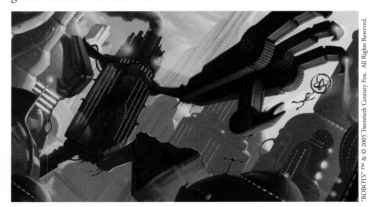

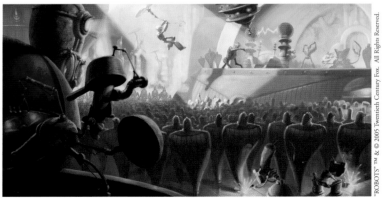

Brom/Artist

Bruce Jensen/Artist

Christopher Klein/Art Director *National Geographic*

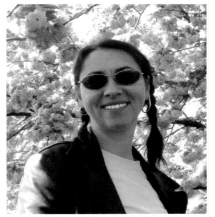

Heidi MacDonald/Journalist/Editor

Stephan Martiniere/Artist

Meg Walsh/Artist

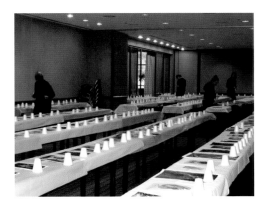

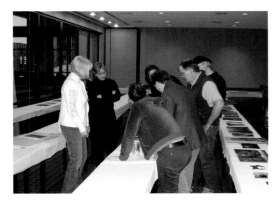

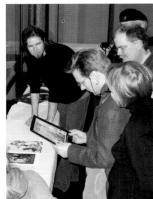
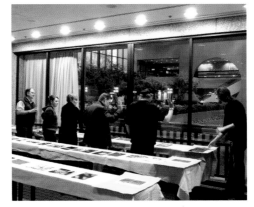

JEFFREY JONES

born February 10, 1944 / Atlanta, GA

If you looked up the word "conundrum" in the dictionary you wouldn't find a photo of Jeffrey Jones used along with the definition—but it would be appropriate if there were. Contradictory and frustrating, enlightening and inspirational, unbelievably friendly and frequently infuriating, Jones has spent the last forty years confusing both his advocates and his critics (and, in all likelihood, thoroughly enjoying all the consternation he's caused in the process).

For those of us who cut our teeth on comics and fantastic art in the turbulent 1960s, Jones was "our guy," the boy from the fannish neighborhood that made good, an unintentional representative of our generation. We grew up with the same influences as he did, witnessed historical events at the same time, listened to the same music, ate the same foods, dreamed the same dreams. We all looked up to—and avidly bought, traded for, or swiped anything by—Art Gods Frank Frazetta and Roy Krenkel, thrilled to the movie monsters of the Harryhausen and Hammer Films, followed the latest news about, first the Mercury, then the Apollo program to put a man on the moon, were challenged and moved by the music of the Beatles, the Stones, and Dylan, and were swept along with the cultural, technological, and social changes that the country experienced as the Baby Boomers came of age.

When Jeff Jones' art first began appearing in the Edgar Rice Burroughs and SF fanzines, then in the Warren comics, and finally on numerous book covers, we shared in his success. Not only because he was a fan that had come up through the ranks and paid his dues (and as such, set an example many of us could follow into the publishing arena), but also because he was simply so incredibly good. Rough around the edges at first and perhaps owing a bit too much to his sources of inspiration? Certainly—but he was "out there" working in the trenches, learning on the fly, and we were given the privilege of watching Jones gain skill and confidence, to see him mature and grow with each new work. We reveled in his accomplishments, rooting from the sidelines, and were rewarded for our faith in his talent. His paintings of Robert E. Howard's Solomon Kane, Fritz Leiber's Fafhrd and the Grey Mouser, and Karl Edward Wagner's Kane were for many years the definitive interpretations of those characters; his "Idyl" strips for *Heavy Metal* were as thoughtful and mordantly amusing as they were beautifully drawn; his fine art paintings like "Blind Narcissus" helped reintroduce audiences and artists alike to romantic themes while showcasing his uniquely contemporary sensibility.

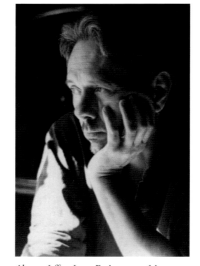

Above: *Jeffrey Jones.* **Facing page:** Messenger of Zhuvastou, *18"x30", oil on canvas, 1973.* From the collection of Pat & Jeannie Wilshire.

As his art became more complex and challenging, as his influences and attitudes evolved, he invited us along for the journey. Many rediscovered the wonders of Gustav Klimt, Winslow Homer, and Frank Schoonover because Jones acted as our unofficial art instructor. When he, Mike Kaluta, Bernie Wrightson, and Barry Windsor-Smith shared a studio, every budding fantasy illustrator in the late 1970s dreamed of either being asked to join them or of having the opportunity to be a part of their own version of the group. Never mind that Jeff never saw much significance in "The Studio"—or in his comic art or commercial work for that matter; he's gone through his career largely oblivious to his stature among readers, collectors, and other painters.

If it were otherwise, he wouldn't be Jeff Jones.

As he said in his last collection, *The Art of Jeffrey Jones* [Underwood Books, 2002]: "If I am lucky all my triumphs will go unremembered until the end. This is of course extreme, but the last thing I need is for me to think I've done something great. The next to the last thing I need is for the world to be hailing me as great. I am an entertainer. I make pictures with stories (however oblique they may be). Have you ever sat down and said to yourself, 'Today I'm going to do something great. Today I'm going to do *real* art.'? It doesn't work. Greatness or mediocrity or 'who?' can only be judged by history. Most of the living artists who are considered great today will be forgotten by history. Yes, I enjoy it when people like my work, because I want to have added something to this world, or whatever gave me life, instead of just taking from it. Every work, hopefully, will leave me unsatisfied. This drives me on to the next one."

Jones has candidly discussed his battles with depression, his troubled childhood relationship with his father, his failed marriages, his lack of artistic confidence, his exploration of gender reassignment, and his struggles with alcohol and addiction in a variety of forums. His secrets are few. But through it all, regardless of circumstances and emotional turmoil, he creates. He sketches and paints and draws and sculpts. And above all he dreams. Of heroes and heroines; of Pellucidar, of Tarzan's Africa and other lands of myths and legends, realms of the imagination. Jeff puts those dreams on paper or canvas for us all to share and be inspired by. He can't help it, despite his best efforts to be contrary.

So if you looked up the definition of "grand master" in the dictionary you wouldn't find a photo of Jeffrey Jones used along with the text—but it would be unquestionably appropriate if there were. †

Previous Grand Master Award Recipients

Frank Frazetta
1995

Don Ivan Punchatz
1996

Leo & Diane Dillon
1997

James Bama
1998

John Berkey
1999

Alan Lee
2000

Jean Giraud
2001

Kinuko Y. Craft
2002

Michael Wm. Kaluta
2003

Michael Whelan
2004

H.R. Giger
2005

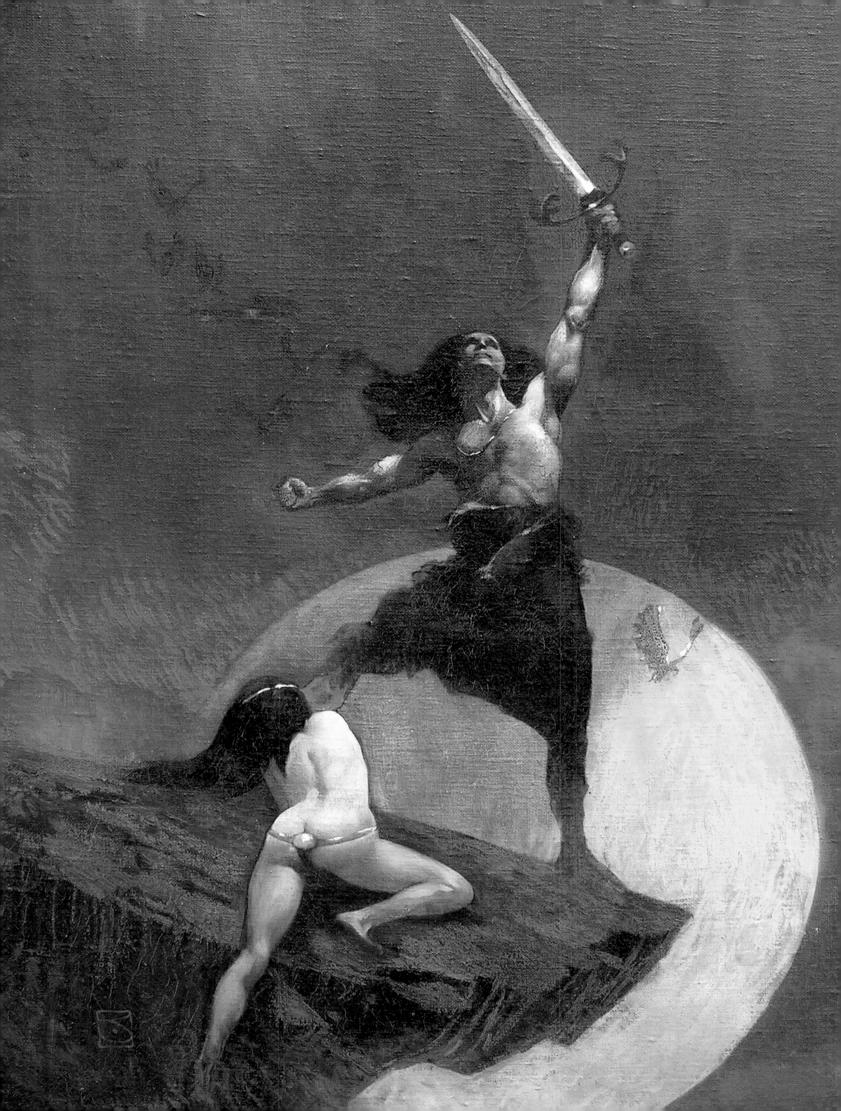

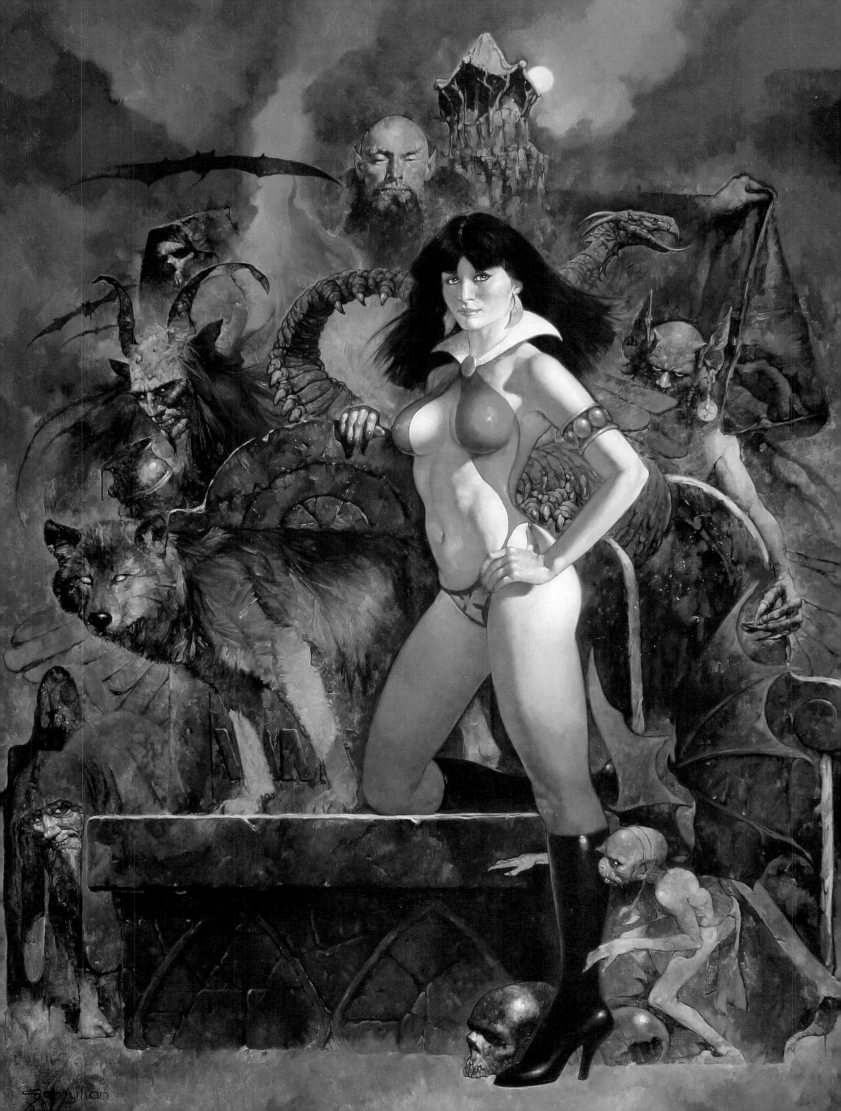

THE YEAR IN REVIEW 2005

BY ARNIE FENNER

"For starters, I clearly miscalculated how popular it would be to show Calvin urinating on a Ford logo. . ."
— *Bill Watterson explaining why he resisted merchandising* **Calvin and Hobbes**

"I believe all God's creatures have a soul. . .except bears, bears are godless killing machines."
— *Stephen Colbert* **The Colbert Report**

You know, it's getting awfully difficult to keep an optimistic smile on my face, let me tell you.

I mean, it's not as if I've ever been a Pollyanna goody-two-shoes, just ask Cathy: I can rant with the best of them. But as anyone whose been reading these reviews for the past few years know, I generally try to note the good along with the bad, try to see the proverbial glass as half full. But 2005 was just jammed to capacity with miserable events and, boy, am I getting cranky.

Yes, the occupation of Iraq and the subsequent "insurgency" or civil war (take your pick) got fouler and deadlier. Roadside IEDs and suicide bombers claimed the lives of civilians, Iraqi police, and U.S. military personal indiscriminantly. Kidnappings and murders were everyday occurrences and Iraq's infrastructure was constantly under assault. Rebels executed hostages in the most gruesome ways and loaded the video footage on the Internet. Any good that was achieved was always overshadowed by new acts of horror; any progress was undermined by new revelations of government ineptitude or brutal acts by miscreants on both sides of the conflict. Though there were successful elections very little was accomplished politically in Iraq and by year's end the situation remained (in the words of John Stewart on *The Daily Show*) "one big Mess-o-potamia."

On the home-front the anti-war movement lurched and sputtered along, never really achieving much cohesion or definitive direction (which indicates that the country, regardless of everything, is still deeply divided on the subject). Their use of Cindy Sheehan (whose son was killed in Iraq) back-

fired when it began to look like she enjoyed being the center of attention rather than devoting much time to getting her message across. (Denouncing America while hugging Venezuelan President Hugo Chavez—a leader notorious for human rights abuses and oppression of the press in his own country while broadcasting threatening rhetoric about the U.S.—was perhaps not the best strategy for getting sympathetic support. Abbey Hoffman was a lot more media savvy. Harry Belafonte, take note.) The lack of any viable solution to the conflict from either political viewpoint created not only confusion, but almost a sense of ennui in the public, a dull feeling of, "well, that's the way it is." And it looked like 2006 was going to be more of the same.

It wasn't only Iraq that cast a pall over the year—oh, *heck* no! As bad as the hurricane season had been in 2004 (and Florida *really* suffered), '05 gave us a suckerpunch followed by several kicks in the crotch when Katrina devastated parts of Louisiana and Mississippi, Rita brutalized parts of Texas and unlucky Louisiana, Stan savaged Central America (killing 1500), and Wilma severely damaged tourist hot spots along Mexico's Yucatan Peninsula. The primary attention was given to the destruction in New Orleans, the misery of which was further exacerbated by incompetence on the part of the local, state, and federal governments

(but to be fair, anyone expecting lightning fast "fixes" and relief obviously didn't have a clue as to the way things *really* work and have been watching too many movies) as well as a sanctimonious media that did its best to alarm people by reporting massive casualty figures (which were false) and rampant crime (which, given the scope of the disaster, turned out to be relatively sparse). Movie stars and rappers jumped in, getting their photo ops and making their political pronouncements—none of which did much to help the people who had lost their homes and livelihoods. Regardless of any action (or inaction), people were more eager to grind a personal axe, to advance a partisan agenda, rather than working together to face a problem. Big surprise. The simple truth is that hurricanes are bound to happen and nothing done immediately in their wakes is ever likely to be as quick or as effective as we'd like. "Disasters" tend to be that way. Likewise, troubles don't miraculously go away once the news crews go home: New Orleans and the Gulf Coast will be in recovery mode and in need of help for years to come.

A gigantic earthquake in Kashmir killed over 70,000 people and left almost two million homeless. Relief efforts were hampered both by the remoteness of the region and by the limitation of readily available funds as agencies still contended with the aftermath of the late December '04 Indian Ocean tsunami.

Islamic terrorism continued to be a concern throughout the year. Four suicide bombers detonated their explosives on three subway trains and a double-decker bus in London on July 7, killing fifty and injuring many more. Another team of four terrorists failed in an attempted second attack on July 21 and were rapidly caught by British authorities. Bombings also took place in Egypt, Lebanon, Saudi Arabia, and Bali.

Several weeks of nightly rioting by predominantly second-generation immigrant youths in the poorer suburbs surrounding Paris prompted heated debates about integration and discrimination in France. Accelerated melting of glaciers and polar ice

ABOVE: *George Lucas rules the media! The final installment of the* Star Wars *prequels was not only '05's box office. champ, but also dominated society's pop-culture conciousness—and, obviously, the newstands. Though no other feature films are planned, a TV series is in the works.*

© Lucasfilm Ltd.

FACING PAGE: *Spanish legend Manuel Sanjulian first came to prominence in the U.S. in the 1970s with his vibrant covers for the Warren horror comic magazines* Eerie, Creepy, *and* Vampirella. *He went on to paint numerous book jackets for several decades before leaving commercial art for the gallery market. This new painting of Vampirella was a marriage of his two career paths: it was sold by Heritage Auctions of Dallas, Texas in October last year, realizing $13,800 (plus the buyer's premium). Oil on canvas, 36"x50".* VAMPIRELLA ™ & © HARRIS COMICS.

offered alarming proof of global warming, fears of an avian-flu strain becoming a pandemic had people stockpiling medications that they weren't even sure would be effective in such an event, North Korea was joined by Iran in the game of "We Got Nukes: Watcha Gonna Do About It?", and international energy prices continued to shoot up, allowing the oil companies to pocket obscene profits while driving up costs across the board for everything. (Whether you drive a car or not, everyone will experience "Gas Pain" in the months ahead.)

Illegal immigration and porous borders; ridiculous fisticuffs over Terri Schiavo's right to die (shame on everyone) and about whether the Supreme Court was going lean left or right (and

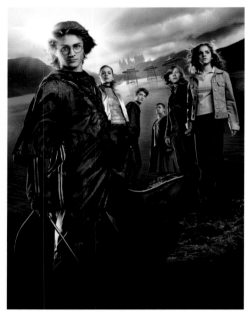

ABOVE: *This wonderfully-executed poster for the 2005* Harry Potter™ And the Goblet of Fire *film adaptation perfectly illustrates my often-given observation that most movie posters these days rely on PhotoShop as the medium rather than oil paints.* ™ & © WARNER BROS. ENTERTAINMENT, INC. HARRY POTTER™ PUBLISHING RIGHTS © J.K. ROWLING.

here I thought it was supposed to represent *everyone*); bigotry, censorship, international indifference to the continued genocide in Darfur, civil rights abuses, fundamentalist attacks on Darwin (hasn't *anyone* seen *Inherit the Wind*?), and crooked politicians and lobbyists; Tom Cruise jumping on Queen Oprah's couch, steroid abuses among athletes, and liars, liars *everywhere*, be they writers, scientists, reporters, "victims" (hello, Runaway Bride!), or government officials—boy, what a *crappy* year!

Okay, so maybe there *were* some good things that happened.

The shuttle Discovery flew to the space station and returned to Earth successfully (though additional safety concerns delayed future flights for awhile), Deep Impact accomplished its mission by slamming into a comet and allowed scientists to study its makeup, and the Hubble Space Telescope celebrated its 15th year in orbit (and discovered two additional moons in orbit around the planet Uranus—no jokes, please). The Mars exploration vehicles, Spirit and Sojourner, seemed to be related to the Energizer Bunny and kept operating and transmitting photos and data long after both were expected to shut down. Paleontologists discovered new dinosaur fossils, including the *Falcarius utahensis*, a sort of missing link (whoops, there's that dopey evolution again) between small meat eaters and large vegetarians.

There were a number of incredible art exhibitions, including "John Berkey Observed," which ran through the winter at the ArtOrg Moving Walls Gallery in Northfield, Minnesota. Featuring 50 originals, along with some of John's experimental videos, it was a wonderful showcase for the influential Grand Master. The Art @ Large Gallery in New York hosted a major H.R. Giger show and, of course, there was a little something called "Spectrum: The Exhibition" at the Museum of American Illustration (more about that in a bit).

The year was a typically wonderful cornucopia of artistic delights and events, not the least of which was the auction of a poster by the noted graphic artist Heinz Schulz-Neudamm for the 1920 film *Metropolis*—one of only four known to still exist—for $690,000! Films were more visually astonishing than ever, thanks to the concept and SFX artists; advertising relied on fantasy imagery and the creatives capable of rising to the challenge; there were more books, more games, more figures, comics, and prints to capture our imaginations, more exhibits and conventions and opportunities to meet the people who bring these fantastic worlds to life. Everything that happened throughout the year, good, bad, fantasy-related or not, will have a cumulative effect on the types of art that are created in the years ahead, its subject matter, and how we access it—interested parties will just have to connect the dots to see how, sort of like James Burke used to do in his old PBS series, *Connections.*

So, alright, I guess that 2005 wasn't *all* bad (though it was damn close).

But 2006? You're On Notice.

A D V E R T I S I N G

Each year I'm always at something of a loss when it comes to talking about the ad biz, simply because it's so anonymous. I see many, many fantasy-themed artworks used to sell everything from drain cleaners to shampoo to cars to software—but as to the creatives behind the splashy graphics…?

Product placement in films, television, and even Marvel Comics (Nike logos were slyly placed here and there on background walls and on character's T-shirts) continued to be a popular strategy for advertisers, but commercials before movies in theaters generated numerous angry protests from patrons. Musicians licensed more classic rock songs for use in ads and as ring tones for cell phones than ever before in an effort to bolster incomes that had dipped to the soft market for CDs. Well-known actors—who you wouldn't think needed money—pitched all manner of goods, either in voice-overs or face-front on screen.

Internet advertising continued to increase at the same time that web-hosts introduced software to block pop-up ads and filter e-mail spam; though e-sales reached a record high in 2005 the jury is still out as to how effective advertising on the web really is. The general feeling is that a web presence of *some* sort is mandatory, but

Below: *Scion's Inspiration/Realization ad campaign used some fantasy/SF images, including this dragon by an unidentified artist.*

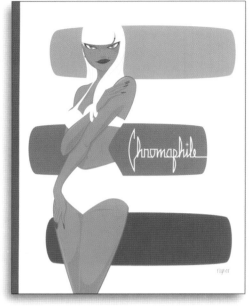

ABOVE: *The way-cool Ragnar was well represented in this collection of his art from Baby Tattoo Books. Exhibiting a retro-chic approach to beauties and beasts,* Chromaphile *was a winner. Ragnar also wrote and illustrated a very entertaining children's book,* Izzy's Very Important Job. *Check out www.babytattoo.com/ for more information.*

that it shouldn't be the *only* way a company tries to market to consumers.

Traditionally-painted art for movie posters is pretty much—with rare exceptions—a thing of the past, replaced by computer-generated stunners that perfectly integrate manipulated cast photos with fanciful graphics, creatures, and backgrounds. I don't see the trend changing anytime soon (especially with the conclusion of the *Star Wars* series).

Rather than launch into my annual tirade about the lack of credits in the advertising industry I'll simply say that I was able to spot some outstanding work through the year that (I think) were created by Ragnar, William Stout (a killer dragon for the Discovery Channel), Bill Mayer, Dace McMacken, Tristan Eaton, Dan Adel…and a host of "nameless" others.

B O O K S

The American book industry experienced something of a decline last year—which isn't necessarily a bad thing. For the first time since 1999 the number of new and reprint titles released in this country dipped, a reduction of something near 9%. There were modest increases in profits for the major booksellers and publishers, but the general consensus was that there were slightly too many books for too few readers and both publishers and chain buyers were taking a much more conservative stance as they headed into 2006.

Two juggernaut fantasies (of a sort) battled it out for dominance on 2005's bestseller lists: Dan Brown's *The Da Vinci Code* and J.K. Rowling's penultimate *Harry Potter and the Half-Blood Prince* (with art by Mary GrandPré once again, thank you very much) please readers, booksellers, and publishing companies alike. Both had their detractors and critics

(*Da Vinci* because it was heretical, goddamit, and *Harry* because Mr. Potter is obviously Satanic), but the religious-fueled sniping had no effect on sales—the first edition of *...Half-Blood Prince* greatly exceeded ten million copies and the film adaptation of *Harry Potter and the Goblet of Fire* was a box office smash.

Google Print, a proposed project to digitize all the world's books and offer a searchable database complete with excerpts of undetermined length, came under fire from authors, publishers, distributors, and booksellers who were concerned about piracy and other legal issues. By year's end the project had shifted to scanning public domain works only pending agreements with copyright holders.

The larger booksellers expanded the lines of titles they published themselves, further complicating the relationships with the companies who produce their own editions of the same public domain works. (Though I have to say that Scott McKowen's covers for various Barnes & Noble books were top-notch.) And in the U.K. there were open hostilities between the WH Smith chain and publishers because of the bookseller's attempt to levy fines (to the tune of £2 million deducted from money owed the various houses) for the late delivery of books. Lawsuits were promised.

Last year I mentioned Anne Rice's dust-up with people posting negative reviews of her latest vampire book on Amazon. 2005's story about Ms. Rice had to do with her turning away from horror and soft-core porn (and combinations of the two) and becoming a Christian-themed writer with the sale of a novel about Jesus' youth. I'm not saying anything (and it ain't easy).

POD was still BFD and E-books were still an over-priced novelty (though dramatized books on disc continued to ring up respectable sales). There were more how-to books, more media tie-ins than you could shake a stick at, more imports, more graphic novels. If there was a decline in titles produced in '05 it sure was hard to notice.

Ok, thinking about single artist collections that caught my eye, I'd say that *Wendling: Drawers 2.0* by Claire Wendling [Legends/le Cycliste] was one of the year's highlights. Claire's energetic and highly stylized drawings and watercolors are both engaging and memorable. I was a sucker for the definitive *The Art of Ray Harryhausen* by Ray

Harryhausen and Tony Dalton [Aurum Press Ltd.] which featured the special effects master's conceptual drawings for all of his films as well as photos of his eye-popping bronze statues. *Kiddography: The Art of Tom Kidd* [Paper Tiger] was a welcome retrospective of one of the paperback field's best cover artists (and included a number of amusing anecdotes about Tom's life). *Arts Unknown: The Life & Art of Lee Brown Coye* by Luis Ortiz [NonStop Press] was a loving tribute to the idiosyncratic horror illustrator and *Weird Tales* alumnus; in a similarly spooky vein, *Everything That Creeps* by Elizabeth McGrath [Last Gasp] was the first collec-

Drawers 2.0, a beautiful career overview of French illustrator Claire Wendling's phenomenal art, covered her work in comics, animation, and films. It's available in the United States from Stuart Ng Books: www.stuartngbooks.com

tion of the LA underground wünderkind's work while the Godfather of Outsider Art was well served by his latest compilation, *Through Prehensile Eyes: Seeing the Art of Robert Williams* [also from Last Gasp]. *Mark Schultz: Various Drawings Volume One*

The gifted creative team behind the William Joyce-inspired 20th Century Fox film, Robots, *received some much-deserved exposure in this enchanting book from Chronicle. www.chroniclebooks.com*

[Flesk Publications] beautifully displayed Mark's powerful compositions and enviable skills with both pencil and brush. *Process Recess: The Art of James Jean* [Adhouse] was a small gem of a showcase for one of today's hottest young creators and Alan Lee's *The Lord of the Rings Sketchbook* was a treasure-trove of exceptional drawings. There seemed to be a ton of fantasy pin-up books last year, but Luis Royo's *Subversive Beauty* [Heavy Metal] was easily the best of the bunch. *Mas Creaturas: Monstruo Addendum* by Carlos Huante [Design Studio Press] was an impressive exhibition of things that go bump in the night, *Onirika* by Simone Bianchi [Pavesio] was a blender of SF/comics/metaphysical illustrations, *Welcome to My Worlds: The Art of Rob Alexander* [Paper Tiger] featured some very impressive paintings, Clive Barker's *Visions of Heaven and Hell* [Rizzoli] was a lavish exhibition for the horror writer/artist (though, honestly, I've never been able to develop a taste for his canvases—his sketches are another matter entirely), *Revelations: The Art of Max Bertolini* [Paper Tiger] included an attractive selection of SF and fantasy work, Jim Burns' gals were the enjoyable focus of *Imago* [Heavy Metal]—as were Greg Horn's in the extremely hot-selling *The Art of Greg Horn* [Image]—and I flat-out loved the retro-cool graphic stylings exhibited in *Chromaphile* by Ragnar [Baby Tattoo Books]. I had looked forward to a pair of books last year, *RGK: The Art of Roy G. Krenkel* by Dave Spurlock and Barry Klugerman and *The Fantastic Art Of Arthur Suydam: Celebration of An American Maverick*, also by Mr. Spurlock (Vanguard's publisher)—and was admittedly disappointed after the wait. Certainly, both books contained some marvelous work, but the text for *RGK* was contradictory and sloppy, and didn't even include a real biography or photos of the artist (it didn't help that the reproduction was all over the place, ranging from superb to blurry). With Suydam the serious-artist tone just didn't seem to match the comics-heavy contents—and it appeared as if there was a conscious decision to skip over the quantity of nudes and erotica he's done through the years, leaving the reader with an

incomplete picture of the artist. I *liked* aspects of the books, mind, but I was hoping for much more than I got. (And, yes, the design for both was, shall we say, *very* familiar.) On a happier note (and speaking of design), for anyone who enjoys graphic art—or who aspires to work in publishing—*Chip Kidd Book One–Work: 1986-2006* by (surprise!) Chip Kidd [Rizzoli] was simply the *must-have* book of the holiday season.

Not fantasy-themed but well-worth buying was *The Paperback Art of James Avati* by Piet Schreuders and Kenneth Fulton [Grant], a thorough look at the life and work of one of this country's foremost illustrators.

As far as "anthology" art books go, I was surprised and pleased by the new design of the latest installment of *Illustrators* (#46, edited by Jill Bossert) [Harper]: smaller at 8"x10", thicker, and with each artwork receiving a page along with commentary from the illustrator, it really was an invigorating new direction for the venerable series. There were a number of art books associated with popular films that appeared in the marketplace and the quality across the board was top-notch: *The Art of Star Wars, Episode III—Revenge of the Sith* by Jonathan Rinzler [Del Rey], *The Art of Robots* by Amid Amidi [Chronicle], *The World of Kong: A Natural History of Skull Island* "by" Weta Workshop [Pocket], *The Alchemy of MirrorMask* by Dave McKean and Neil Gaiman [Collins Design], *Frank Miller's Sin City: The Making of the Movie* by Frank Miller and Robert Rodriguez [TroubleMaker Publishing], and *The Art of Howl's Moving Castle* by Hayao Miyazaki [VIZ Media LLC] were all—and I mean ALL—worth buying. Also in the George Lucas universe of titles were the mammoth *Star Wars Poster Book* by Stephen Sansweet and Peter Vilmur [Chronicle] and *Dressing a Galaxy: The Costumes of Star Wars* by Trish

Wandering Star failed to get their deluxe edition of this Conan collection published before Del Rey got their softcover into print, depriving us of Greg Manchess' staggering color illustrations (all printed in b&w in this paperback). Whether the hardcover will eventually appear was still unknown at year's end.

Biggar [Abrams]: both were big and beautifully printed. Surprisingly, no one published a book of the art of Steven Speilberg's updated reworking of *The War of the Worlds*: I think someone missed out on sure a winner.

There were some nice pieces in *The Art Of George R. R. Martin's A Song Of Ice And Fire* [Fantasy Flight Games], *Art of Darkwatch* edited by Chris Ulm and Farzad Varahramyan [Design Studio Press], *The Art of World of Warcraft* [Brady Games], and *Aphrodisia 1: Art of the Female Form* edited by Craig Elliot [Aristata]. Australia's Ballistic Publishing kept pumping out books at an amazing rate: *Exposé 3* (which unfortunately featured an award-winner whose piece plagiarized Stephen Hickman's popular painting "The Lion Pavilion"), edited by Mark Snoswell and Daniel Wade, *CG Challenge: Machineflesh*, and *CG Challenge: Grand Space Opera*—all included some exceptional works.

With the speed that they've funneled multiple series of books into the market Ballistic will either dominate the digital category or hurt themselves by oversaturating it. It'll be interesting to see which.

Of the illustrated fiction titles of 2005 among my favorites were *The Plucker* by Brom [Abrams] (which confused critics who weren't quick enough to realize that Brom's darkly beautiful horror tale wasn't intended for children), *The Serpent Came to Gloucester* by M.T. Anderson with art by Bagram Ibatoulline [Candlewick], and *The Conquering Sword of Conan* by R.E. Howard with art by Gregory Manchess [Del Rey]. *Worlds: A Mission of Discovery* by Alec Gillis [Design Studio Press], *Izzy's Very Important Job* by Ragnar [Baby Tattoo Books], and a new edition of Lewis Carroll's classic *Alice's Adventures in Wonderland/Through the Looking Glass* with paintings by Anne Bachelier [CFM Gallery] were all worth picking up and adding to the your bookshelf.

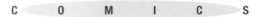

Patrick O'Brien's painted art for Kevin O'Malley's Captain Raptor and the Moon Mystery *[Walker] winningly combined sentient dinosaurs and rocketships—in a graphic novel format even! What's not to like?*

Covers were a little bit of everything last year: though it didn't seem like there was a surge of new narrative images when compared to jackets sporting stock art, graphic solutions, photos, or typographic designs, there didn't appear to be significantly fewer, either. A few of the paintings that struck a chord with me included Gary Ruddel's for *Olympos* by Dan Simmons [Eos], David Bowers' for *The Hallowed Hunt* by Lois McMaster Bujold [HarperCollins], Jim Burns' for *Resolution* by John Meaney [Bantam UK], Kinuko Y. Craft's for *The Divided Crown* by Isabel Glass [Tor], Tom Canty's for *The Year's Best Fantasy & Horror* co-edited by Ellen Datlow, Kelly Link, and Gavin Grant [St.

Part folk-artist, part Thomas Hart Benton wannabe, Lee Brown Coye was properly remembered in Luis Ortiz's tribute volume from NonStop Press. to www.nonstop-press.com

Martin's] (which as always includes a valuable year-end summary), Jon Foster's for *Snake Agent* by Liz Williams [Night Shade Books], John Jude Palencar's for *Eldest* by Christopher Paolini [Knof] and *Chasing Fire* by Michelle M. Wech [Bantam Spectra], and Bob Eggleton's for *The Martian War* by Gabriel Mesta [Pocket]. And that, naturally, just

scratches the surface. Wonderful covers appeared by Donato Giancola, Justin Sweet, Michael Whelan, Stephan Martiniere, the Dillons, Fred Gambino, Greg Spalenka, Les Edwards, Douglas Klauba, Michael Koelsch, Cliff Nielsen, Matt Stawicki, Jean Pierre Targete, and literally an army of other worthy talents. It's still unfortunately fairly common for some publishers not to credit their cover artists—why is anyone's guess (a line of type certainly doesn't cost anything).

With the possible passage of the outrageous "Orphan Works" legislation currently being debated (which will effectively undermine the copyrights of individual creators, particularly those who are not prominently credited for their works) it is important for illustrators to receive the byline they deserve. When you encounter a book in which the cover artist isn't acknowledged, I encourage you to write or e-mail the publisher in question and ask (nicely, naturally) that they do so—not only as a courtesy, but also as a show of support for creators' rights.

C O M I C S

For the last couple of years I've noted that, barring a few exceptions (one of which was spelled m-a-n-g-a), the comics industry has been in something of the doldrums. Good books have always been produced, sure, but sales tended to be flat, smaller companies went out of business, successful movies didn't necessarily provide much of a boost in circulation, and some industry professionals spent their time bickering in public instead of promoting the industry. But there was something of a positive shift in 2005 as all of the graphic-novel-buzz of the last few years seemed to finally sink in. Comics in a variety of formats could be found in all of the major booksellers' stores; movie fans actually began seeking out the sources for their favorite comics film adaptations (and one, *A History of Violence*, was an Oscar® contender); and—catch me before I faint—there was even an honest-to-goodness balanced trade journal for the industry in the *PW Comics Week* e-mail newsletter, thanks to *Publisher Weekly's* Calvin Reed and Heidi MacDonald (available *free* to all interested readers by registering at: www.publishersweekly.com). Instead of thinking of their products as low-priced disposable entertainment, the companies seriously started to treat their properties as valuable back-list titles, ones that would continue to generate revenues for years to come. If they're not careful, comics are going to become *gasp* respectable. (Though not if retailers continue to rack—unshrinkwrapped—*The R. Crumb Handbook* on the same kid-friendly shelves as the various superhero titles—as we witnessed them doing in virtually every traditional bookstore we visited. Elections are coming up and there are plenty of Estes Keefauver-style politicians who would just love to wave Bob's notorious "Joe Blow" story in front of a TV camera if it'll scare up a few votes. It's a good book, a great overview of Crumb's career—just not for children.)

The up-tick in the comics market didn't necessarily translate into lucre for everyone, of course:

the smaller, independent companies struggled to maintain their modest share of the market, especially as distribution options continued to contract. 2006 will provide more challenges.

With stationery, figurines, journals, and an increasing number of genre-fiction paperbacks, Dark Horse expanded their strategy of product diversity through the year. Without owning the majority of their properties (as their larger competitors do), DH played up their "hip" factor by advertising to the outsider and alternative demographics to help insure their success. Robert Rodriguez's faithful film adaptation of Frank Miller's *Sin City* pushed the graphic novels (with unifying redesigns by Chip Kidd) to the top of the sales charts. Mike Mignola, Evan Dorkin, Eric Powell, Kelley Jones, and Gary Gianni contributed to *Dark Horse Book of the Dead*, the latest in their series of horror-themed hardcovers. Various *Star Wars* titles rode the wave of interest in the franchise that was generated by the last film in the series, *Episode III—Revenge of the Sith* while *Penny Arcade Comics* (written by Jerry Holkins with art by Mike Krahulik) was an unexpected hit (thanks in no small part to the web-pair's fervent following among video gamers). Cary Nord wonderfully illustrated Kurt Busiek's take on Robert E. Howard's *Conan* while Mike Mignola's *Hellboy: The Island* mini-series was positively poetic and moving (trust me). *The Goon* (written and illustrated by Eric Powell), Jason Alexander's *Damn Nation* (scripted by Andrew Cosby), *Conan and the Jewels of Gwahlur* (adaptation and art by P. Craig Russell), and *The Will Eisner Sketchbook* were all worth picking up.

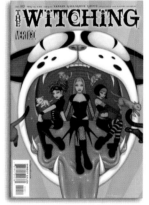

DC always has some of the best covers in the field, but Tara McPherson's series for The Witching *were really stand-outs.*

DC Comics calmly moved into the dominant position in the industry as their mass-market strategies came to fruition. With strong sales in both comic shops and in the chain bookstores—and with the boxoffice success of *Batman Returns*—the company's product line really was the class act (and most diverse) of the major publishers. If the possible revision of copyright for Superboy (and perhaps a few other characters) to the heirs of Superman co-creator Jerry Siegel had the message boards buzzing on one side of the fence, Publisher Paul Levitz's cutting "thank you" checks to Neal Adams and Denny O'Neil (for their concepts that were used for the relaunch of the Batman film franchise) had the bloggers tip-tapping on the other. The joint-venture with both France's Humanoids and Britain's 2000AD didn't meet profit expectations and the association ended, but DC's CMX manga-flavored line seemed to be working quite well. The incredibly stylish *Catwoman: When in Rome* series by Tim Sale (written by Jeph Loeb) was completed and released as a single hardcover collection by year's end, the Mark Chiarello-edited *Solo* series featured outstanding issues devoted to Darwyn Cooke, Teddy Kristiansen, and Jordi Bernet, while underground pioneer Richard Corben proved that he was just as comfortable in the mainstream with his art for *Swamp Thing #20*

(written by Joshua Dysart). Alex Ross collaborated with writer Jim Krueger and fellow artist Doug Braithwaite on the first installments of the 12-part maxi-series *JLA/Justice*, Kent Williams beautifully realized Darren Aronofsky's vision of *The Fountain*, and Leinil Yu did a bang-up job illustrating Andy Diggle's scripts for *Silent Dragon*. Adam Hughes' covers for *Catwoman* were uniformly breathtaking—and he wasn't alone: James Jean, Jae Lee, Tim Bradstreet, Tony Harris, Grand Master Mike Kaluta, Jock, Frazer Irving, and Mike Huddleston all contributed staggering cover art throughout '05. And I can't forget *Batman: Cover to Cover*, a hefty coffeetable book that featured art by anyone and everyone that's ever done covers for the Dark Knight.

Marvel seemed to be in something of a hover-mode last year as it caught it's corporate breath. Their one major film license, *The Fantastic Four*, was drubbed by critics but moderately profitable; the toy spin-offs suffered from flat sales in the face of declining demand, publishing revenues were "okay" but not exceptional, a Mike Mayhew cover for *Magneto* owed more than a little to a photo of King Juan Carlos De Borbon and sparked protests from the Spanish government, and an embarrassing profit-sharing lawsuit from Stan "The Man" Lee resulted in an expensive settlement. True Believers (doncha love those old Marvel catch phrases?) were rewarded through the year with the *House of M* mini-series (written by Brian Michael Bendis with art by Olivier Coipel), *Ghost Rider* (revised in preparation of the forthcoming Nicholas Cage film) with scripts by Garth Ennis and art by Clayton Crain, *Daredevil* as written by Bendis with illustrations by Alex Maleev, *Loki* (writer: Rob Rodi/art: Esad Ribic), and, of course, Frank Cho's sumptuously-drawn *Shanna, The She-Devil* mini-series. Marvel's various titles featured some excellent covers by Bill Sienkiewicz, Paolo Rivera, Jo Chen, Ryan Sook, Katsuya Terada, Joshua Middleton, and Brandon Peterson, among many others.

When it came to "the other guys" last year, I noted earlier that the distribution hurdle was raised just a little higher for the small companies in 2005. With the comic shops working on finite budgets and the Big Three ramping up production of new product, owners had to pick and choose their non-returnable inventory carefully—and that usually left the smaller publishers out in the cold. The mass-markets, with their restrictions and return policies, were largely closed to the independents not closely aligned with a distributor. I regularly visit the comics retailers in my area and, lemme tell you, unless you special ordered the small press titles, pickings were pretty slim. I was uncomfortable with the *Classic Comics Illustrators: The Comics Journal Library* edited by Gary Groth and Tom Spurgeon from Fantagraphics (which is distributed by

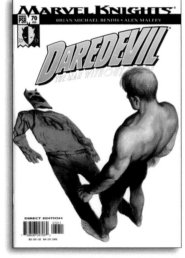

After a few years of playing it fanboy-safe with their covers, Marvel came back strong with some arresting work by Frank Cho, Bill Sienkiewicz, Alex Maleev (like this for Marvel Knights: Daredevil).

Norton), not because it wasn't attractive (it was) or didn't include good stuff (it did), but for the simple reason that they apparently didn't cut the artists in for a share of the profits. Granting interviews for their magazine was one thing and I'm sure all the parties were happy to do it: repackaging those same interviews and adding more art for the book trade would ethically dictate that some sort of compensation be made. But maybe that's just me. (Whereas *Krazy & Ignatz 1935-1936: "A Wild Warmth of Chromatic Gravy"*, the latest installment in Fantagraphics' archives of George Herriman classic humor strip, gets my strongest endorsement.) IDW produced Rob Zombie's rowdy creature-feature mini-series, *Bigfoot*, with scripts by Steve Niles and art by Rich Corben, the first issue of their horror anthology magazine *Doomed* (think *Creepy* for a 21st Century audience), and literally a whole slew of horror and edgy SF comics, many featuring outstanding work by Ashley Wood and Jeremy Geddes. Black Bull released writer Jimmy Palmiotti's and artist Phil Noto's *The New West*, Geof Darrow collaborated with *The Matrix*'s Wachowski brothers on *Shaolin Cowboy* for Burlyman Entertainment, *Tomb Raider: The Greatest Treasure of All* (written by Dan Jurgens and published by Top Cow) was exquisitely painted by Joe Jusko, Simon Bisley collaborated with scripter Simon Reed on Full Cirkle (Full Cirkle Publishing), and latest installment of *The Acme Novelty Library* by Chris Ware [Pantheon] was an astoundingly designed artifact. Of the comics-related history books last year, my favorites included *Foul Play! The Art and Artists of the Notorious 1950s E.C. Comics!* by Grant Geissman [Harper Design], *Masters of American Comics* edited John Carlin, Paul Karasik, and Brian Walker [Yale University Press] (a bit uneven, but interesting nevertheless), *Winsor McCay : His Life and Art* by John Canemaker [Abrams], and *Will Eisner: A Spirited Life* by Bob Andelman [Dark Horse].

As for Manga, the bloom seemed to be ever-so-slightly off the rose. As more and more American publishers launched their own lines, as the shelves began to fill and groan under the weight of all the titles, the field rapidly became just another type of book rather than the Phenomenon it had been in the last few years. Some shake-out is inevitable and will probably come much sooner than some companies will be ready for.

The mixture of comics-related magazines produced last year changed only slightly: *Wizard*, *Alter Ego*, *Draw!*, *Comic Buyer's Guide*, and *Back Issue* appeared like clockwork, but *Comic Book Marketplace* was canceled and *Comic Book Artist* managed only one

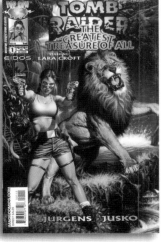

It took awhile, but he got there! Joe Jusko's painted Tomb Raider *comic for Top Cow was several years in the making, but ultimately well worth the wait.*

issue (a tribute to the late great artist, Will Eisner).

Oh, but I can't finish talking about comics without mentioning the Andrews McMeel (who pay me very nicely as one of their art directors, thank you very much) hefty collection, *The*

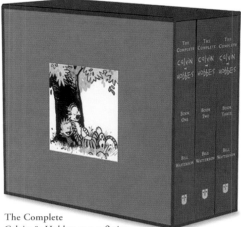

The Complete
Calvin & Hobbes was a fitting tribute to one of the most beloved–and popular–strips in the history of newspaper comics. And yes, Watterson still refuses to license the characters for use on any other products.

Complete Calvin & Hobbes by Bill Watterson. Not only was it a terrific set of three books in a slipcase (and my opinion wasn't swayed because I got mine, umm, gratis), but at $150 it established something of a record for being the most expensive title ever to appear on the *New York Times* best-seller list.

Did I mention that I got my set for free?

DIMENSIONAL

Every year I think the market for collectible statues, toys, and action figures has reached its saturation point—and every year I'm proven wrong. Sure, demand has softened a bit (and the bankruptcy of Musicland was a major blow to many collectibles companies, who were forced to take losses on outstanding invoices) and the number of retail outlets shrank some, but there seemed to be enough interest in new works to keep the sculptors busy.

NECA filled out their line of 18"-tall *Lord of the Rings* figures with a "Gandalf" (which even included a sound chip with movie dialogue by Ian McKellen) and "Balrog"—as well as equally large interpretations of the main characters from *Sin City*—Mezo released the first in a series of comic-art inspired "Hellboy" toys (and they were pert-near perfect interpretations of Mignola's work), and Dark Horse—in partnership with Kotobukiya—brought out more of their of exquisitely detailed 12" *Star Wars* figures. DH also teamed with New Zealand's Weta workshop to produce statues based on Peter Jackson's remake of *King Kong* and Disney's adaptation of *The Chronicles of Narnia: The Lion, The Witch, and the Wardrobe*—across the board they were large, rather pricey (Kong fighting the V-Rex was around $500!), weren't especially faithful to their film sources (the *Narnia* pieces were particularly off), and—the cardinal sin—they were late arriving in stores.

McFarlane released the second series of their Conan toys (all nicely done) and offered a new line of original "Dragon" figures, each with their own linking storyline. Palisades Toys and Kotobukiya kept their

focus on various film and video game licenses, with *Alien, Predator, The Terminator,* and *Transformers* for the former and *Final Fantasy* and *Full Metal Alchemist* from the latter.

Stand-outs from DC Direct last year included "The Flash Vs. Gorilla Grodd" statue (designed by Michael Turner; sculpted by Tim Bruckner and Tony Cipriano), "Green Lantern Vs. Sinestro" (again sculpted by the talented Mr. Bruckner), "Foster's Home for Imaginary Friends: Blooregard, Mac, & Eduardo" (sculpted by Karen Palinko), and John G. Mathews' masterfully done "Black Canary" maquette and the "Batman B&W: Brian Bolland" figurine.

Marvel's 3D offerings included a very good "Black Panther" sculpt by Randy Bowen and a "Mephisto" mini-bust by Thomas Kuntz. Sideshow released some very attractive *Star Wars* and *Alien* collectibles (including some high-dollar ceramic wall plaques by actor Lance Henrickson) while the Franklin Mint (which had produced nice works based on the art of Brom, Michael Whelan, Boris Vallejo, and Julie Bell) seemed to be getting out of the fantasy business. The Greenwich Workshop released a beautiful bronze by James C. Christensen, "Sleeper Lost in Dreams," and Joe DeVito produced his own perfectly dandy interpretation of the classic "King Kong."

King Kong returned in a big way in 2005. Peter Jackson's remake prompted a large amount of spin-offs, but Joe DeVito went back to the 1933 movie poster as his inpiration for this amazing statue. Visit his website to see if any are still available: www.jdevito.com

"Bouteque" artist toys were still hot (my favorite was "BunnyDuck" in it's pre-distressed box by Todd Schorr and Nathan Cabrera), one-off designer dolls were pricey and popular, and garage kit makers were kept busy (it didn't get much better than Mike Petryszak's interpretation of Frank Cho's "Deja Thoris"). There are a batch of magazines geared for the 3D enthusiast: I recommend *Amazing Figure Modeler* (amazingmodeler.com) and *Sculptural Pursuit* (sculpturalpursuit.com).

EDITORIAL

In Days of Yore (meaning before *Star Wars,* cable TV, and the Internet), the fiction magazines were the center of the SF universe for genre fans: if you had a serious interest you read *Astounding* (later *Analog*), *Amazing Stories, Galaxy, The Magazine of Fantasy & Science Fiction* or one of the lesser known (and shorter lived) publications. Circulations were significantly higher and the circle of talent (writers and artists) was appreciably smaller: people kept in touch via letters (and the very occasional expensive long-distance call) while conventions were few and far between. Times were simpler.

Today there are almost infinite ways for people to satisfy their genre habit and interact with others with similar interests. Websites, e-mail, blogs, vlogs,

and instant messaging; fantasy and science fiction films and TV shows and cable networks and games; conventions and readings and gallery shows somewhere every week, usually with a lot of overlap; and magazines—for every taste and interest, fiction, comics, video games, crafts, poetry, news, erotica (*C'thullu Sex* anyone?), you name it, there's a title available either on-line or sitting on a rack waiting to be purchased that caters to that fan base. I mentioned fragmentation in *Spectrum 12*'s review, the fact that with every passing year there is less commonality in society as each splinter group goes its own way and ignores everything else not specifically to its taste: 2005 gave us a little more of the same, and that fracturing was reflected in additional drops in the circulation figures for the various genre stalwarts. *Realms of Fantasy* was the fiction magazine with the most visual panache, featuring some striking story illustrations and some attractive artist profiles/portfolios (including very nice pieces about Tony DiTerlizzi, the Duirwaigh Gallery, and, ahem, *Spectrum*). *Isaac Asimov's SF* featured some great covers by Donato Giancola, *Analog* sported several fine works by Vincent Di Fate and Bob Eggleton, and *The Magazine of F&SF's* painting on the Oct./Nov. issue by Cory and Catska Ench was outstanding. *Rue Morgue, Dark Realms, Weird Tales,* the afore mentioned *C'thullu Sex,* and *Cemetery Dance* included some appropriately macabre works. *Amazing Stories* officially folded (again!) after going on hiatus in 2004, but *Fantasy* made its debut to take it's place.

ImagineFX: Fantasy & Sci-Fi Digital Art appeared late in the year with an impressive first issue; jammed full of computer art, tutorials, and even demos and workshops on an enclosed DVD (marketing.futurenet.com/imaginefx). For traditional art (of all genres) Dan Zimmer's *Illustration* beautifully examined the careers of artists of the last fifty years or so (give or take a decade) while he gave contemporary creators a similar showcase in *Illustration '05* (www.illustration-magazine.com and www.illo.us). I also recommend *Communication Arts* and *Print* for those wanting to keep up with evolving trends and styles.

Sci Fi (the official magazine of the cable channel) was a very good—and nicely designed—general interest magazine for the field and did a great job covering new films, television, books, and games. *Playboy* was naturally impeccably designed and featured some of the best narrative art produced in 2005; *National Geographic* included some knock-out work by Jon Foster, John Gurche, and the CG design studio DamnFX;

and fantastic illustration continued to find a home at *Time, Cricket, Rolling Stone, Entertainment Weekly, Scientific American,* and *Discover* on a regular basis. *Juxtapoz* switched to a monthly schedule,

Despite being unable to make it out as frequently as planned, the two issues of Dan Zimmer's Illustration '05 *were chock-full of amazing art by the likes of C.F. Payne, Marc Gabbana, Joe DeVito, and Peter de Sève.*

Though their original movies were regularly (and justifiably) raked over the coals on The Soup, *the Sci Fi channel definitely produces a first-class magazine, full of news and reviews. www.scifi.com/sfw*

bringing a double dose of angry, politically incorrect outsider art to the newsstands, including outstanding examples by Robert Williams, Mark Ryden, Todd Schorr, and even Virgil Finlay!

I'm occasionally asked how I keep track of a lot of the goings-on in our little field and my answer is pretty much the same each time: I read *Locus,* the trade magazine for the F&SF community. While it's true that I design their covers and main interview spreads each month (I use my feet), that doesn't color my feelings—I've been buying and reading *Locus* since I was young and innocent (and everyone knows that was a *long* time ago!). Information about sample issues or subscriptions can be found at their website (as expertly run by Mark R. Kelly): www.locusmag.com. And for a slightly different perspective on the industry, check out *Science Fiction Chronicle* at www.dnapublications.com

INSTITUTIONAL

The "institutional" category is our Mulligan Stew: you can find just a little bit of everything. Art created for products (not covered in the other categories) for such things as packaging or for promotions. Cards, posters, games, mailers, corporate reports, portfolio samples, concept work—all fit comfortably under the umbrella.

It may have been that I was paying more attention last year—or maybe the publicists were doing a better job than usual—but there certainly seemed to be a *lot* of shows last year. Michael Kaluta and Charles Vess teamed up for "Modern Fairy Tales" at the Museum of Comic and Cartoon Art in New York, which also hosted a major retrospective of Will Eisner's art. (For information about the MoCCA visit www.moccany.org.) The Society of Illustrators (www.societyillustrators.org) featured the first serious look at the art of Bob Peak; the Jonathan LeVine Gallery displayed new works by Daniel Martin Diaz, Todd Schorr, and Kathy Staico Schorr; Robert Williams was on center stage at the Ben Maltz Gallery, Chris Mars was likewise at the CoproNason Gallery, and Mark Ryden, resplendent in white tie and tails, introduced guests to his new show, "Wondertoonel," at the Pasadena Museum of California Art. As mentioned earlier, the Rockwell Museum boasted an excellent exhibit of "Art From the National Geographic," which featured astonishing canvases by James Gurney, Robert McGinnis, and Greg Manchess, among a host of others: Jim also participated in the "Pirates!" display at the Oshkosh Public Museum with Don Maitz and some unknown named Howard Pyle. The Modern Gallery in Palm Springs, CA and Excellent Virtu in Deland, FL mounted some excellent group shows.

William Stout kept busy throughout 2005 painting prehistoric murals for the San Diego Natural History Museum while Shag's art became the basis of a theatrical musical in L.A., "Shag With a Twist."

There were a number of nicely designed calendars released last year including keepers by Kinuko Craft, John Jude Palencar, Mike Mignola, Brom, Luis Royo, Michael Parkes, and Alex Ross. Ken

Jane Frank celebrated the 15th anniversary of her Worlds of Wonder original art gallery with a limited edition catalog—worth the price for the Richard Bober cover alone!

Meyer, Jr. continued to gather a wonderful mix of artists for the Tori Amos RAINN benefit calendar.

There were many posters, portfolios, prints, and limited editions offered through '05 and most artists were selling their own gicleés via their websites. Googling the names of your favorites—or attending any of the major conventions—usually results in some magnificent finds. If you collect originals you can check with your favorite artist to see what's available. Or you can visit a reputable dealer's or collectors' websites such as: Worlds of Wonder: www.wow-art.com, Heritage Galleries: www.heritagecomics.com, or the Illustration Exchange: www.munchkinpress.com.

R E Q U I E M

In '05 we lost these talented creators:
Mar Amongo [b. 1936] comic artist
Jim Aparo [b. 1932] comic artist
Pietro Ardito [b. 1919] caricaturist
David Austin [b. 1935] cartoonist
James Avati [b. 1912] artist
Zdzislaw Beksinski [b. 1929] artist
Stanley Berenstain [b. 1923] artist/writer
Peter Bramley [b. 1945] cartoonist/art director
Daniel Branca [b. 1951] comic artist
Rafal Fornes Callado [b. 1917] cartoonist
Ryan Richard Carriere [b. 1973] comic artist
Fred Carrillo [b. 1926] comic artist
Paul Cassidy [b. 1910] artist
Raymond Chiavarino [b. 1927] comic artist
Yutsuko Chusonji [b. 1962] manga artist
Paul Deliege [b. 1931] artist
Napier Dunn [b. 1938] cartoonist
Pierre Dupuis [b. 1929] comic artist
Will Eisner [b. 1917] comic artist
Jean Michel Folon [b. 1934] artist
Bill Fraccio [b. 1924] comic artist

Remembering Byron V. Preiss
1953-2005
by William Stout

I was devastated by the news of the death of my dear friend Byron Preiss. I expected to be seeing him that week and received a note in the mail from him the day before the accident. We always had dinner together the Friday evening of Comic-Con at the Panda Inn in Horton Plaza. Byron always picked up the tab. This year I planned to surprise him and pay for him and his crew, just to see the expression on his face.

Byron Preiss has been a part of my family since the late 1970s. Byron shared my triumphs in this funny business; I shared his. Together we celebrated the mainstream success of our 1981 book *The Dinosaurs: A Fantastic New View of a Lost Era*. While I produced the content for that book, Byron was the glue that held it together, the engine running the machine. We met and mutually (and wholeheartedly) approved of each other's future spouses. When we became parents we were both as proud of each other's kids as we were of our own. Whenever Byron phoned me he greeted me, calling me "Uncle Bill" (I found out later that "Uncle Bill" is how Byron had his staff refer to me as well).

In reality, Byron was more like a brother to me than an uncle. We took turns at being each other's older and younger brothers. Like brothers we had disagreements – but these were always business disagreements, differences of aesthetics or production – rarely anything major. And even though I was usually the hothead in these disagreements not for once did I ever let that color or diminish our personal relationship or the love I felt for him and his family.

I discovered very early in our relationship that Byron possessed a big, deep heart. One sunny day on the streets of New York I was witness as a tragic newspaper headline he glimpsed in a newsrack instantly changed his mood to one of great sorrow. One contract point I never disputed was his insistence that Braille copies of our books would be distributed royalty-free to the blind.

We shared many common loves. Despite (or maybe because of) being a New Yorker, Byron was a huge Beach Boys fan. One of our first projects together was *The Authorized Beach Boys Biography*. Through Byron I was able to meet the Beach Boys I hadn't met (I had already met Brian and Dennis Wilson) and together we watched them perform at the Hollywood Bowl. We also loved and were close friends to Harvey (and Adele) Kurtzman and worked on *Harvey Kurtzman's Strange Adventures* together. It was also through Byron that my long friendship and working relationship with Ray Bradbury began.

I admired Byron for always being experimental. He was constantly trying new forms to break comics into the mainstream. Despite occasional failures and spurred on because of his many successes (as I write this he has two books in the New York Times bestseller list), he never relented in his efforts to have comics reach everyone so that the world could understand and share his love of and passion for this great creative genre.

Byron's publications opened the eyes of many people who were not in the comics industry to the potential of using comics creators. My own entry into the film business was facilitated by the fact that John Milius, the director of *Conan the Barbarian*, had seen my story from Byron's *The Illustrated Harlan Ellison* ("Shattered Like A Glass Goblin") in *Heavy Metal* and had loved it.

I received copies of our new book, *The Emerald Wand of Oz*, the first of a series we were doing of three new *Oz* books, just a day before the accident. I was looking forward to unveiling the cover of our second *Oz* book, *Trouble Under Oz*, at Comic-Con mostly because, despite being in the business as long as he had been, Byron had never lost his fan enthusiasm for good new work.

I thought I would be working with Byron off and on forever. He always had a knack of approaching me with just the right dream project, something I had always wanted to do.

I am still numb from the news. I can't believe it. My brother Byron has passed on much too early, leaving a large hole in my life. My warmest and deepest sympathies go out to Sandi and the girls.

Andre François [b. 1915] cartoonist
Frank Kelly Freas [b. 1922] artist
John Gallagher [b. 1926] cartoonist
Dudu Geva [b. 1950] cartoonist
Tom Gill [b. 1913] comic artist
Joe Grant [b. 1908] cartoonist/animator
Wesley Hazelton Sr. [b. 1919] cartoonist/animator
Robert Hendel [b. 1938] artist
Fred Julsing 0b. 1942] artist
Phil Kellison [b. ?} stop-motion animator
Selby Kelly [b. 1918] cartoonist/animator
John Klamik [b. 1935] cartoonist
Dan Lee [b. 1970] animator
Jerry Marcus [b. 1924] cartoonist
Owen McCarron [b. 1929] cartoonist
Dale Messick [b. 1906] cartoonist

Lou Meyers [b. 1915] artist
Luis "Lucho" Olivera [b. 1942] comic artist
Keith Parkinson [b. 1958] artist
Dan Patterson [b. 1951] artist
Jim Sasseville [b. 1927] cartoonist
Romano Scarpa [b. 1927] comic artist
Hinako Sugiura [b. 1958] manga artist
Martin Tooder [b. 1912] comic artist
David C. Sutherland [b. 1949] artist
Edmund Valtman [b. 1914] cartoonist
Ov Vijayan [b. 1930] cartoonist
Robert White [b. 1928] comic artist
Clint Wilson [b. 1914] cartoonist
Rowland B. Wilson [b. 1930] cartoonist
Juan Zanotto [b. 1935] comic artist
Nevio Zeccara [b. 1924] artist †

Spectrum: The Exhibition
THE MUSEUM OF AMERICAN ILLUSTRATION • NEW YORK CITY
Sept. 7 – Oct. 1, 2005

Two years of planning, more than a month of late night coordination and preparations leading up to the event, and a final week of furious activity culminated in the gala opening of *Spectrum: The Exhibition* at the Museum of American Illustration in New York City September 7. Curated by Tor Books art director Irene Gallo, painter Gregory Manchess, and *Spectrum* founders Cathy Fenner and Arnie Fenner, the show featured 190 pieces of art that were selected from the 3224 works that had appeared in the first 11 volumes of *Spectrum: The Best In Contemporary Fantastic Art*. The show turned out to be one of the most popular exhibitions in the Museum's history, attracting visitors from around the country until closing on October 1.

Some of the artists participating in the show included Donato Giancola, Jon Foster, Shaun Tan, Bob Eggleton, James Gurney, Sandra Lira, Thomas Kuebler, Scott Gustafson, Rick Berry, Phil Hale, and John Jude Palencar among many others: a total of 155 creators displayed work. A special section of the exhibition highlighted art by the first 11 Grand Master Award recipients: Frank Frazetta, Don Ivan Punchatz, James Bama, Leo and Diane Dillon, John Berkey, Alan Lee, Kinuko Y. Craft, Jean Giraud, Michael Kaluta, and Michael Whelan.

An invitation-only reception was held the evening of September 9; artists and their guests began gathering well before the door officially opened at 5:30 p.m. The line quickly stretched down the block in front of the historic carriage house which serves as both home for the Museum and headquarters for the Society of Illustrators. Fortunately the evening was clear and cool. The event was standing room only, with more than 300 attendees enjoying an open bar and an elaborate spread of gourmet hot and cold hors d'oeuvres. The reactions to the works on display were overwhelmingly positive and attendees expressed their surprise at how large (or how small) some pieces were, at how much "better" some art looked when compared to printed versions. Collectors, art directors, and dealers sought out individual creators throughout the evening, making purchases or discussing possible assignments – the small color catalog produced for the event was being used by some as a shopping guide.

Midway through the evening Society of Illustrators Director Terry Brown called everyone's attention to the stage and gave a brief history of the organization before introducing the show's curators. Gregory Manchess thanked the Society and its staff for help in the preparation for the show and Dan dos Santos, Jeff Fischer, Arkady Roytman, and David Hollenbach for help hanging the art; Irene Gallo thanked Manchess, dos Santos, the Society, Bridget McGovern for "*tons* of logistical work," and her "very understanding" staff and co-workers at Tor. She also thanked the Fenners, not only for *Spectrum*, but for introducing her to Greg during their service on the jury for volume 8 in 2001. Speaking on Cathy's and his behalf, Arnie Fenner commented on how wonderful it was that the exhibition featured work by many of the field's legendary artists hanging side-by-side with a significant number of today's hot up-and-comers. He thanked the Society for making the venue available, everyone that had worked so hard to put the show together, the collectors for making pieces available, the artists for making *Spectrum* possible in the first place, and Tim Underwood for being willing to take a chance and publish the first book in the series 12 years ago.

At the reception's conclusion, many guests adjourned to the Society's third floor gallery and bar – which featured a small display of classic SF paintings by Stanley Meltzoff, Paul Lehr, John Schoenherr, and Richard Powers from the collections of Vincent Di Fate and Robert Wiener.

The next day, Tor Books and Utrecht Art Supplies sponsored "Art Out Loud," a demonstration of collaborative painting on the fly with Rick Berry filling the role of ringmaster as a benefit for the Society's student scholarship fund. Painting with Rick were Brom, Dan dos Santos, Justin Sweet, Donato Giancola, and Gregory Manchess. An audience of over 100 (with attendees from as far away as Tennessee and Illinois and including such notables as Boris Vallejo, Julie Bell, Charles Vess, and John Jude Palencar) watched the demo; ticket sales to the four-hour-event and an auction of 14 of the 16 artworks created raised nearly $6000 for the fund. †

Jon Foster's show banner.

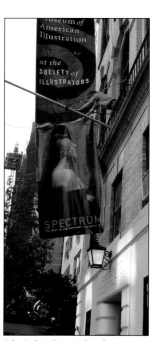

John Jude Palencar's show banner.

Irene Gallo makes some layout decisions for the exhibition.

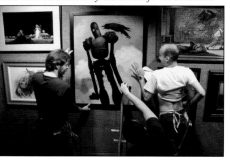

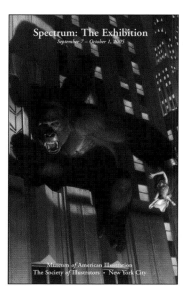

ABOVE: *Thomas Blackshear II's "Eighth Wonder of the World" was an appropriate cover for the show catalog.* AT LEFT: *Gregory Manchess, Dan dos Santos, and Jeff Fischer hang Jon Foster's "Crowbot."*

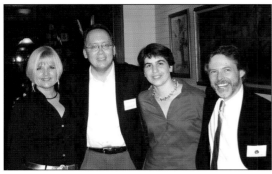
Show curators Cathy Fenner, Arnie Fenner, Irene Gallo, Greg Manchess

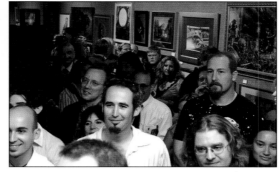
Artists, collectors, and guests filled the museum's two galleries (and bar).

Ellen Datlow and Claire Eddy

FRONT: *Melissa Ferreira, Kinuko Y. Craft*. REAR: *Jon Foster, Mahlon Craft*

CLOCKWISE FROM LOWER LEFT: *Donato Giancola, Michael Whelan, Stephan Martiniere, Joe DeVito*

A partial view of the guests in Gallery One of the museum.

Brom

Jerry LoFaro

Omar Rayyan

Robert E. McGinnis, Tim Underwood

Michael Kaluta, Scott Gustafson

Sandra Lira and her sculpture

Leo Dillon, Diane Dillon, Thomas Blackshear II

Mary and Tim Bruckner

Mark A. Nelson

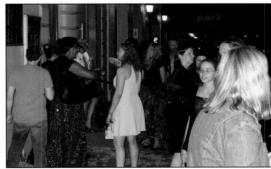
At one point during the evening the crowds spilled out the door.

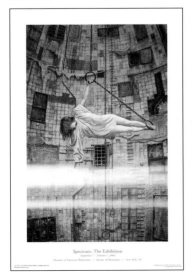
Spectrum: The Exhibition

Justin Sweet

ABOVE: *Rick Berry warms up the audience for "Art Out Loud."* AT LEFT: *Michael Whelan's show poster. A signed edition is available from Glass Onion Graphics:* 1-877-798-6063 *or* www.michaelwhelan.com

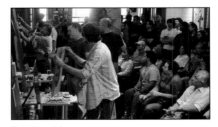
Painting without a net.

Manchess, dos Santos, Sweet, and Giancola collaborate

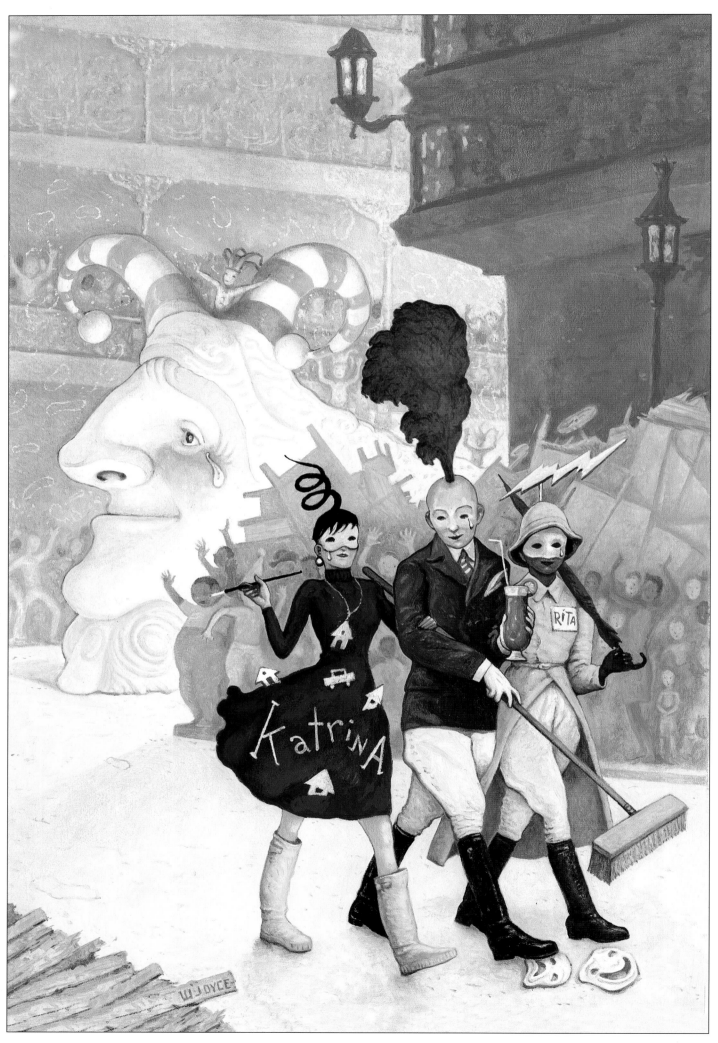

KATRINARITA GRAS

BY WILLIAM JOYCE

My wife was going to a 12th night party dressed as Hurricane Katrina. Her hair was styled in great swooping whirls. Her dress was a hoop-skirt wrapped in black netting and festooned with dozens of tiny houses, cars and other stormy ephemera.

A friend of mine (whose whereabouts since the hurricanes I was unsure of until I saw her on Christmas Eve) explained that it's generally accepted that people in New Orleans will burst spontaneously into tears during even the most cursory conversations.

"Any little thing will trigger it," she said. "I mean you say hello and you'll get sobs. But everyone knows to just be quiet for a minute and it'll pass." Then she added with that cheerful, attractive insolence so common to New Orleanians, "I add 15 minutes of "cryin' time" to everything. Goin' to the grocery store takes forever. There are more tears than in Tolstoy."

Like my wife's dress this line got a laugh. It had to.

It's glad/sad time down here. Glad you're alive. Sad about everything else. If you can't laugh about it, baby you are toast.

There's been some controversy about having Mardi Gras post-Katrina. That it is somehow inappropriate given the scale of the tragedy and disaster.

The punch line to that misguided sentiment is that Mardi Gras is a celebration actually *devoted* to being inappropriate in a community that has courted disaster since the day it was founded.

You don't build a city on land that sits below sea level and is surrounded by water and not expect to get soggy at some point. It is a geographical crap-shoot well understood by New Orleanians and Mardi Gras is part of their gallant disregard for that particular unpleasant reality.

It's one of their ways of laughing at doom.

The history of Mardi Gras is so deep, vast and strange, that it's difficult to encapsulate. Starting hundreds of years ago with the shepherds of Arcadia and detouring through most of the more interesting cities in history it has always been steeped in sin and redemption.

The Romans. The Greeks. The Catholics. They've all put in their two bits of paganism or piety.

But it's fitting somehow that much of Mardi Gras' pomp and plumage would evolve from the carnivals of Venice, that other impossible city at odds with time and tide.

And for all this historical pedigree there's still something very childish about Mardi Gras.

If you are exposed to it as a kid you will never be quite like other people. How could you be?

You've watched an entire adult population, your parents, your aunts and uncles, your teachers or your school principals; all your authority figures, suddenly transform into Poseidon, or Mae West or a cross-dressing Santa Claus. Everyday life becomes an overnight Technicolor fever dream. Schools close. The daily schedule is thrown out for a new schedule of parties and parades that become an unending delirium where it's not inconceivable but in fact highly likely that you might look out the den window at any given moment and see several dozen people dressed as Yogi Bear drift nonchalantly by in a papier-mâché galleon.

It's like somebody knocked over the TV set and cartoons came spilling out.

For those of us who grew up in Louisiana, "The Wizard of Oz" was like a documentary. Dorothy left Kansas and simply went to Mardi Gras.

Talking trees and wicked witches seemed perfectly normal if you've seen your librarian walking down St. Charles dressed in a gorilla suit and a set of woman's breasts complete with blinking neon nipples.

As a result we tend to grow up with a keen sense of life's absurdity and a healthy regard for the curative potential of fun.

And there is no fun quite like a Mardi Gras parade. Its epic silliness can be very seductive. It is one of the marvels of modern man that the quest for giving or catching cheap plastic beads can lead people of every temperament to engage in behavior that is singularly, perhaps historically ridiculous.

Not that I'm a pillar of normalcy but I do pay taxes and manage to mingle in polite society occasionally, yet I once led an organization called the Mystik Knights of Mondrian's Chicken. In homage to the great painter we rode in a giant cube- shaped chicken, wore costumes the color of yolks and threw egg-shaped beads, while white helium balloons were periodically released from a hole in the chicken's ass.

After three years with this same float we were told by the parade's organizers that we would have to change our design. The Novelty of our cubist chicken had apparently worn off. It just wasn't weird enough anymore.

There are people, ordinary both-feet-on-the-ground people who, during Mardi Gras sport titles like The Lord of Misrule or the Abbot of Unreason.

I think we all need to transform ourselves from time to time. To be, however briefly, something else; a satyr, a god, or anything deliciously forbidden. It's such easy, low-cost therapy. You simply don a mask and give in to enchantment, joy or desire. New Orleans is one of the few places on the planet, *one of the few places in history* that can supply the surreal splendor that is essential to that sense of escape. Of being otherworldly, out-side of time, and off the chart of the everyday.

But the 2006 Mardi Gras will be remembered as the most surreal of all. Never has the gaiety confronted so grim a reality. The walls of rubble, the vanished neighborhoods, and the memory of the city from before the storm haunt every street.

Mardi Gras has had troubled times before. One newspaper wrote in 1851, "The carnival embraced a great multitude and a variety of oddities. But alas! The world grows everyday more practical, less sportive and imaginative. Mardi Gras with its laughter-moving tomfooleries must content itself with the sneering hard realities of the present age."

The streets of the city are in black and white now. Like Dorothy's Kansas. A thin coat of grayish dust covers entire neighborhoods since the flood.

Maybe this will make the traditional green, purple and gold colors shine out even brighter.

New Orleans is a "let's face the music and dance" town. It always has been. Try as they might, the sneering hard realities cannot keep it down.

But it'll be harder to catch the beads. Those spontaneous tears will make it tough to see.

William Joyce is the multi-award-winning creator of such classic children's books as A Day with Wilbur Robinson *and* Santa Calls. *His* Rolie Polie Olie *is a staple of the Disney Channel and he inspired (and produced) the hit animated film from 20th Century Fox,* Robots. *His art last appeared in* Spectrum 5. *A native of New Orleans, Bill has established a foundation to help individual Louisiana Artists and Arts Organizations affected by hurricanes Katrina and Rita. For more information about the organization and events or to learn how you can help, visit the official website:* www.williamjoyce.com

the **s**how

Spectrum 13 Call For Entries Poster
by Phil Hale
Oil on canvas, two panels each 32"x45"

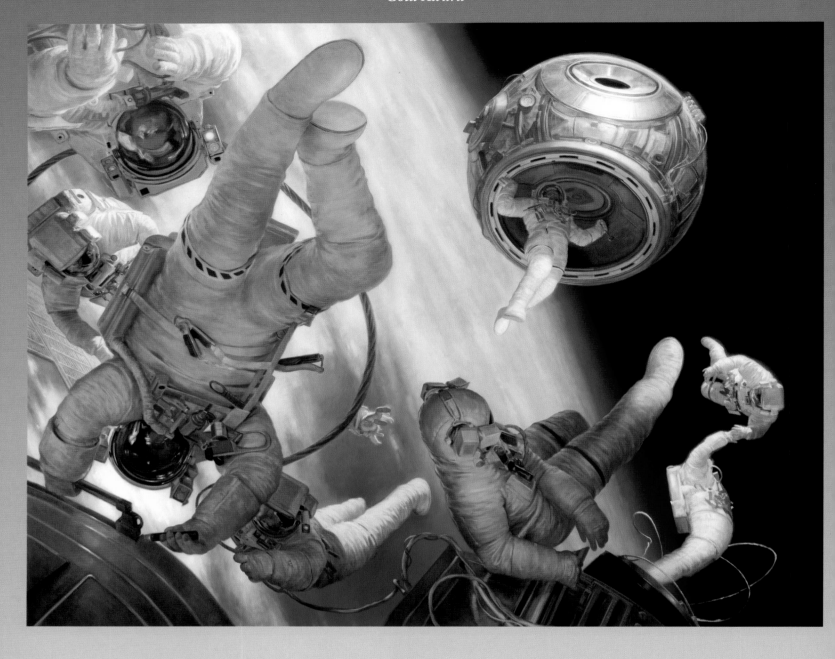

artist: **Donato Giancola**

client: Asimov's SF *title:* Prometheus *size:* 95"x77" *medium:* Oil on canvas

ADVERTISING
Silver Award

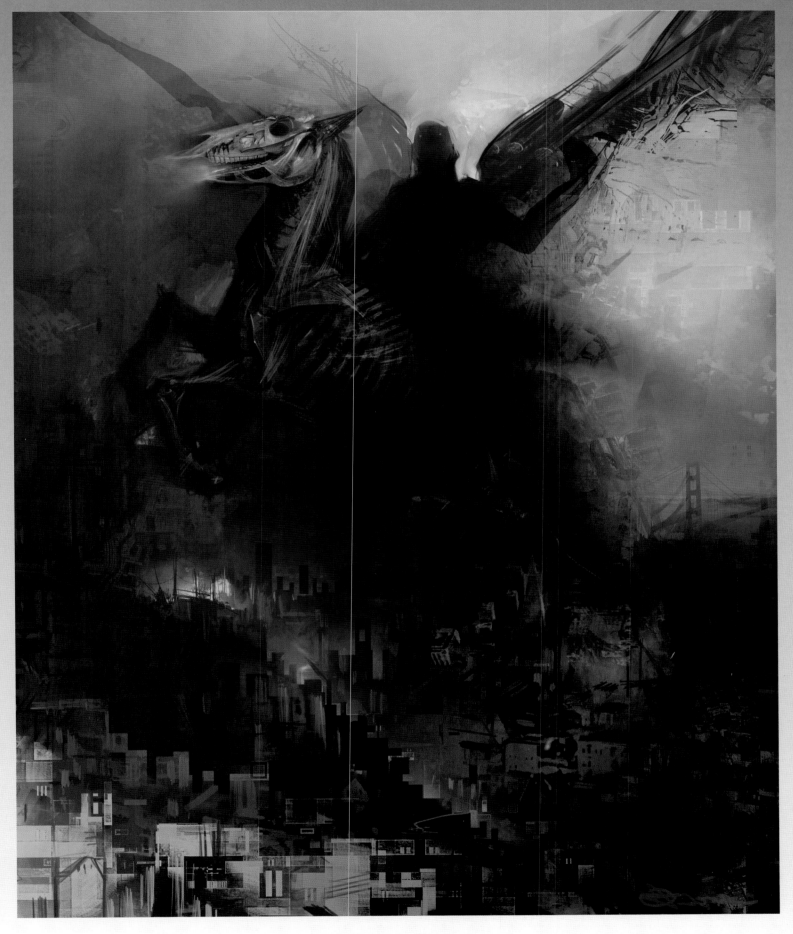

artist: **Andrew Jones**

art director: Massive Black *client:* ConceptArt.org *title:* Die SF *medium:* Digital/Painter 9

ADVERTISING

1
artist: **David Ho**
art director: Fabian Guschlbaur
client: Mental Amputation
title: Mental Amputation
medium: Digital
size: 12"x12"

2
artist: **Marko Djurdjevic**
client: Massive Black
title: Adrian
medium: Digital
size: 8"x11"

3
artist: **Tony DiTerlizzi**
art director: Michelle Montague
designer: Francine Kass
client: Simon & Schuster
title: Look Out! Spiderwick's
 Field Guide is coming!
medium: Gouache
size: 15"x20"

4
artist: **William Stout**
art director: Peggy Ang
designer: William Stout
client: Discovery Channel/Animal Planet
title: Dragons
medium: Ink & watercolor on board
size: 24"x36"

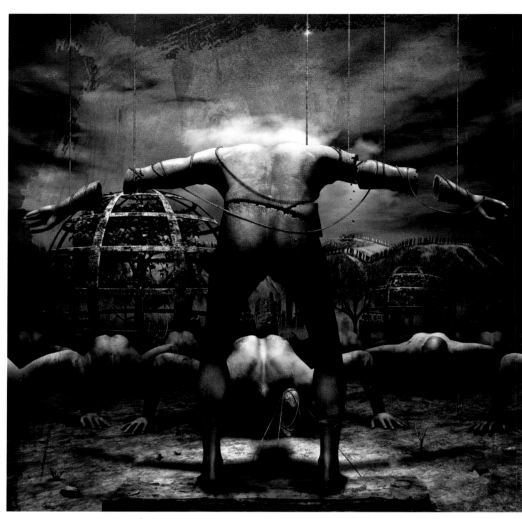

1

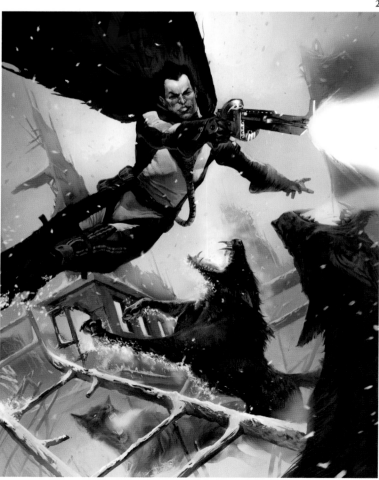

2

3

4

1

2

3

4

5

ADVERTISING

1
artist: **Nate Van Dyke**
art director: Steve Whittier
client: Copper Mountain
title: Copper Catalyst Terrain Park
medium: Mixed
size: 16"x21"

2
artist: **Son Duong**
art director: Scott Byerly
client: Hyperlite MFG
title: Speak Evil
medium: Acrylic on wood
size: 24"x72"

3
artist: **Glen Orbik**
art director: Peter Bickford
designer: Glen Orbik & Laurel Blechman
client: Human Computing
title: Comic Base #10
medium: Oil on board
size: 17"x24"

ADVERTISING

1
artist: **Stephan Martiniere**
client: Utopiales Festival
title: Billboard Poster
medium: Digital

2
artist: **Eric Joyner**
art director: Jackie Murphy
inker: John Heebink
client: BMG Music
title: Worlds Collide
medium: Oil on wood panel
size: 48"x24"

3
artist: **R.K. Post**
art director: Sean Glenn
client: Dragon Magazine
title: Lady of Pain
medium: Digital
size: 9"x12"

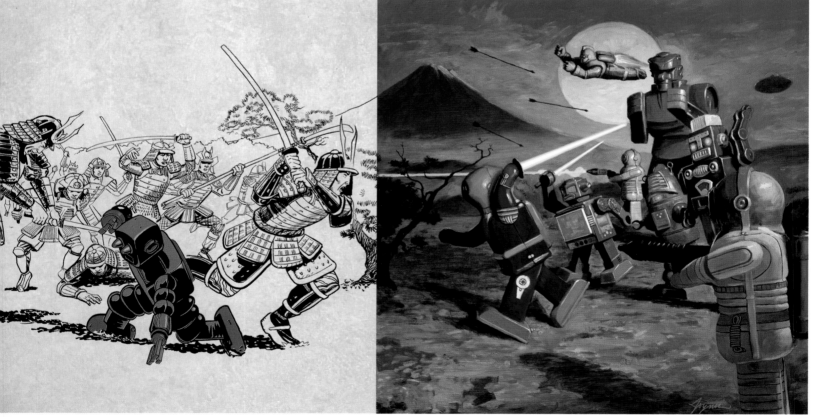

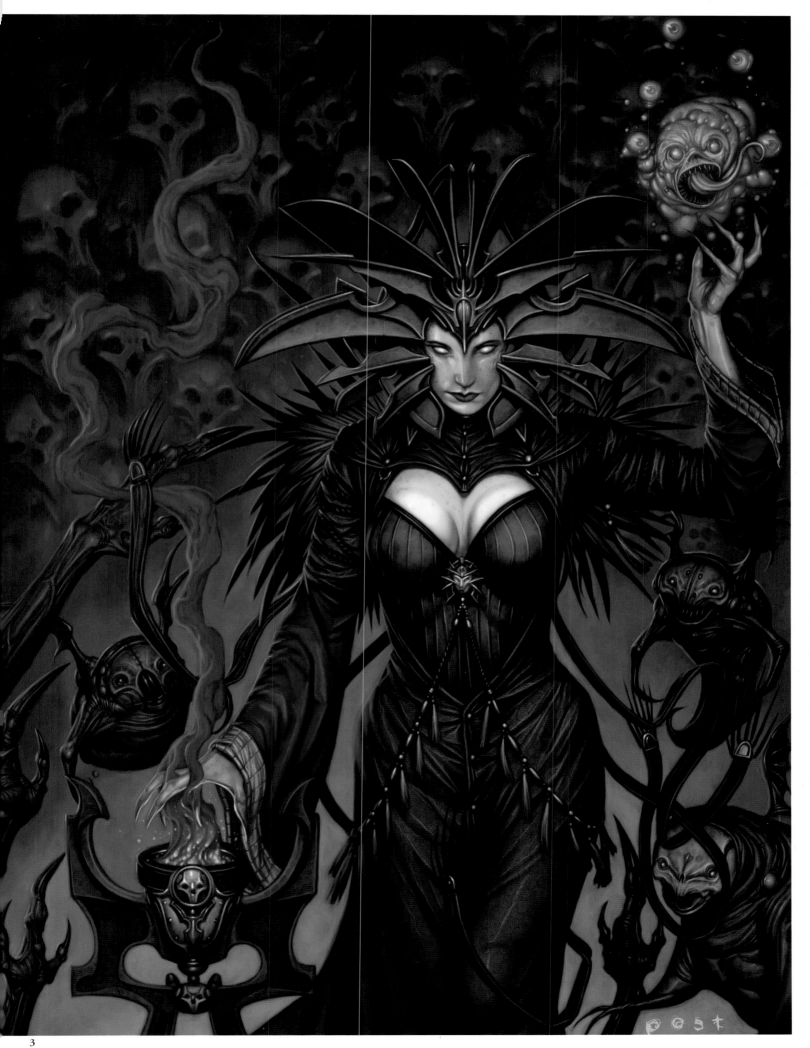

1
artist: **Jesse Turbull**
art director: Robin Goodhue
client: Ammonia Records
title: Suppression
medium: Mixed/digital *size:* 7"x7"

2
artist: **Rafal Olbinski**
client: Nowy Theater
title: Passion—Peter Nichols
medium: Acrylic *size:* 30"x40"

3
artist: **John Rush**
art director: Dan Bruce
client: State of Illinois
title: World's Tallest Man
medium: Oil on canvas *size:* 22"x50"

4
artist: **Anita Kunz**
art director: Anthony Padilla
client: Laguna College of Art
title: Hybrid
medium: Mixed *size:* 12"x16"

1

2

3

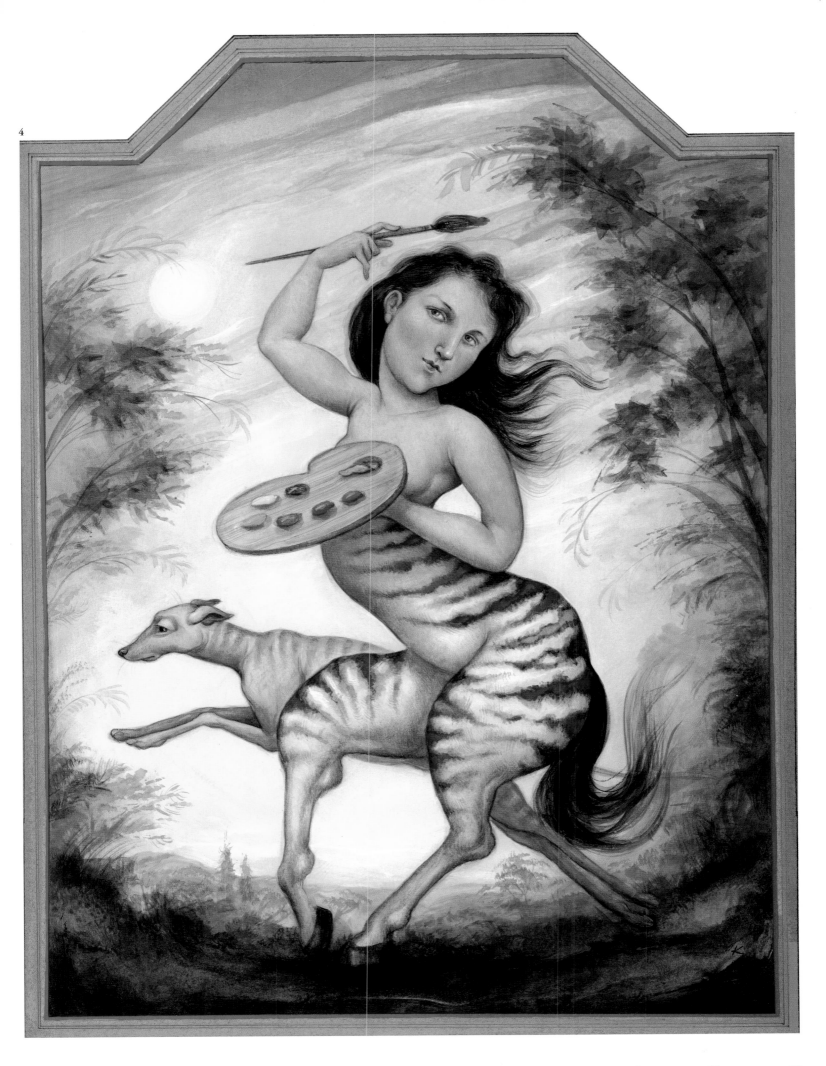

4

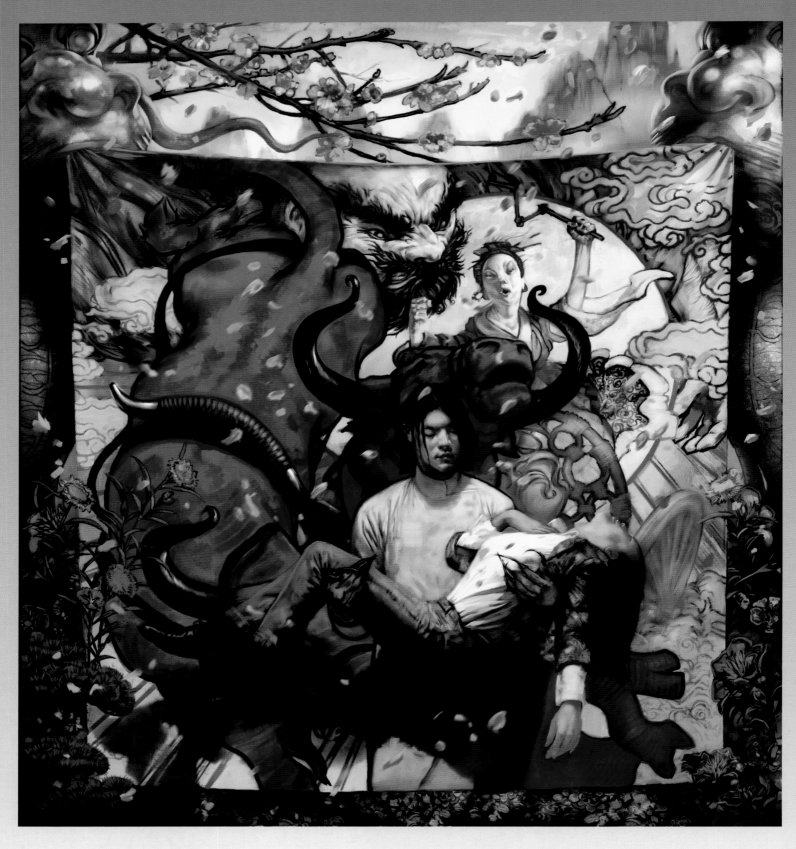

artist: **Jon Foster**

art director: Jeremy Lassen *client:* NightShade Books *title:* Demon in the City *size:* 6"x9" *medium:* Digital

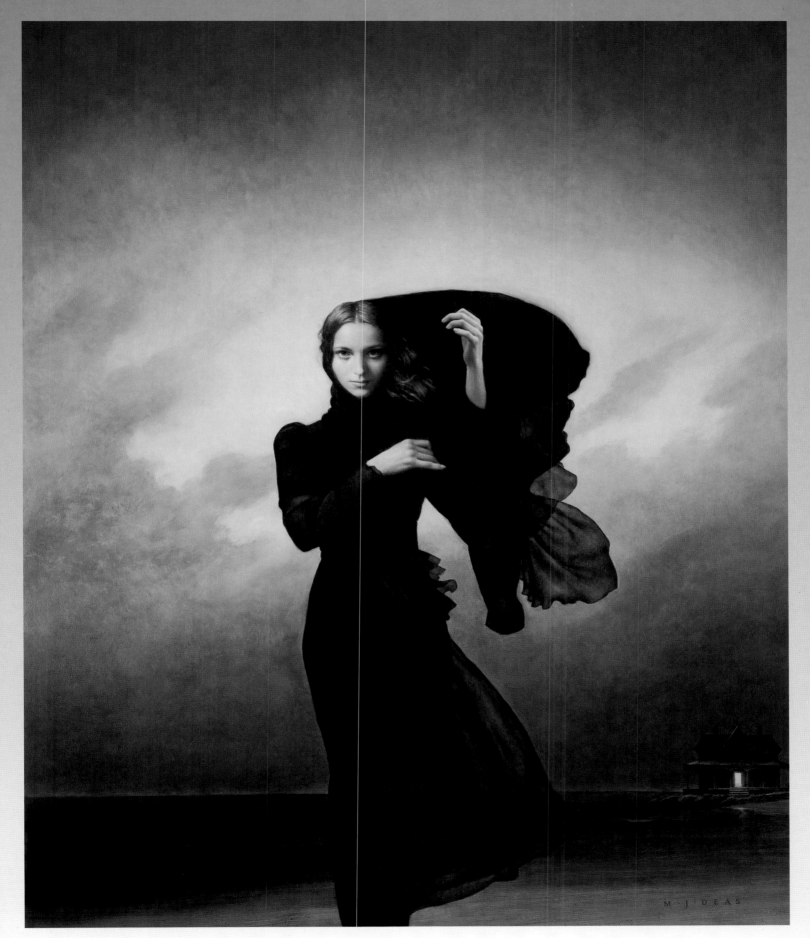

artist: **Michael J. Deas**

art director: Irene Gallo *client:* Tor Books *title:* Earthbound *medium:* Oil

BOOK

1
artist: **John Jude Palencar**
art director: Christopher Moisan
client: Houghton Mifflin
title: Fellowship of the Ring
medium: Acrylic
size: 17"x23"

2
artist: **John Jude Palencar**
art director: Yuki Katsura/Hanao Rine
client: Sony Magazines–Japan
title: Eldest Vol. 2
medium: Acrylic
size: 17"x22"

3
artist: **Duane O. Myers**
art director: Matt Adelsperger
client: Wizards of the Coast
title: Bloodwalk
medium: Digital

4
artist: **John Jude Palencar**
art director: Christopher Moisan
client: Houghton Mifflin
title: The Two Towers
medium: Acrylic
size: 17"x22"

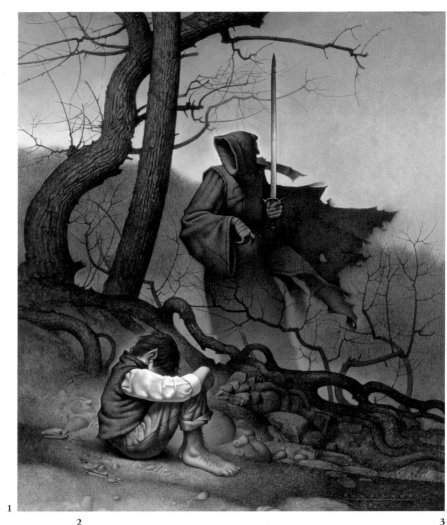

1

2

3

4

BOOK

1
artist: **Gris Grimly**
client: Baby Tattoo Books
title: Three Little Kittens
medium: Ink & watercolor
size: 7"x7"

2
artist: **Ralph Horsley**
art director: Marco Chacon
client: Jags
title: Wonderland
medium: Acrylic
size: 11"x16"

3
artist: **Ragnar**
client: Baby Tattoo Books
title: Phantomime
medium: Digital
size: 20"x27"

4
artist: **Ragnar**
client: Baby Tattoo Books
title: Haunt Me
medium: Digital
size: 18"x25"

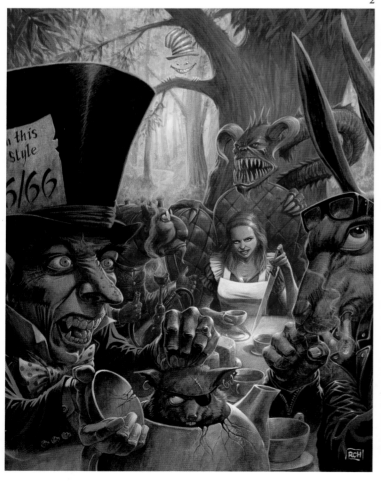

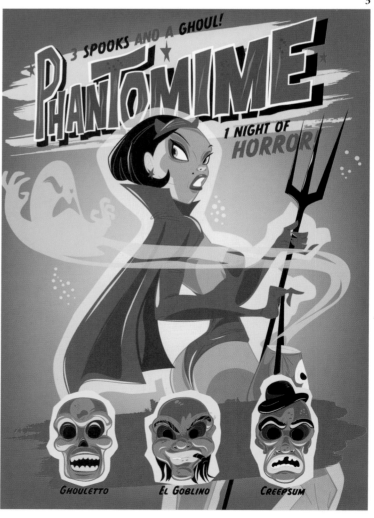

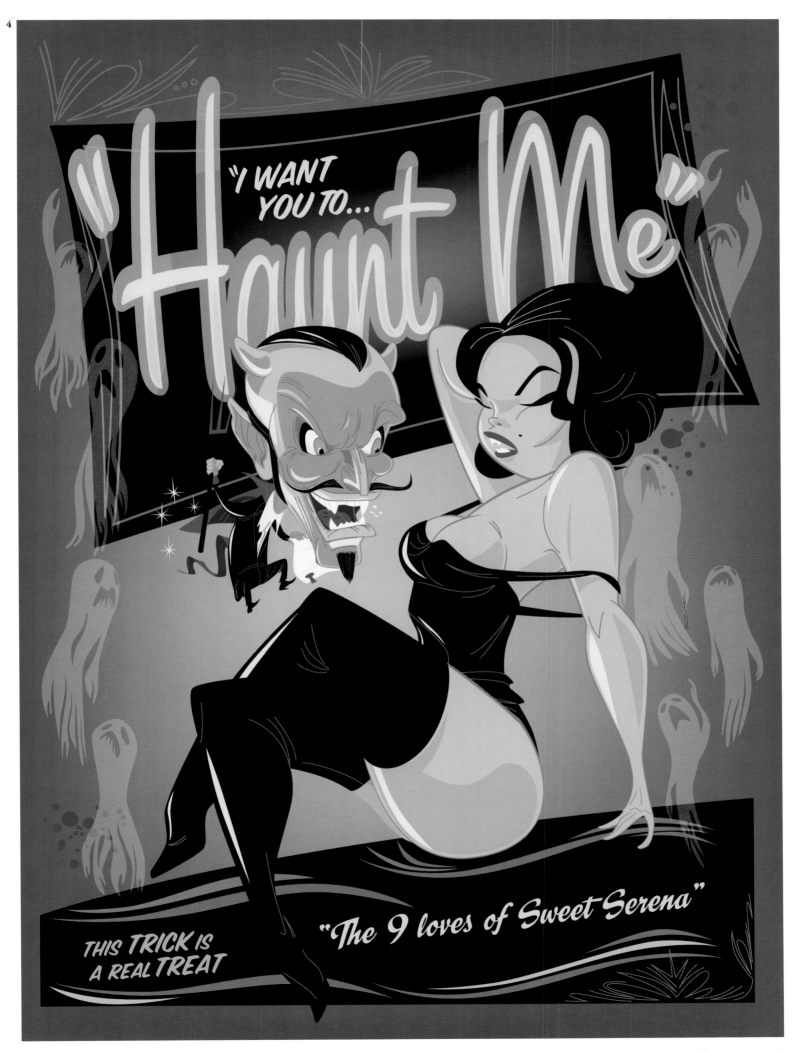

BOOK

1
artist: **Lance Erlick**
client: Aristata Publications
title: Europa Castaway
medium: Digital
size: 14"x12"

2
artist: **Fred Gambino**
art director: Peter Cotton
client: Time Warner U.K.
title: Engaging the Enemy
medium: Digital

3
artist: **John Harris**
art director: Irene Gallo
client: Tor Books
title: The Ghost Brigade
medium: Oil on canvas
size: 22"x30"

4
artist: **Mark Chiarello**
art director: Steve Saffel & Erich Schoenweiss
client: Random House
title: Star Wars Essential Chronology
medium: watercolor

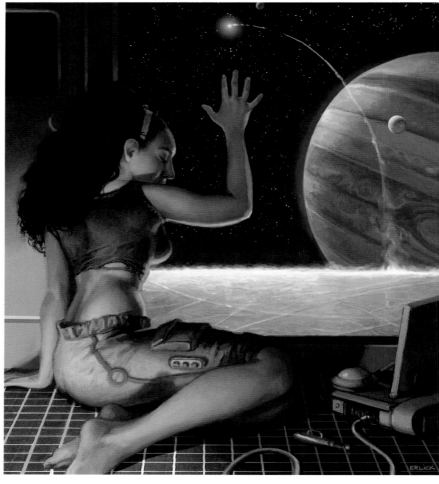

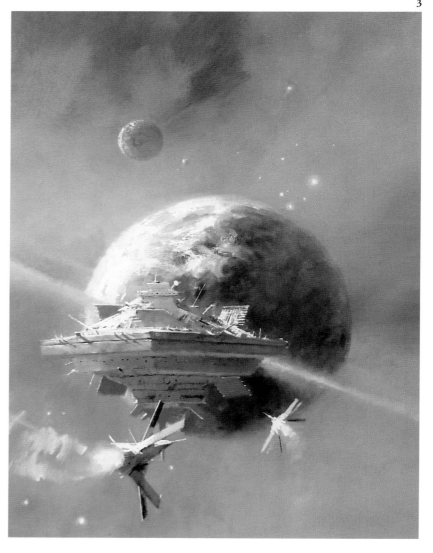

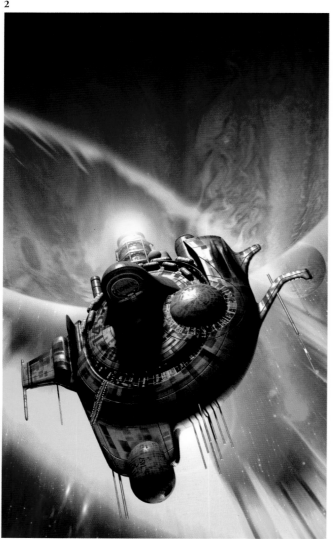

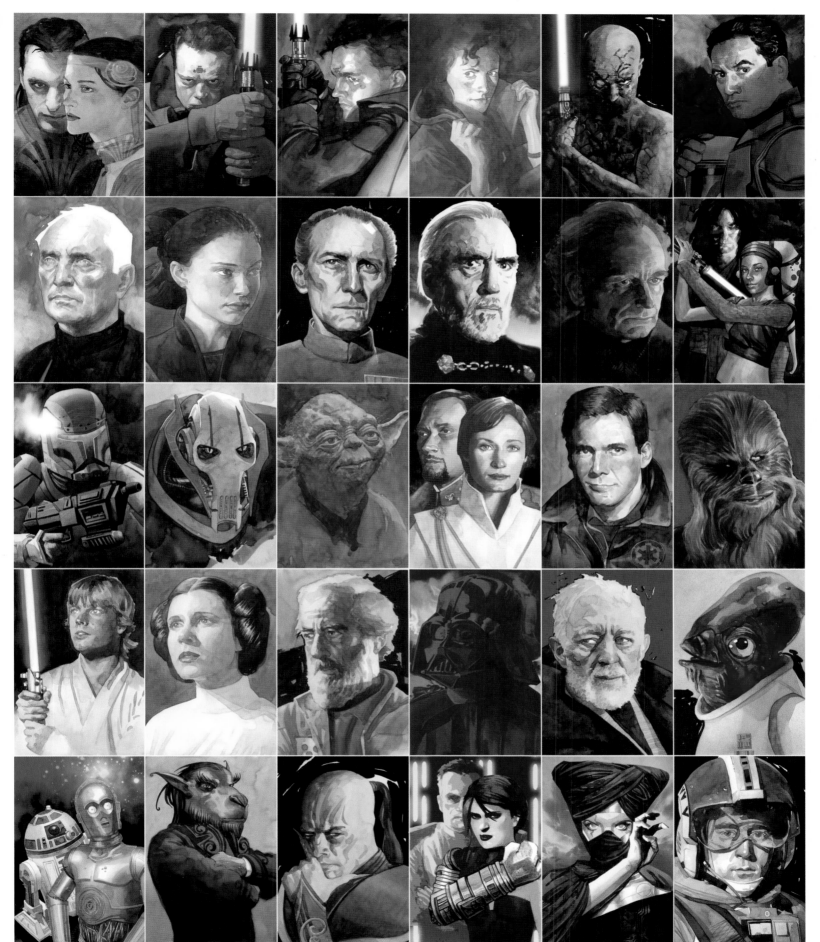

4

B O O K

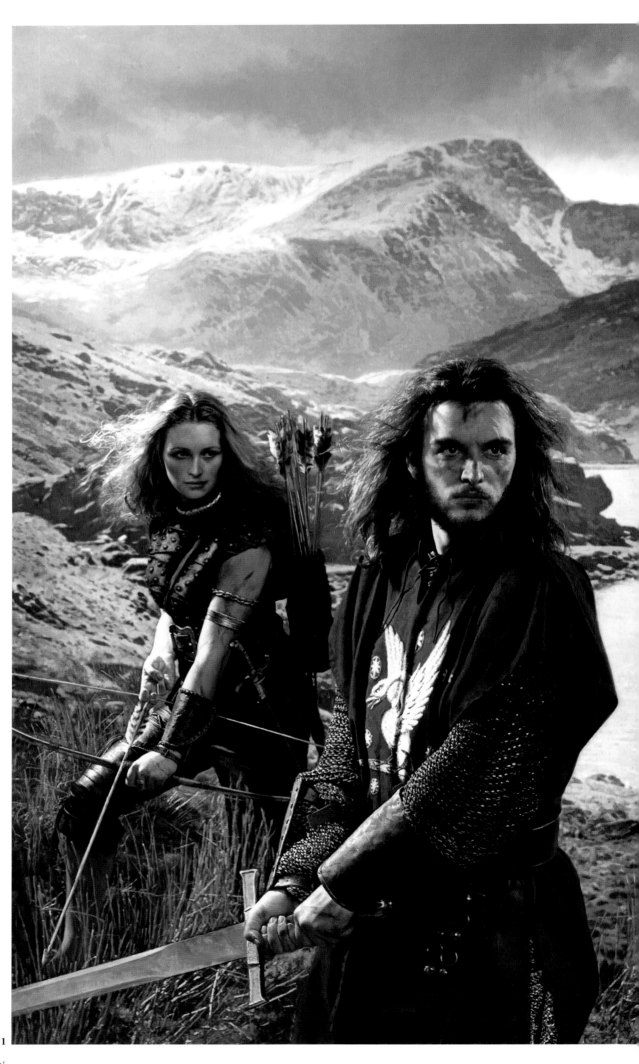

1

2

3

4

5

B O O K

1
artist: **Bruce Jensen**
art director: Nicholas Sica
client: Science Fiction Book Club
title: Deathbird Stories
medium: Digital

2
artist: **Bruce Jensen**
art director: Nicholas Sica
client: Science Fiction Book Club
title: Four Frontiers
medium: Digital

3
artist: **Erik Siador**
art director: Lanimulbus
client: CulpritRearchProject.com
title: Territorial
medium: Acrylic on paper
size: 23"x15"

4
artist: **Stephan Martiniere**
client: Design Studio Press
title: Nautilus
medium: Digital

1

2

3

4

BOOK

1
artist: **Manchu**
art director: Gerard Klein
client: Livre de Poche
title: Les Passeurs de Millénaires
medium: Acrylic *size:* 19"x25"

2
artist: **Jon Foster**
art director: Arnie Fenner
client: Underwood Books
title: King Kong
medium: Oil *size:* 11"x15"

3
artist: **Jon Foster**
art director: Chad Beckerman
client: Harper Collins
title: Brind
medium: Digital *size:* 6"x9"

4
artist: **Jon Foster**
art director: Irene Gallo
client: Tor Books
title: Skyborn
medium: Oil/digital *size:* 11"x15"

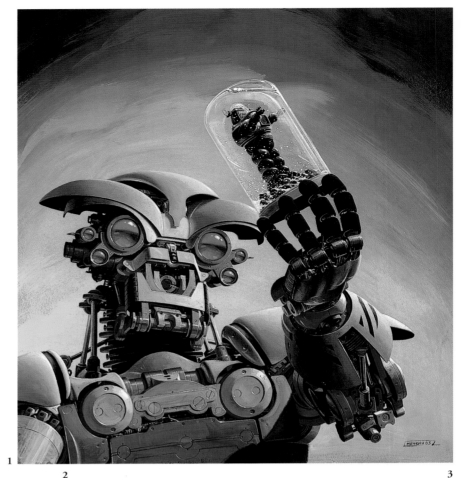

1

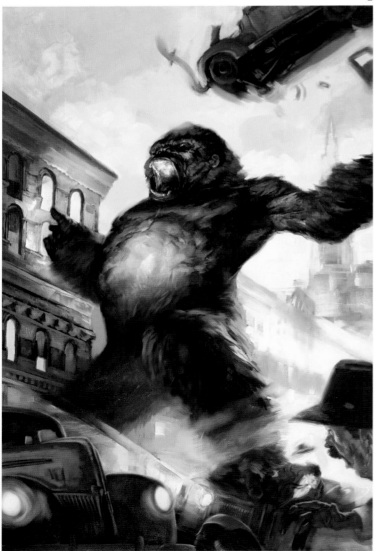

2

3

4

BOOK

1
artist: **Ciruelo**
client: DAC–Editions
title: Hobsyllwin and Angus
medium: Oil/digital
size: 21"x21"

2
artist: **Kinuko Y. Craft**
art director: Elizabeth Parisi
client: Scholastic, Inc.
title: Cry of the Icemark
medium: Oil on board
size: $25^{3}/4$"x$17^{1}/2$"

3
artist: **Adam Rex**
art director: Matt Adelsperger
client: Wizards of the Coast
title: The Final Gate
medium: Oil
size: 20"x15"

4
artist: **Donato Giancola**
art director: Irene Gallo
client: Tor Books
title: Boromir in the Court
 of the Fountain
medium: Oil on paper
size: 40"x27"

3

4

BOOK

1
artist: **Dave McKean**
designer: Dave McKean
client: Harper Collins
title: Alchemy of MirrorMask
medium: Mixed
size: 14"x12"

2
artist: **Samuel Araya**
art director: Chip Dobbs
client: Visionary Entertainment
title: Shroud of Red
medium: Digital

3
artist: **Alice Egoyan**
title: Creation
medium: Digital
size: 6"x9"

4
artist: **Dave McKean**
designer: Dave McKean
client: Harper Collins
title: Sphinx
medium: Mixed
size: 12"x14"

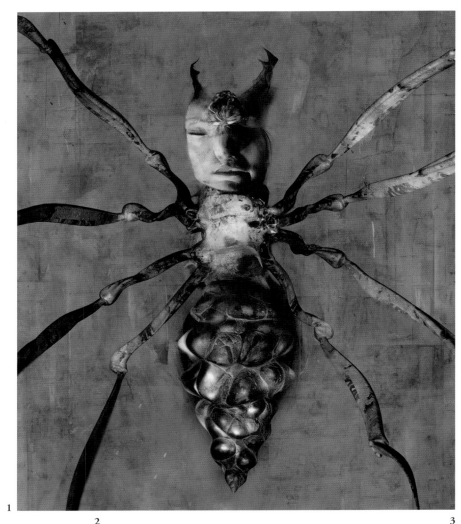

1

2

3

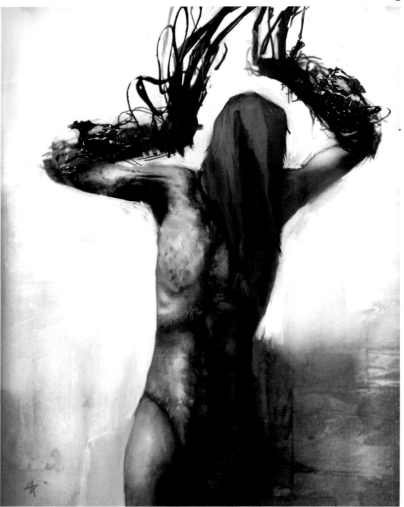

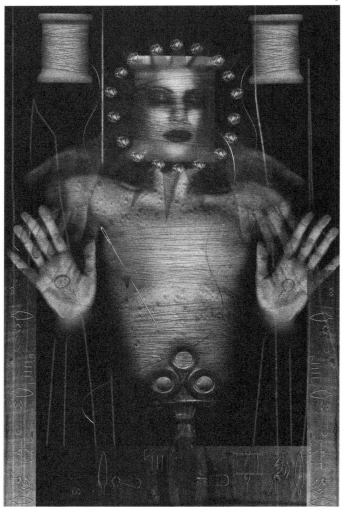

4

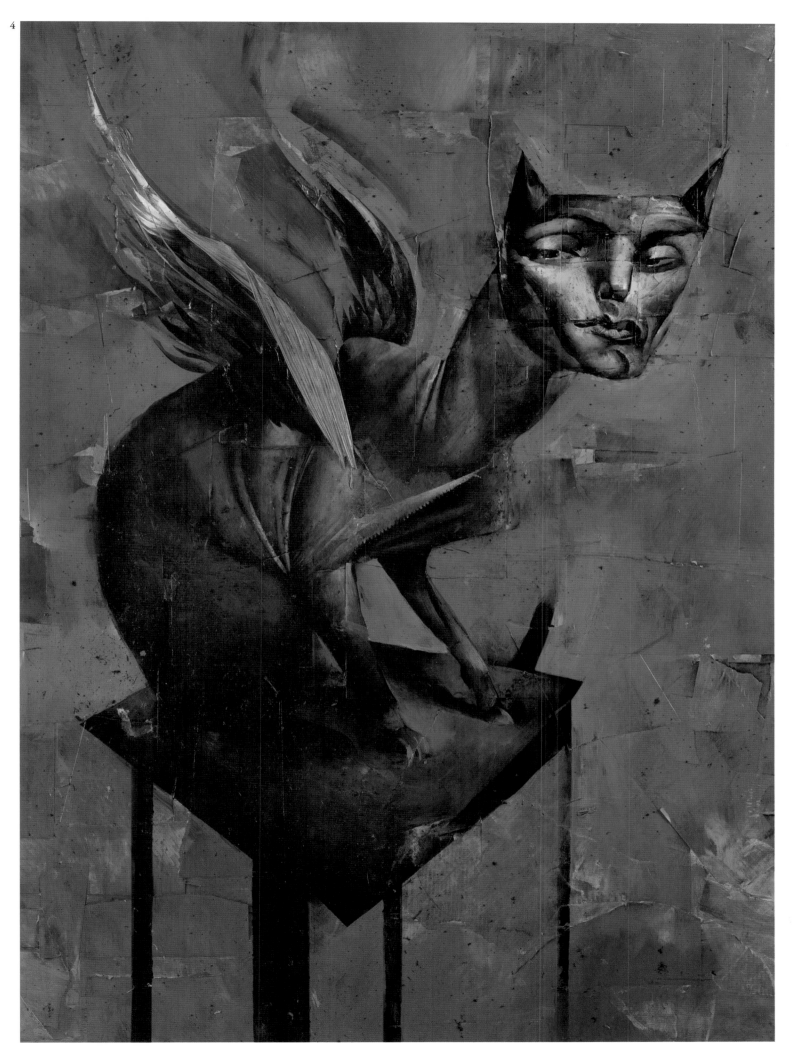

B O O K

1
artist: **Adam Rex**
art director: Scott Piehl
client: Harcourt
title: Frankenstein Makes a
 Sandwich: The Dentist
medium: Oil/mixed
size: 12¹/₂"x11¹/₂"

2
artist: **Adam Rex**
art director: Scott Piehl
designer: April Ward
client: Harcourt
title: Frankenstein Makes a
 Sandwich: Dracula
medium: Oil/mixed
size: 12¹/₄"x11¹/₂"

3
artist: **Robert MacKenzie**
client: Paquet/O.O.P. Comics
title: Around the Corner
medium: Gouache
size: 11"x14"

4
artist: **Paul Hess**
art director: Irene Gallo
client: Tor Books
title: Dreams & Visions
medium: Watercolor

5
artist: **Adam Rex**
art director: Scott Piehl
client: Harcourt
title: Tree Ring Circus:
 Snail Bus
medium: Oil/mixed
size: 23"x15"

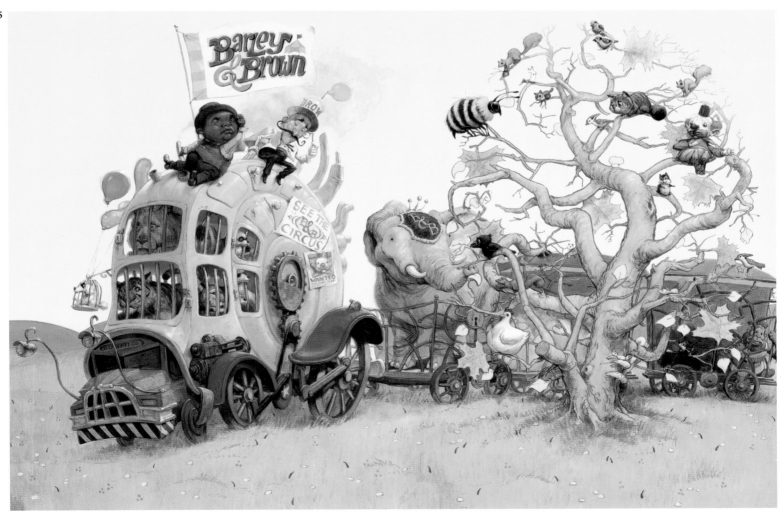

B O O K

1
artist: **Dan dos Santos**
art director: Deborah Kaplan
title: Spirits Who Walk in Shadows
medium: Oil on board
size: 16"x20"

2
artist: **Sym 7**
art director: Josh Matsuda
designer: Sym 7
client: Aerial 67/Argos
title: Archetype Paln B
medium: Oil/digital
size: 11"x17"

3
artist: **Luis Royo**
client: Norma Editorial
title: The Cross of the Night
medium: Acrylic/colored inks
size: 13"x22"

4
artist: **Dan dos Santos**
art director: Judith Murello
client: Ace Books
title: Moon Call
medium: Oil on board
size: 18"x24"

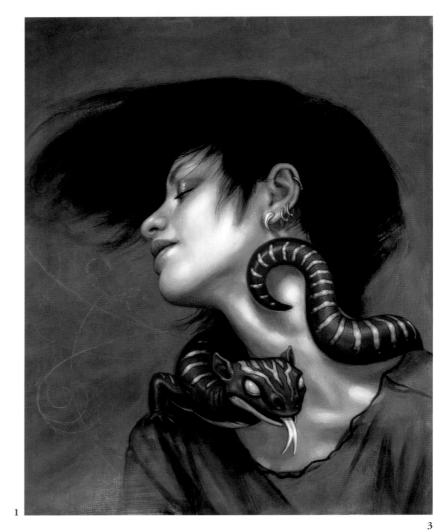

1

2

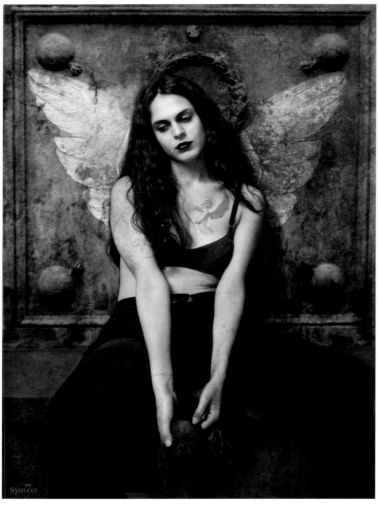

3

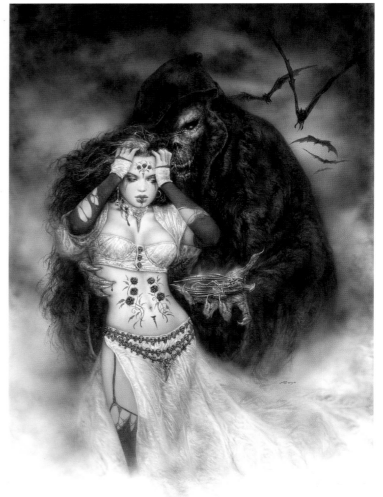

4

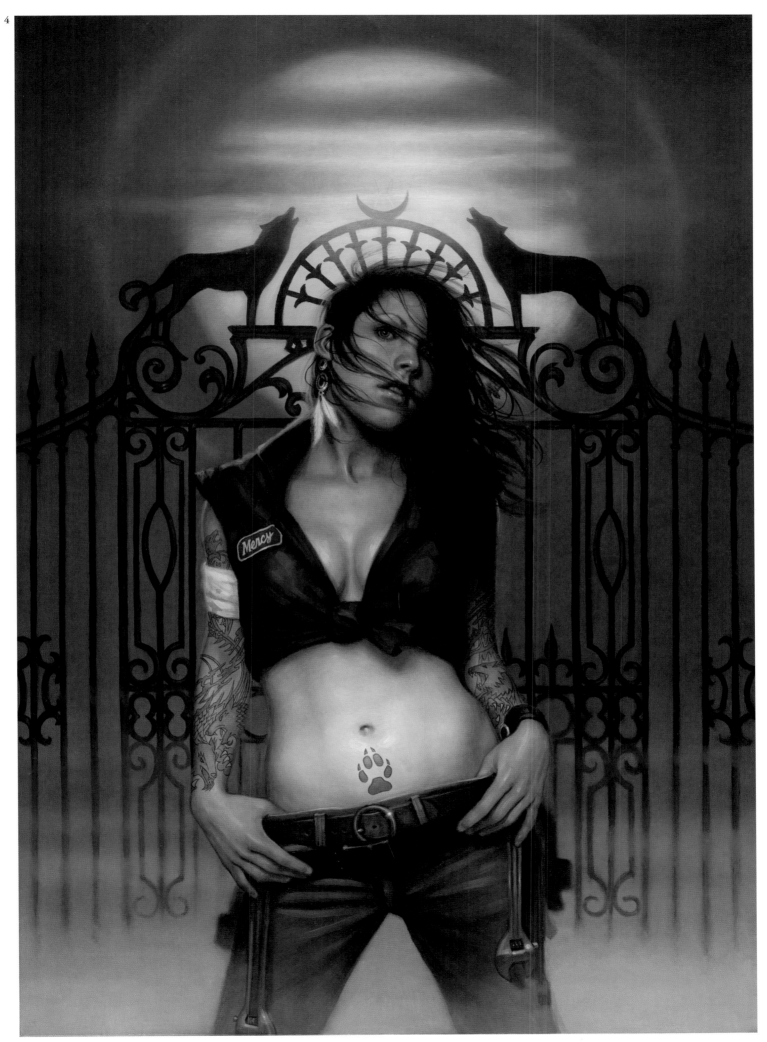

B O O K

1
artist: **Jeff Nentrup**
art director: Robert Raper
client: Wizards of the Coast
title: Cityscape
medium: Digital
size: 18"x6"

2
artist: **Chris McGrath**
art director: Richard Aquan
client: Harper Collins
title: Second Wave
medium: Digital
size: 14"x9"

3
artist: **Thomas Thiemeyer**
art director: Ronni Hoppe
client: Shayol Verlag Berlin
title: Visionen 2005
medium: Oil
size: 39"x28"

4
artist: **Robh Ruppel**
client: Martin McKenna
title: Gothic City
medium: Digital

5
artist: **Donato Giancola**
art director: Kevin Murphy
client: Meisha Merlin
title: Crystal Dragon
medium: Oil on paper
size: 36"x25"

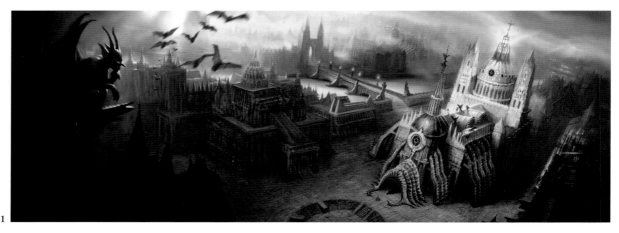

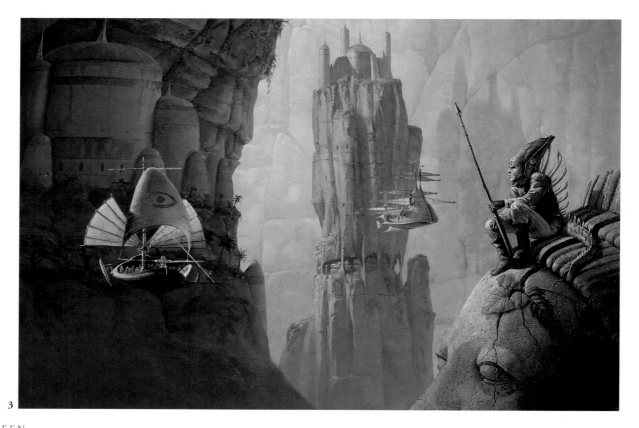

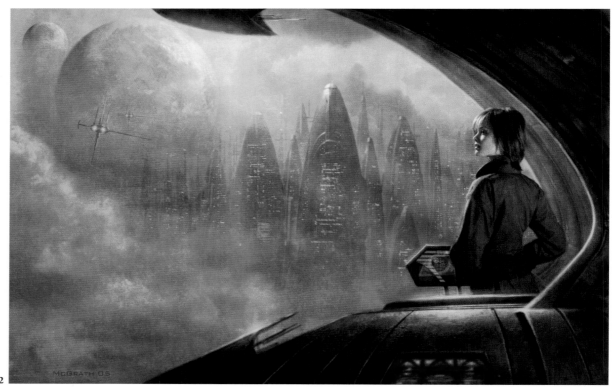

4

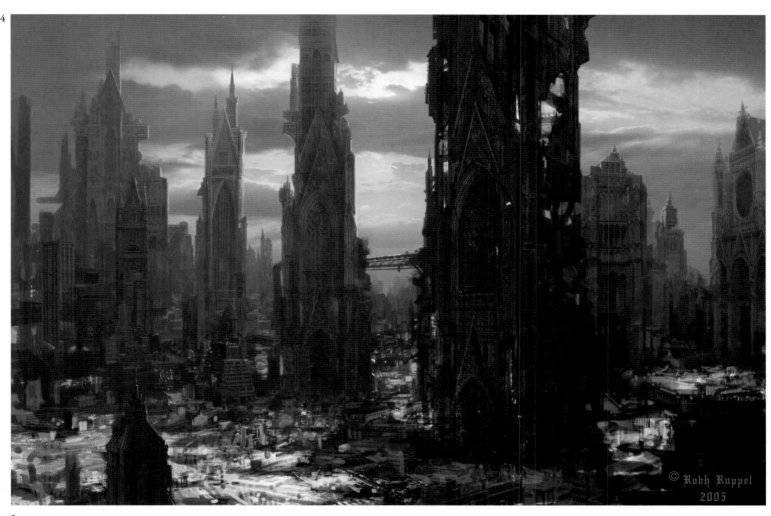

© Robh Ruppel
2005

5

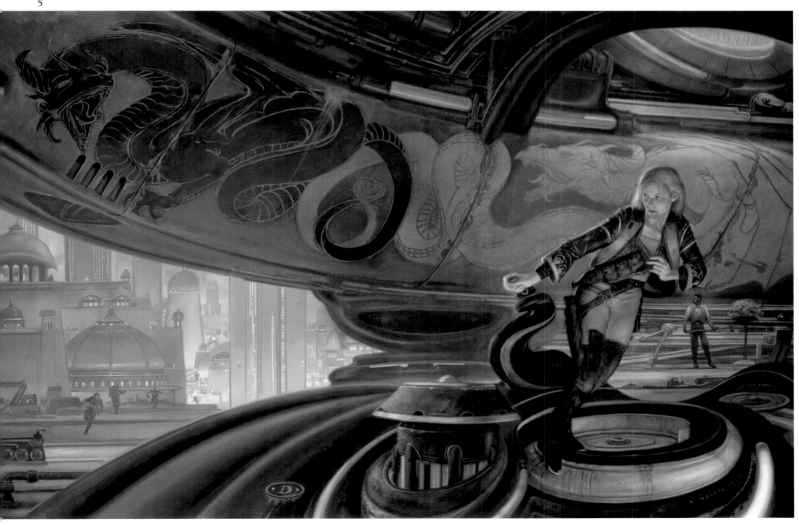

BOOK

1
artist: **Gregory Manchess**
art director: Marcelo Anciano
client: Wandering Star
title: Conquering Sword of Conan
medium: Oil *size:* 30"x40"

2
artist: **Doug Beekman**
art director: Kate Wiswell
client: Easton Press
title: The Mists of Avalon
medium: Watercolor/acrylic *size:* 16"x26"

3
artist: **Gregory Manchess**
art director: Irene Gallo
client: Tor Books
title: The Christmas Dragon
medium: Oil *size:* 18"x20"

4
artist: **Gregory Manchess**
art director: Marcelo Anciano
client: Wandering Star
title: Conquering Sword of Conan
medium: Oil *size:* 30"x40"

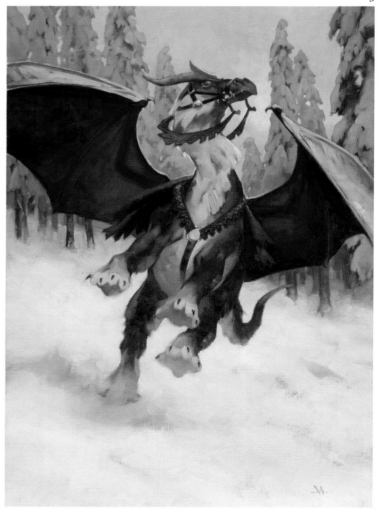

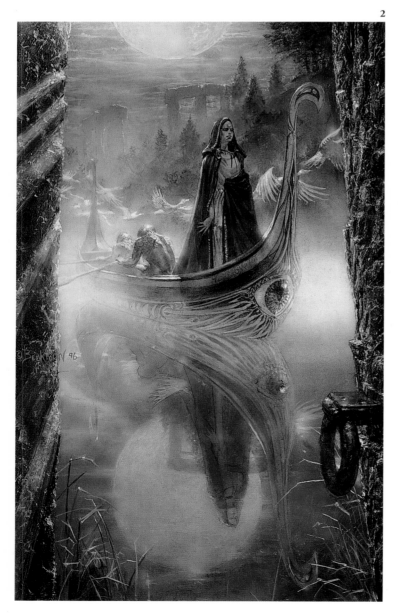

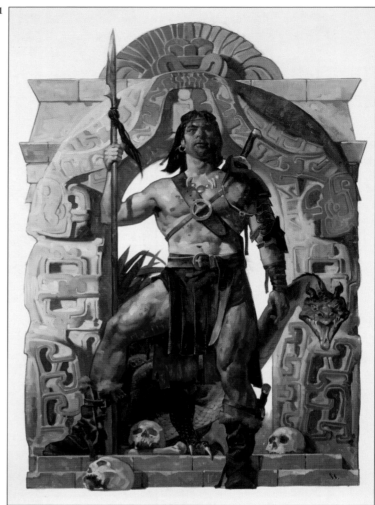

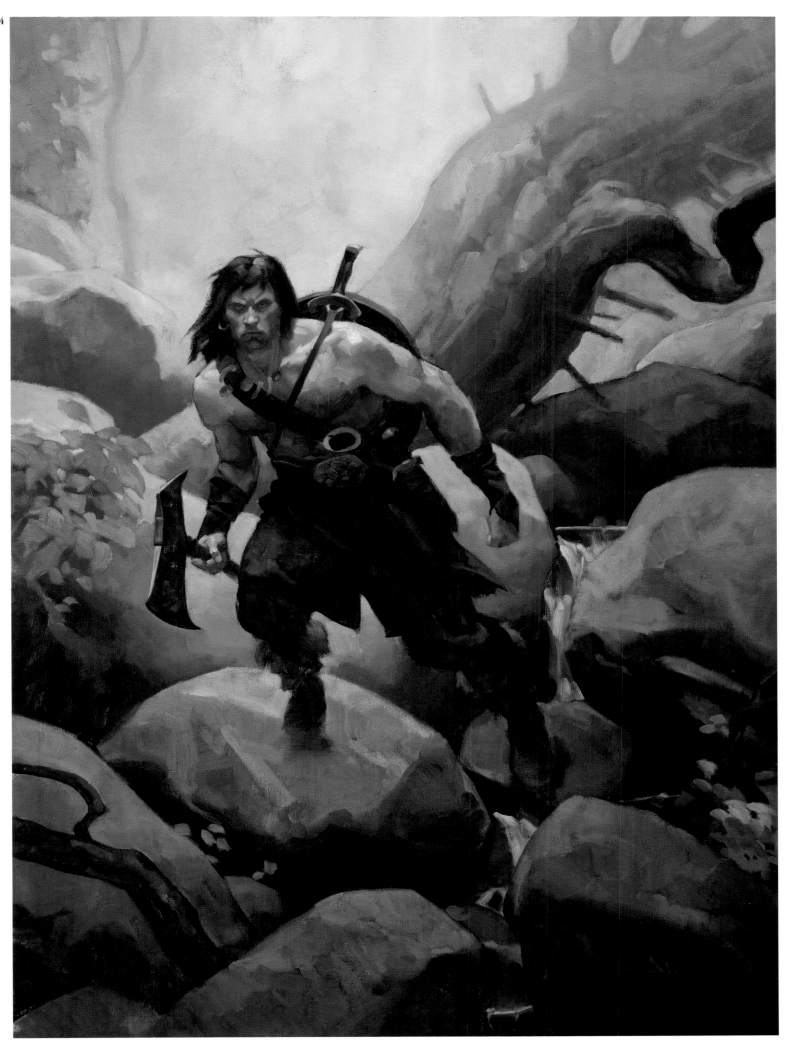

BOOK

1
artist: **John Picacio**
art director: Irene Gallo
client: Tor Books
title: Ghosts of Columbia
medium: Mixed/digital
size: 15"x17"

2
artist: **David Seidman**
art director: W.H. Horner
client: Fantasist Enterprises
title: Morphogenesis
medium: Digital

3
artist: **Jeffrey Scott "1019"**
client: Baby Tattoo Books
title: The Monumental Task
 of Retiring Old Baggage
 of Decaying Traumas
medium: Photo/digital
size: 15"x20"

4
artist: **Dave Seeley**
art director: Ray Lundgren
client: Penguin Books
title: Chill Factor
medium: Mixed
size: 14"x19"

5
artist: **Martin French**
art director: David Kopp
designer: D. Carlson
client: Multnomah Press
title: Tummis
medium: Mixed
size: 13"x17"

6
artist: **Steve Montiglio**
client: Golden Gryphon Press
title: The Jennifer Morgue
medium: Digital
size: 6^1/$_2$"x8^1/$_2$"

7
artist: **Greg Spalenka**
art director: Jason Jamajtuk
designer: Jason Jamajtuk
client: Random House
title: Light of the Oracle
medium: Mixed/digital
size: 8^1/$_2$"x11^1/$_2$"

1

2

3

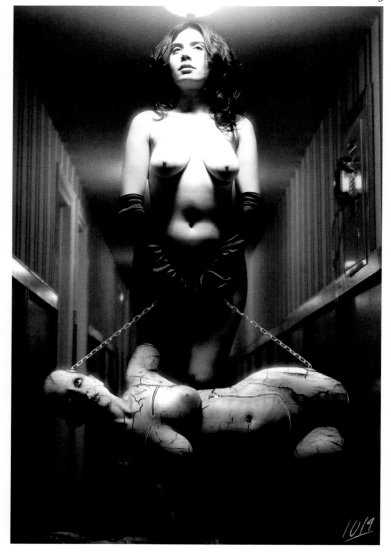

4

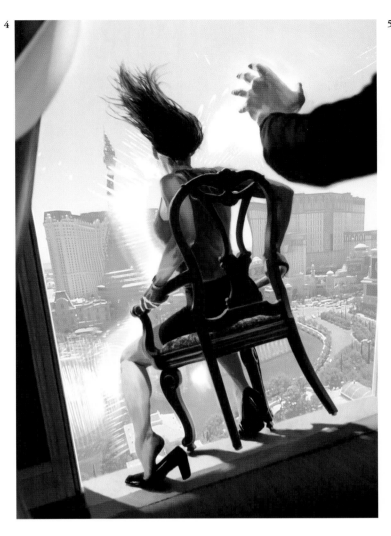

5

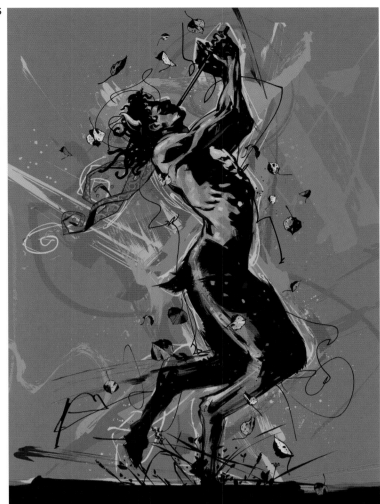

6

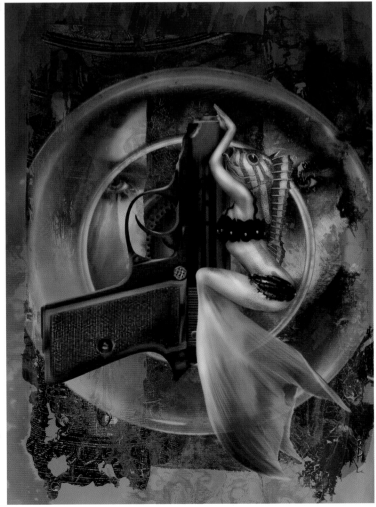

7

Book

1
artist: **Tomislav Torjanac**
client: Mozaik Knjiga
title: James Joyce's "The Cat
 and the Devil" p. 10-11
medium: Oil/digital
size: 16¹/₂"x11³/₄"

2
artist: **Daisuke DICE Tsutsumi**
client: Simplestroke.com
title: Magic Bat–Ken & Clown
medium: Mixed
size: 20"x12"

3
artist: **Teresa Murfin**
art director: Ellen Stein
client: Carolrhoda Books
title: I'm Not Afraid of This
 Haunted House
medium: Acrylic

4
artist: **Scott McKowen**
art director: Karen Nelson
client: Sterling Publishing
title: Alice's Adventures in
 Wonderland
medium: Scratchboard
size: 7"x10"

1

2

3

BOOK

1
artist: **William O'Connor**
title: Zephyr's Tomb
medium: Digital
size: 18"x11"

2
artist: **John Jude Palencar**
art director: Irene Gallo
client: Tor Books
title: Moonlight & Vines
medium: Acrylic
size: 30"x17"

3
artist: **David Grove**
art director: Irene Gallo
client: Tor Books
title: In the Eye of Heaven
medium: Acrylic/gouache

4
artist: **Michael Komarck**
art director: Brian Wood
client: Fantasy Flight Games
title: The Art of George R.R.
 Martin's A SONG OF ICE
 AND FIRE
medium: Digital

5
artist: **Thomas Canty**
art director: Michael Storrings
designer: Edwin Tse
client: St. Martin's Press
title: Year's Best Fantasy &
 Horror #18
medium: Oil
size: 18"x23"

6
artist: **Mark Zug**
art director: Elizabeth Parisi
client: Scholastic Publishing
title: Quadehar
medium: Oil

7
artist: **Matt Wilson**
art director: James Davis
client: Privateer Press
title: Apotheosis
medium: Oil
size: 25"x32"

4

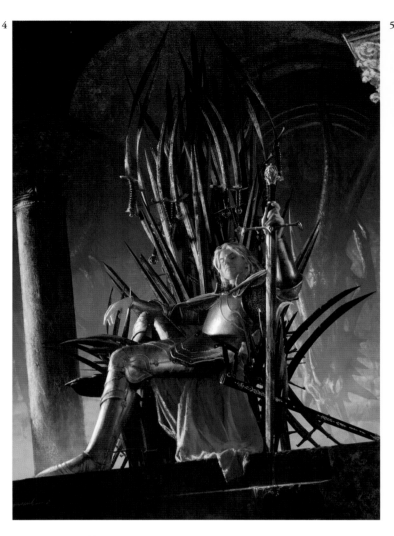

5

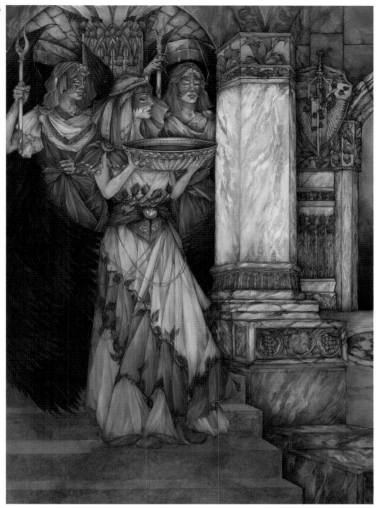

6

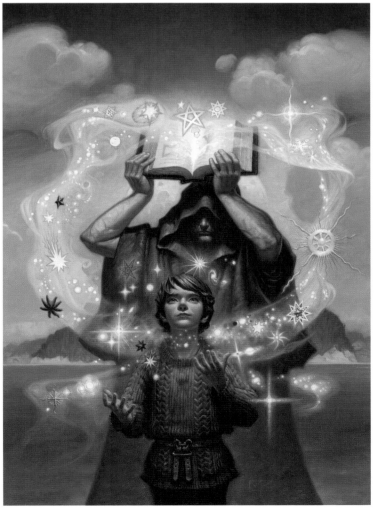

7

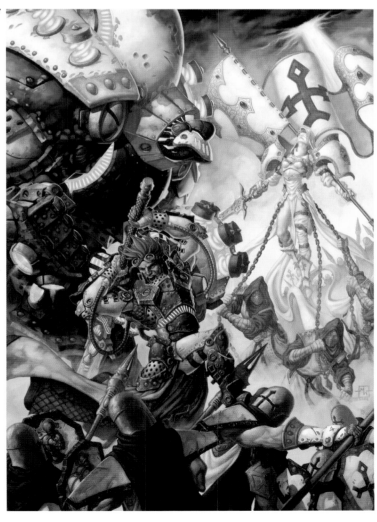

B O O K

1
artist: **Mark Harrison**
client: Rebellion
title: Durham Red: Infernal
medium: Watercolor/digital
size: 10¹⁄₂"x17¹⁄₄"

2
artist: **Stephan Martiniere**
art director: Lou Anders
client: Pyr
title: River of Gods
medium: Digital

3
artist: **Stephen Youll**
art director: Rob Simpson
client: Dark Horse Publishing
title: DNA War
medium: Digital
size: 8¹⁄₂"x11"

4
artist: **Raymond Swanland**
art director: Irene Gallo
client: Tor Books
title: The Wizard Lord
medium: Digital

5
artist: **Jeffrey Scott "1019"**
client: Baby Tattoo Books
title: Erasure
medium: Photo/digital
size: 15"x20"

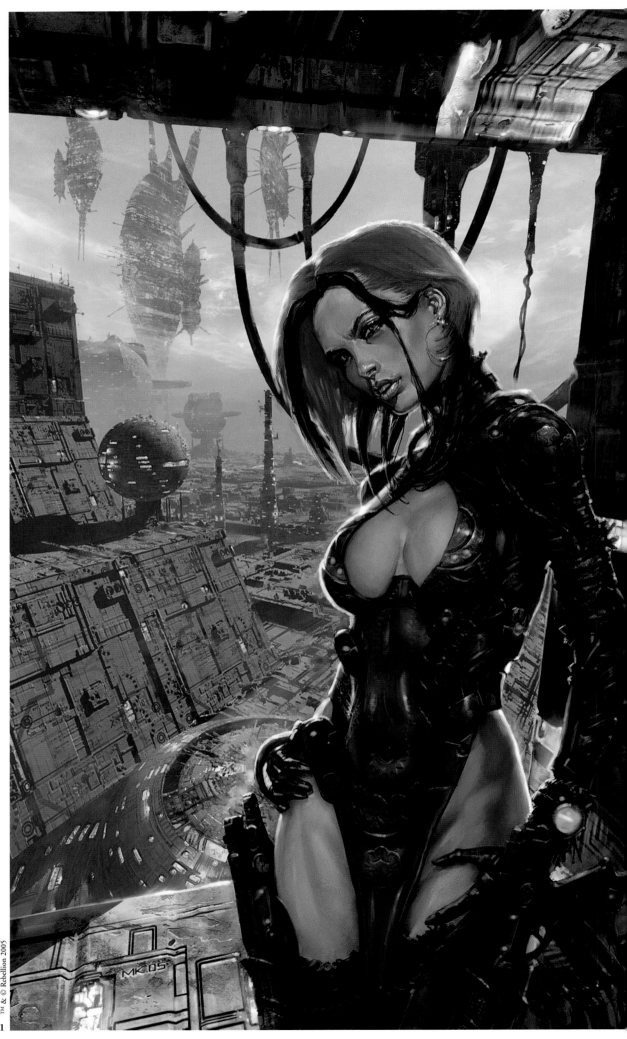

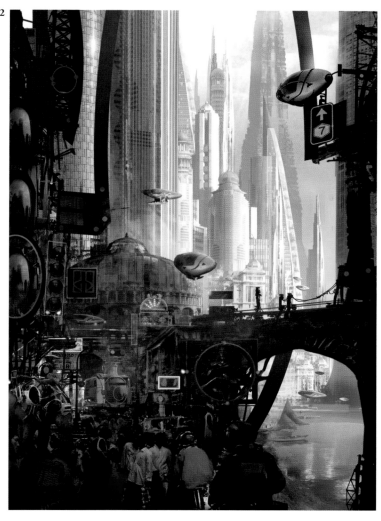

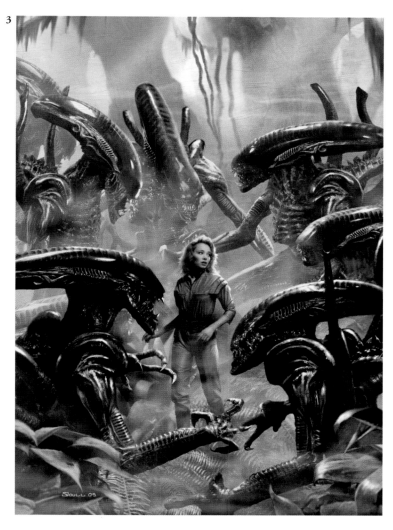

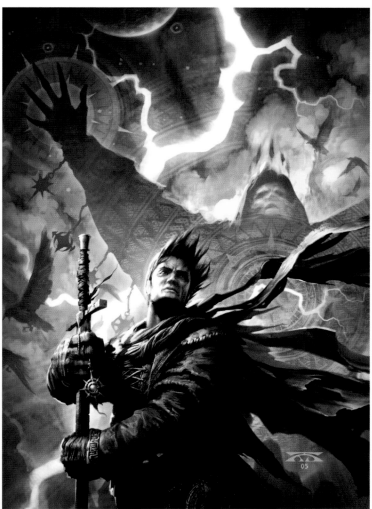

B O O K

1
artist: **Dwayne Harris**
art director: Chris Knight
client: Audiocraft Books
title: Poltergeists of Petoysky
medium: Digital
size: 7"x10"

2
artist: **Vince Natale**
art director: Lisa Litwack
client: Pocket Books
title: Hunger Like No Other
medium: Oil
size: 15"x20"

3
artist: **Tristan Elwell**
art director: Irene Gallo
client: Tor Books
title: Mage Books #1: Steel Magic
medium: Oil on board
size: 11"x16"

4
artist: **James Jean**
art director: Irene Gallo
client: Starscape Books
title: Among the Dolls
medium: Mixed

B O O K

1
artist: **Cathie Bleck**
art director: Mark Murphy
client: Open Spaces Books
title: The Choice
medium: Scraperboard/colored inks

2
artist: **Bobby Chiu**
client: Imaginism Studios
title: My Red Bike!
medium: Digital

3
artist: **Tristan Elwell**
art director: Irene Gallo
client: Tor Books
title: Magic Books #2:
 Octogon Magic
medium: Oil on board
size: 11"x16"

4
artist: **Brom**
client: Abrams Books
title: Stickmen
medium: Oil
size: 18"x12"

1

B O O K

1
artist: **Scott Johnson**
art director: Kevin Siembieda
client: Palladium Books, Inc.
title: Rifts Ultimate Edition
medium: Digital
size: 8¹/2"x11"

2
artist: **Francis Tsai**
art director: Ryan Sansaver
client: Wizards of the Coast
title: Rhashaak of
 Haka 'Toryhak
medium: Digital
size: 7¹/2"x16¹/2"

3
artist: **Todd Lockwood**
art director: Sheila Gilbert
client: DAW Books
title: The Mirror Prince
medium: Digital
size: 15"x20"

4
artist: **John Howe**
art director: John Bey
designer: Mathieu Harlaut
client: Rackham, Ltd.
title: Dragons & Elves
medium: Inks/watercolor
size: 39"x27"

5
artist: **Todd Lockwood**
art director: Irene Gallo
client: Tor Books
title: House of Chains
medium: Digital
size: 20"x15"

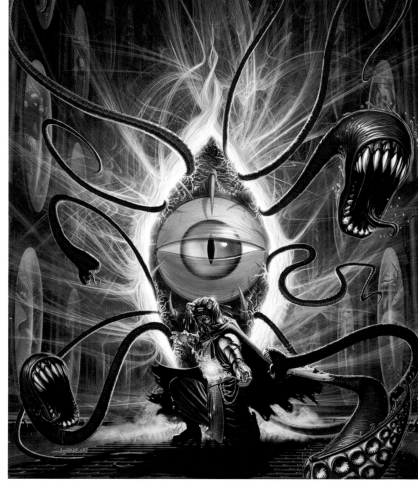

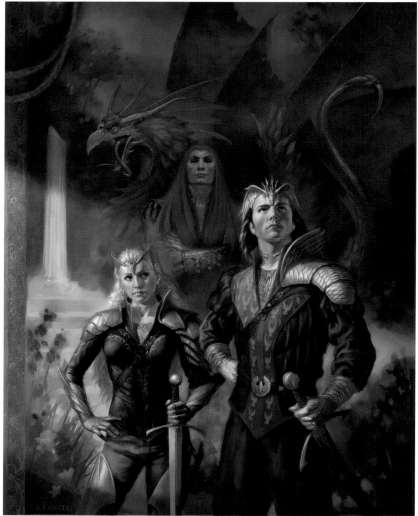

4

5

B O O K

1
artist: **Joel Thomas**
art director: Stacy Longstreet
client: Wizards of the Coast
title: Holy Mount
medium: Digital
size: 7"x6$\frac{1}{2}$"

2
artist: **Joe DeVito**
client: St. Martin's Press/Griffin Books
title: Merian C. Cooper's King Kong
medium: Oil
size: 16"x24"

3
artist: **Douglas Smith**
art director: Michelle Ishay
designer: Michelle Ishay/Douglas Smith
client: Regan Books/Harper Collins
title: Son of a Witch
medium: Scratchboard/watercolor
size: 9"x12$\frac{1}{2}$"

4
artist: **Ruth Sanderson**
art director: Jane Yolen
client: NESFA Press
title: Once Upon a Time, She Said
medium: Oil
size: 24"x36"

5
artist: **Leo & Diane Dillon**
client: Science Fiction Book Club
title: The Earthsea Trilogy
medium: Mixed

6
artist: **Jody A. Lee**
art director: Betsy Wollheim
client: DAW Books
title: The Wizard of London
medium: Acrylic/gouache
size: 18"x27"

3

4

5

6

BOOK

1
artist: **Tony DiTerlizzi**
art director: Dan Potash
designer: Jessica Sonkin
client: Simon & Schuster
title: North American Griffen
medium: Gouache
size: 30"x20"

2
artist: **Ian Ameling**
art director: Dawn Muren
client: Wizards of the Coast
title: Black Pill
medium: Digital
size: 9"x6"

3
artist: **Jeremy Jarvis**
art director: Sue Cook
client: Malhavoc Press
title: Iron Heroes
medium: Watercolor
size: 22"x7¹/₄"

4
artist: **Bob Eggleton**
art director: Irene Gallo
client: Tor Books
title: Island of the
 Golden Cthulhu
medium: Acrylic
size: 36"x24"

5
artist: **Cos Koniotis**
client: Games Workshop
title: Ogre Kingdoms
medium: Digital

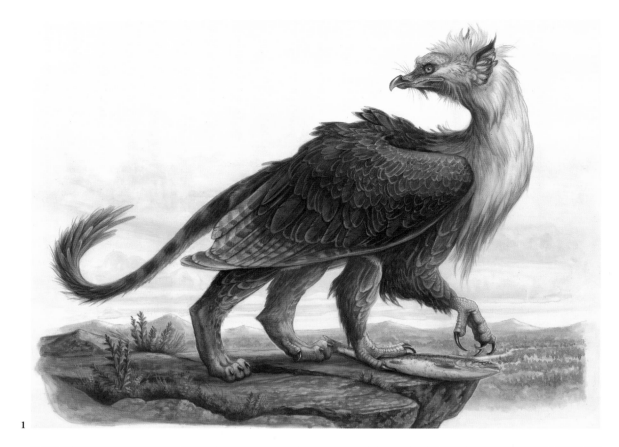

1

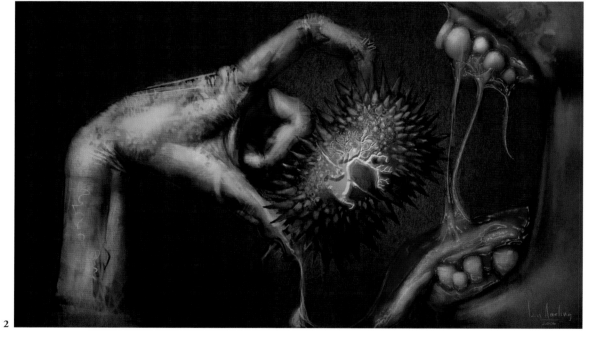

2

3

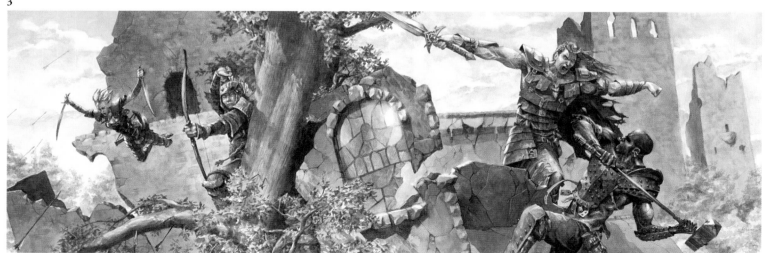

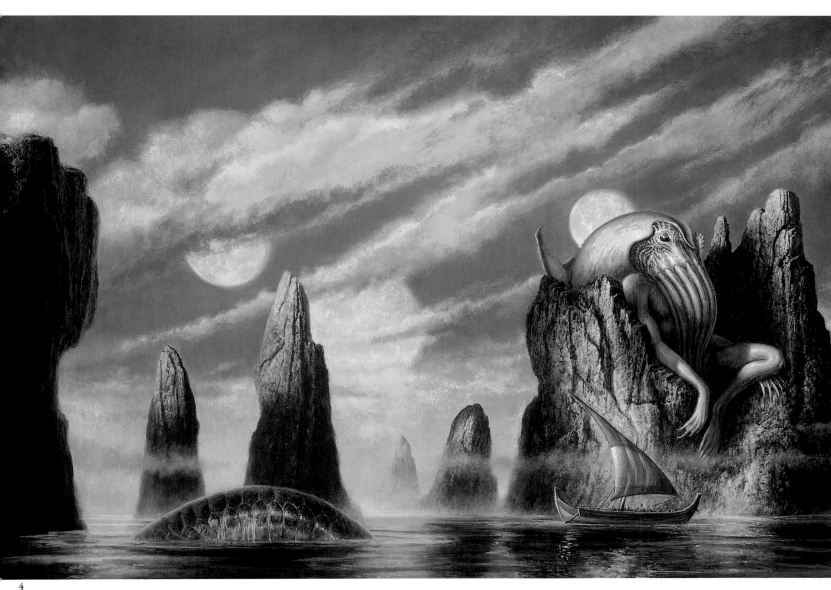

4

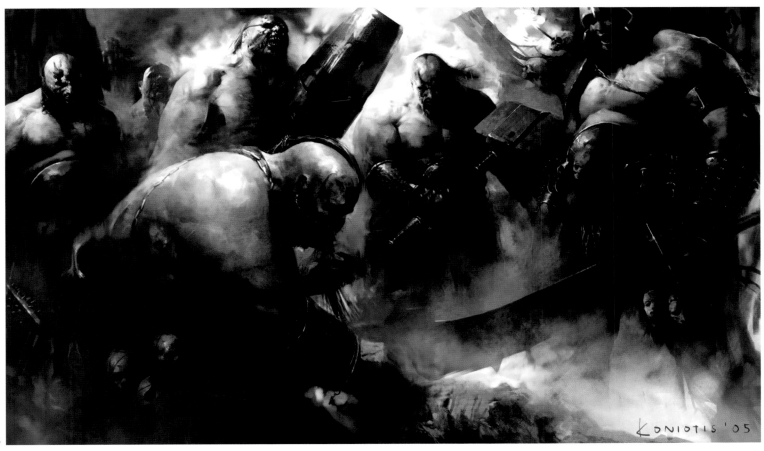

5

B O O K

1
artist: **Steve Fastner & Rich Larson**
art director: Sal Quartuccio
designer: Rich Larson
client: SQ Productions, Inc.
title: Little Black Book #3
medium: Airbrush/markers
size: 8¹/₂"x11"

2
artist: **Robert MacKenzie**
client: Paquet/O.O.P. Comics
title: Around the Corner
medium: Gouache
size: 20"x11"

3
artist: **Greg Swearingen**
art director: Vaughn Andrews
client: Harcourt
title: A Wizard Abroad
medium: Mixed
size: 8"x12"

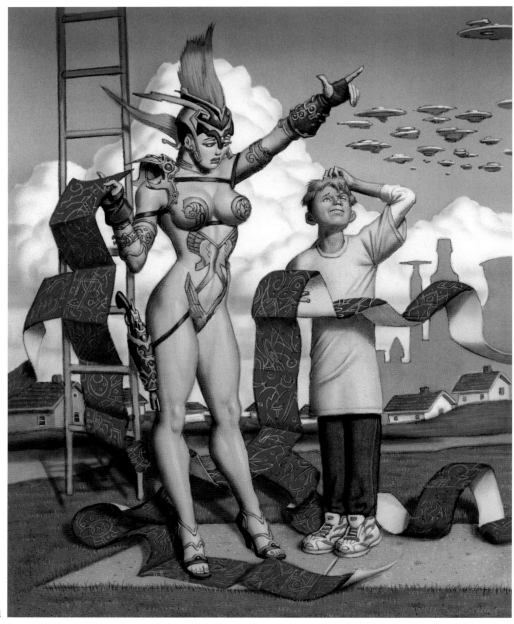

1

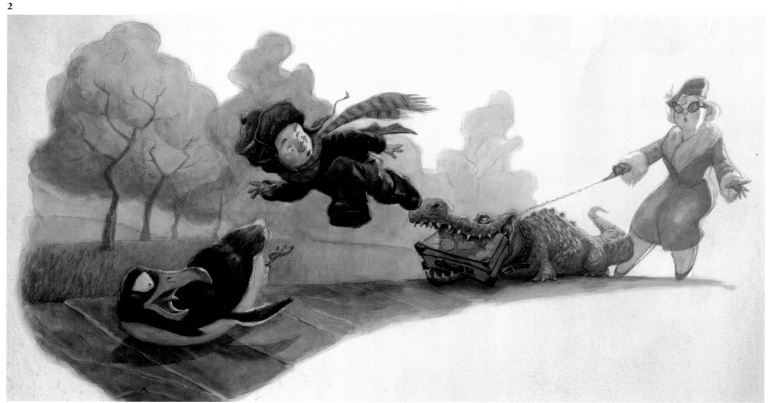

2

3

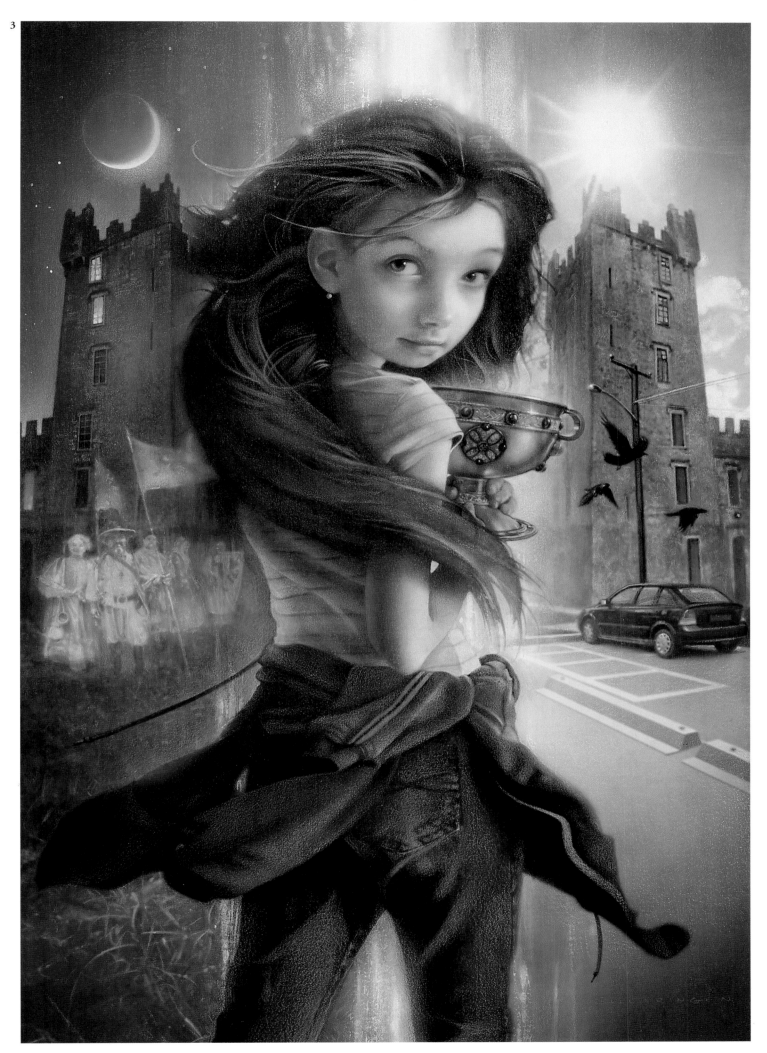

B O O K

1
artist: **Craig Mullins**
art director: Irene Gallo
client: Tor Books
title: When Gravity Fails
medium: Digital

2
artist: **Lee Moyer**
art director: Stacy Longstreet
client: Wizards of the Coast
title: Nereid
medium: Digital
size: 7"x7"

3
artist: **James Gurney**
client: Dinotopia
title: Mountain Tribesman
 from Journey to Chandara
medium: Oil
size: 18"x11"

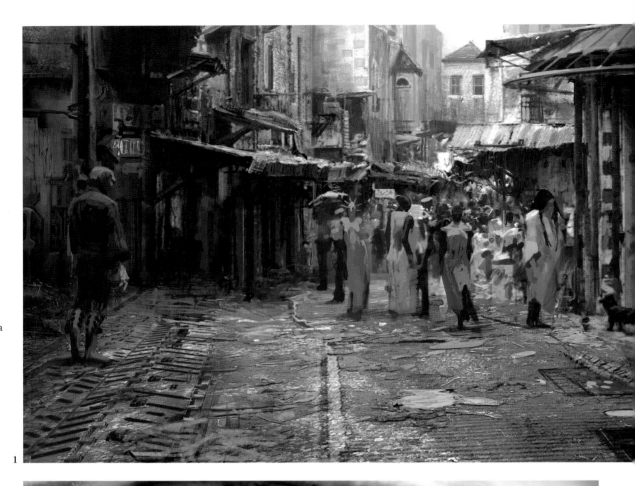

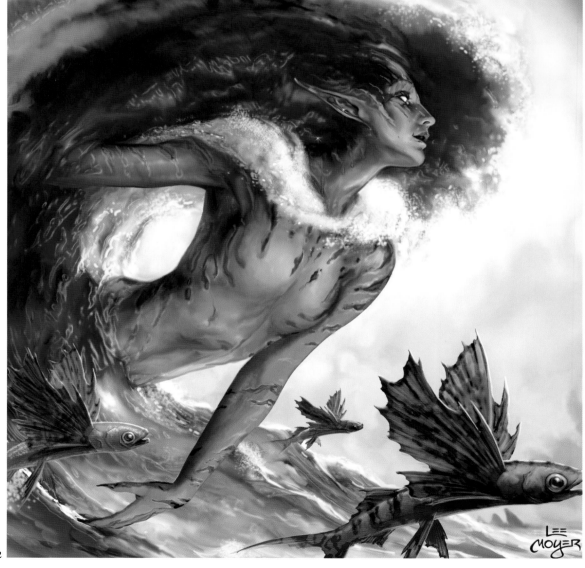

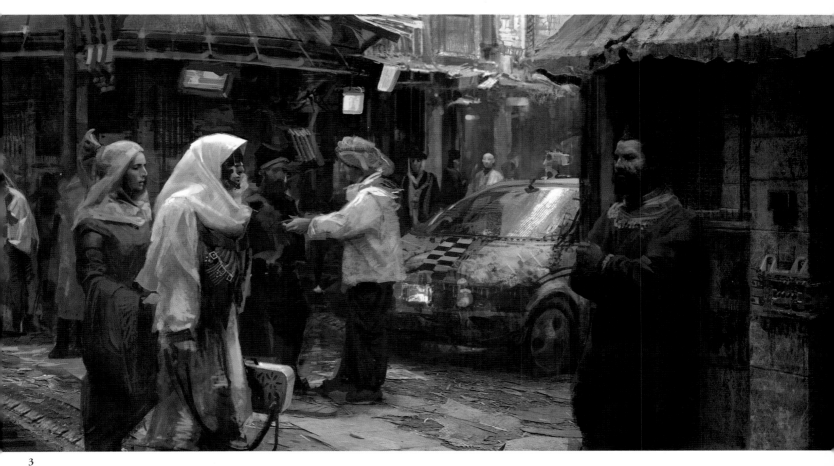

3

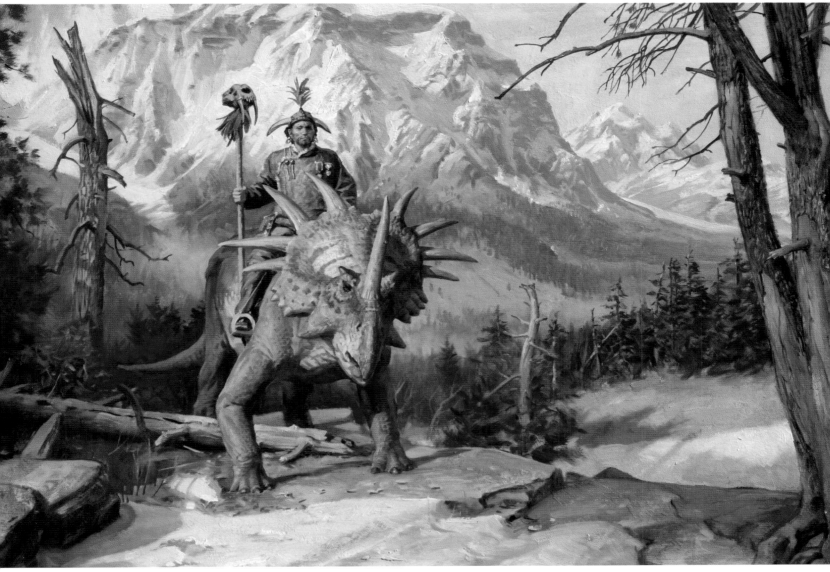

BOOK

1
artist: **Luis Royo**
client: Norma Editorial
title: Dancer of Pain #2
medium: Ink/acrylic
size: 21"x14"

2
artist: **Donato Giancola**
art director: Judith Murello
client: Berkley Publishing
title: Mystic and Rider
medium: Oil on paper
size: 18"x30"

3
artist: **Douglas Klauba**
art director: Robert Garcia
client: American Fantasy
title: Invisible Pleasures
medium: Acrylic
size: 18¹/2"x30"

4
artist: **Raymond Swanland**
art director: Irene Gallo
client: Tor Books
title: Ardneh's Sword
medium: Digital

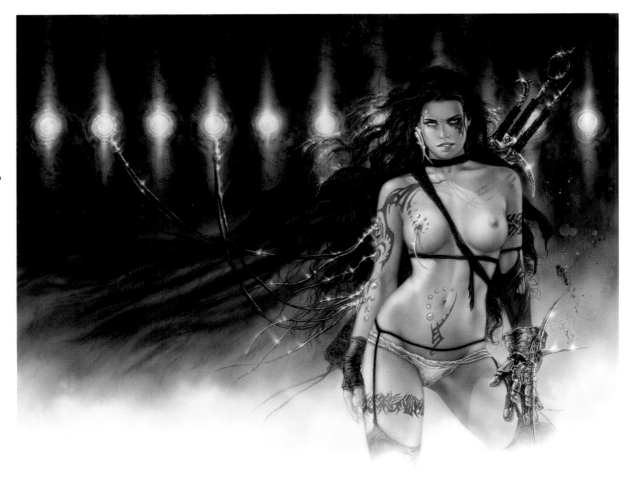

1

2

3

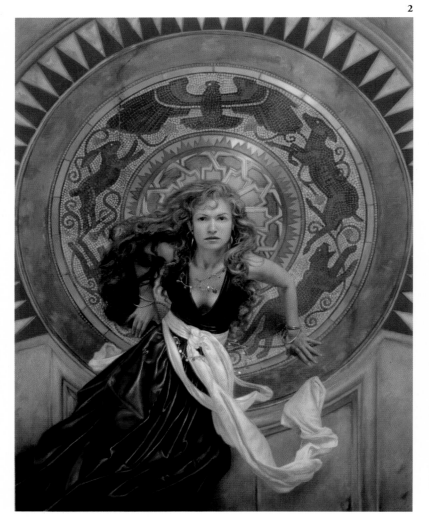

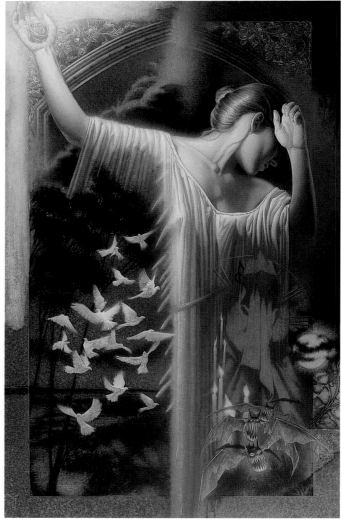

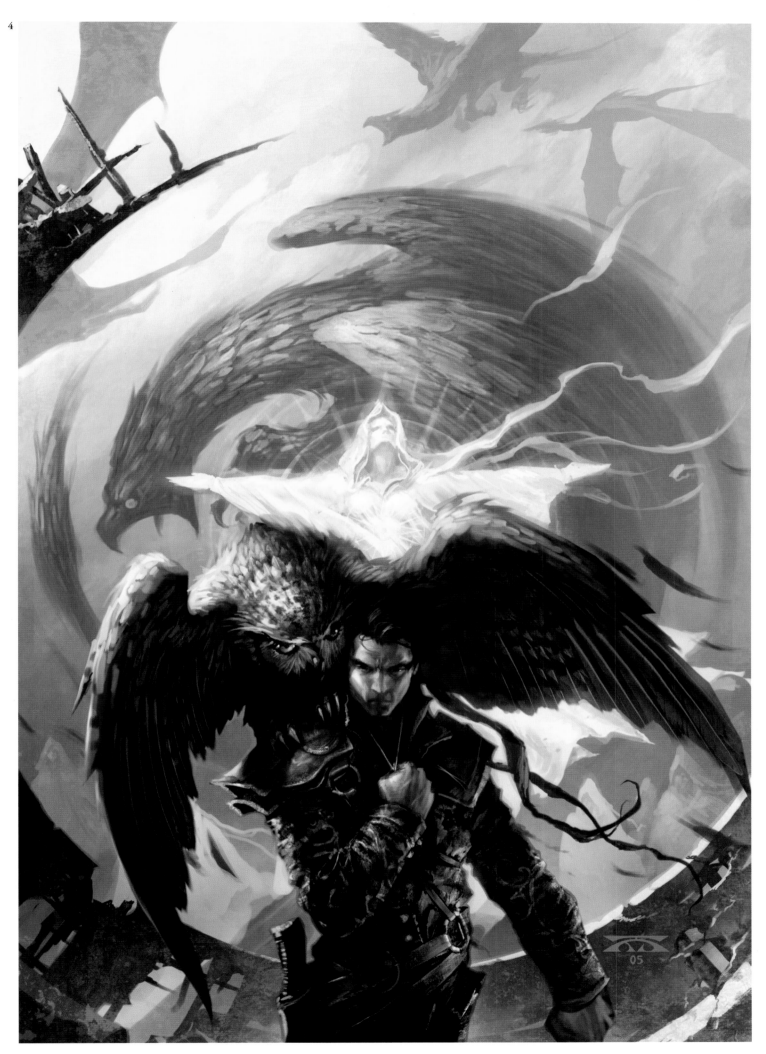

artist: **Jeremy Geddes**

art director: Ashley Wood *client:* IDW Publishing *title:* Doomed #4 Cover *size:* 35"x47" *medium:* Oil

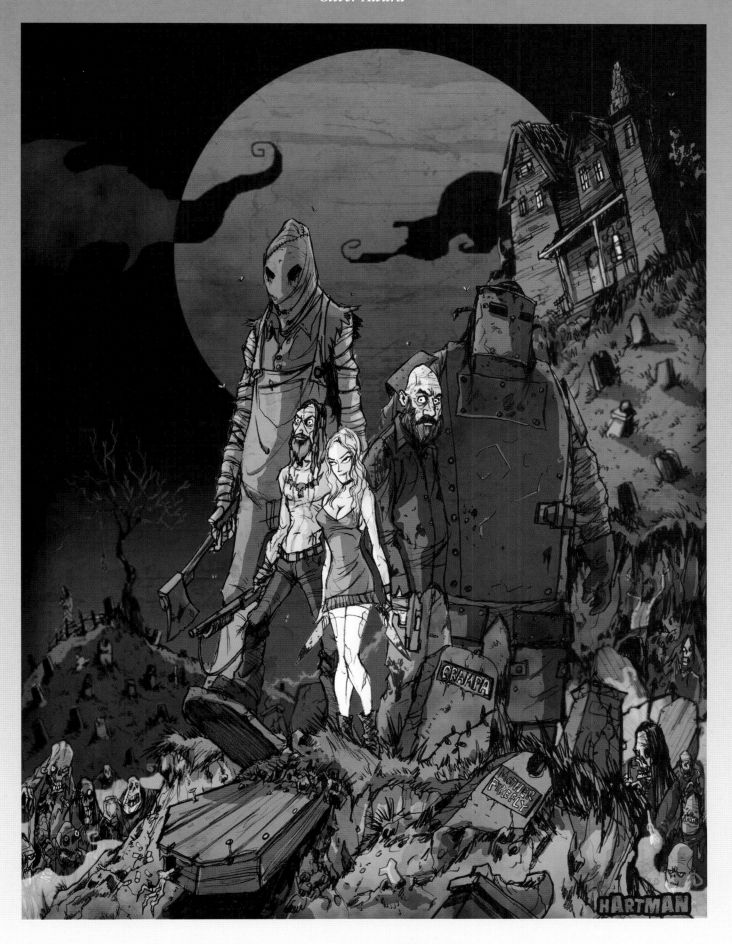

artist: **David Hartman**

art director: Kris Oprisko *client:* IDW Publishing/Rob Zombie *title:* The Devil's Rejects *medium:* Pencil/ink/digital

C O M I C S

1
artist: **Adam Hughes**
art director: Mark Chiarello
designer: Adam Hughes
client: DC Comics
title: JSA Classified #1
medium: Pencil/ink/digital
size: 18"x24"

2
artist: **Adam Hughes**
art director: Mark Chiarello
designer: Adam Hughes
client: DC Comics
title: Catwoman #50
medium: Pencil/ink/digital
size: 12"x19"

3
artist: **Adam Hughes**
art director: Mark Chiarello
designer: Adam Hughes
client: DC Comics
title: Catwoman #51
medium: Pencil/ink/digital
size: 12"x19"

4
artist: **Adam Hughes**
art director: Mark Chiarello
designer: Adam Hughes
client: DC Comics
title: Catwoman #49
medium: Pencil/ink/digital
size: 16"x23"

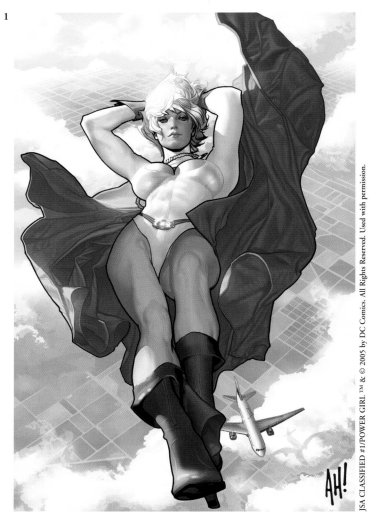

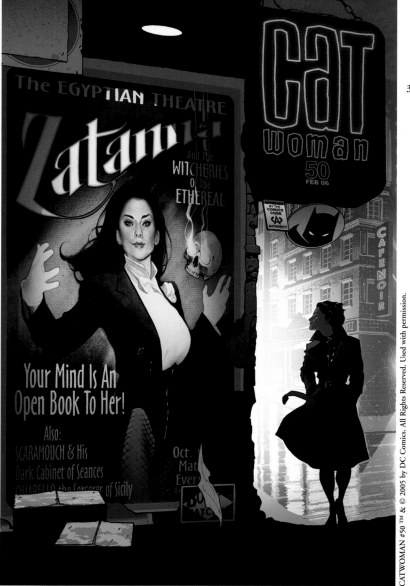

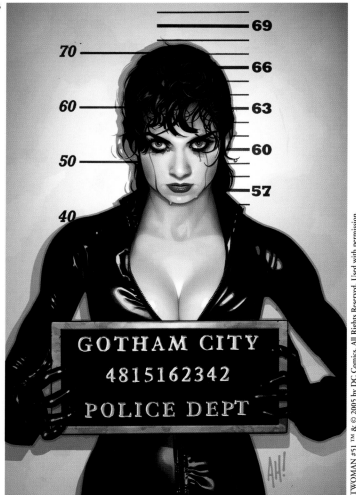

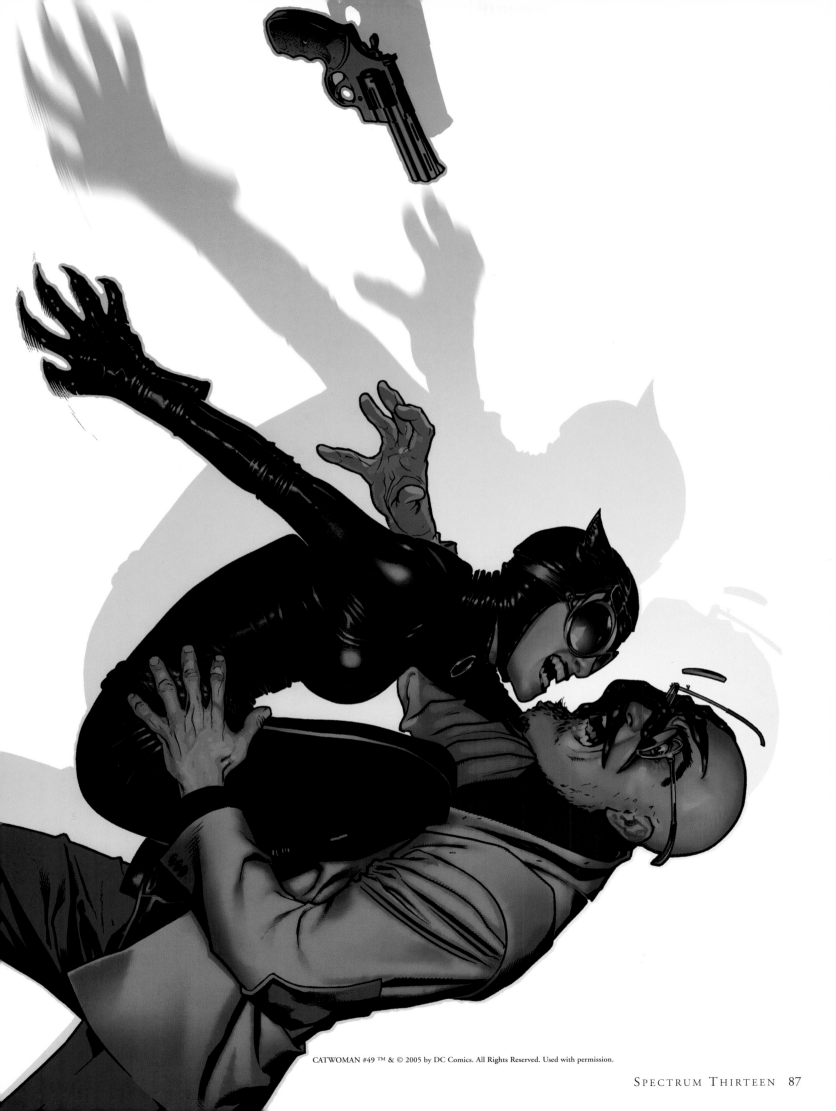

1
artist: **Brandon Peterson**
client: Marvel Entertainment, Inc.
title: Ultimate Extinction #4
medium: Ink/digital
size: 7"x10$\frac{1}{2}$"

2
artist: **Arcadia Studio**
art director: Marco Bianchini
designer: Patrizio Evangelisti
client: Vittorio Pavesio Editore
title: Termite Bianca
medium: Ink/watercolor
size: 10"x14"

3
artist: **Andy Brase**
art director: Courtney Huddleston
designer: Andy Brase
client: Penny Farthing Press
title: The Victorian III
medium: Ink
size: 11"x17"

4
artist: **Paul Chadwick**
art director: Diana Schutz
client: Dark Horse Comics
title: Postpartum Exam—
 Concrete: The Human Delemma
medium: Ink/digital
size: 11"x17"

5
artist: **Luis Diaz**
art director: Ricardo Porven
client: Hallucinonia
title: 3 Days the Devil Danced
medium: Digital/Painter 9
size: 10"x15"

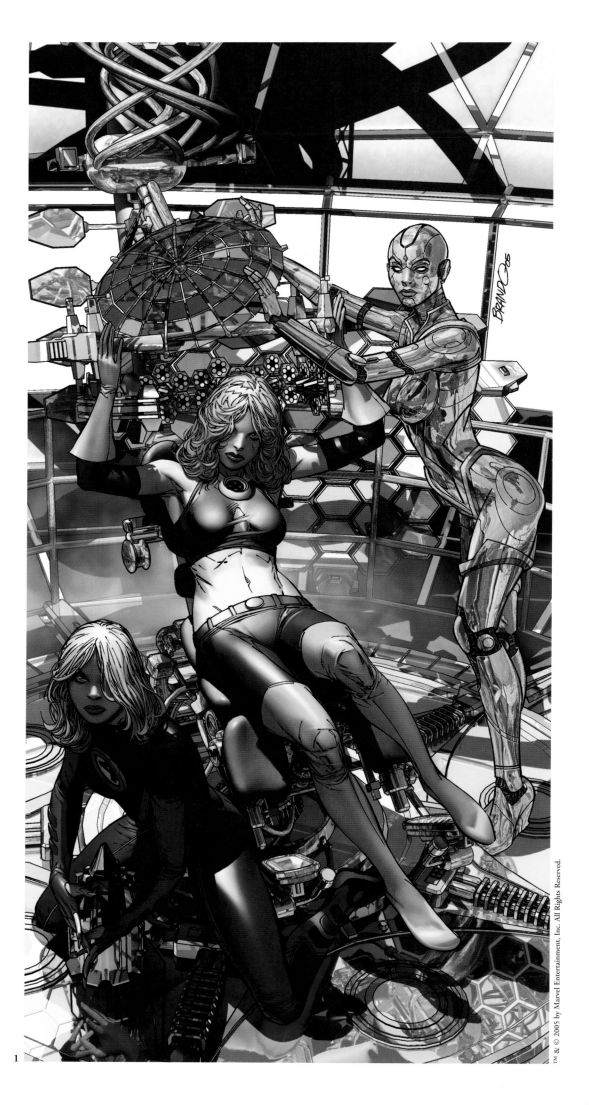

1

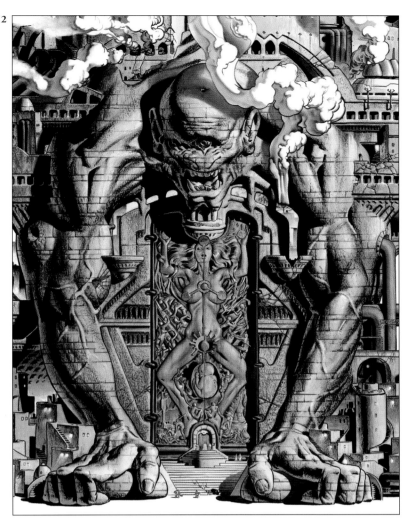

COMICS

1
artist: **Michael Wm. Kaluta**
art director: Rick Remender
client: Image Comics
title: Strange Girl #1 [Alternate]
medium: Ink/watercolor
size: 11¹/2"x17"

2
artist: **Frank Cho**
inker: Jason Keith
client: Aaron Williams
title: Nodwick #30
medium: Ink/digital
size: 14"x21"

3
artist: **Frank Cho**
colorist: Dave Stewart
client: Marvel Entertainment, Inc.
title: Shanna #3
medium: Ink/digital
size: 14"x21"

4
artist: **Frank Cho**
colorist: Jason Keith
client: Marvel Entertainment, Inc.
title: Shanna #3
medium: Ink/digital
size: 14"x21"

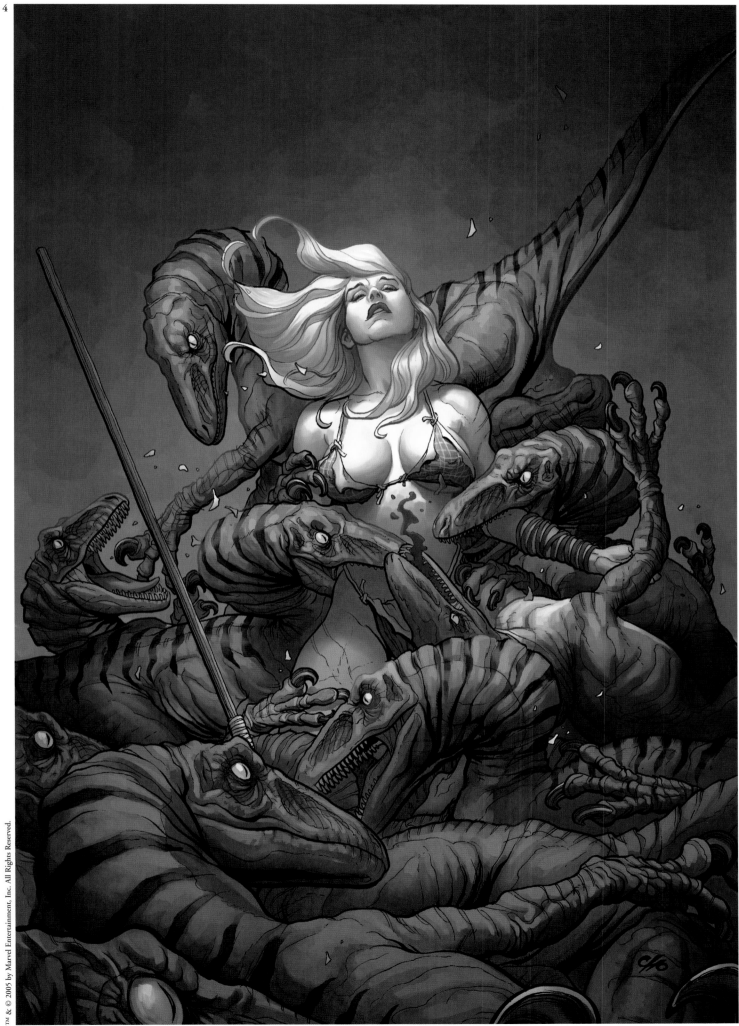

COMICS

1

2

3

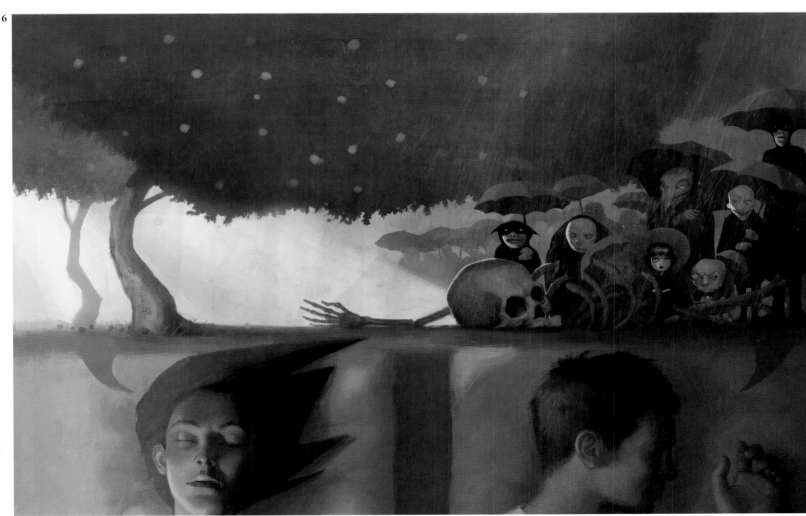

COMICS

1
artist: **Jeremy Geddes**
art director: Ashley Wood
client: IDW Publishing
title: Doomed #3
medium: Oil
size: 35"x47"

2
artist: **Marc Sasso**
art director: Regent St. Claire
client: Good Intentions Paving Co.
title: Sanction
medium: Mixed/digital

3
artist: **Michael Knapp**
client: Out of Picture
title: Newsbreak
medium: Digital
size: 18"x12"

4
artist: **Michael Knapp**
client: Out of Picture
title: Newsbreak
medium: Digital
size: 18"x12"

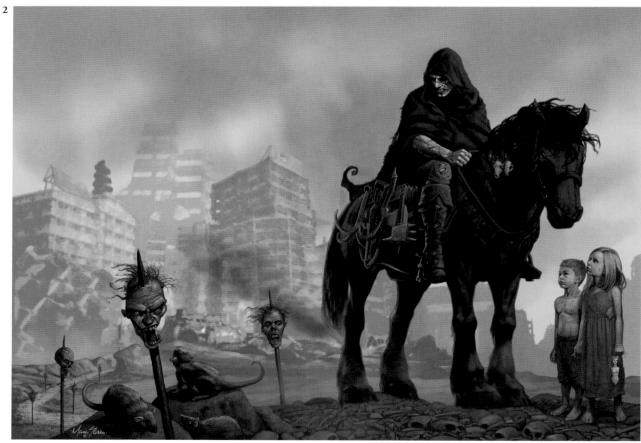

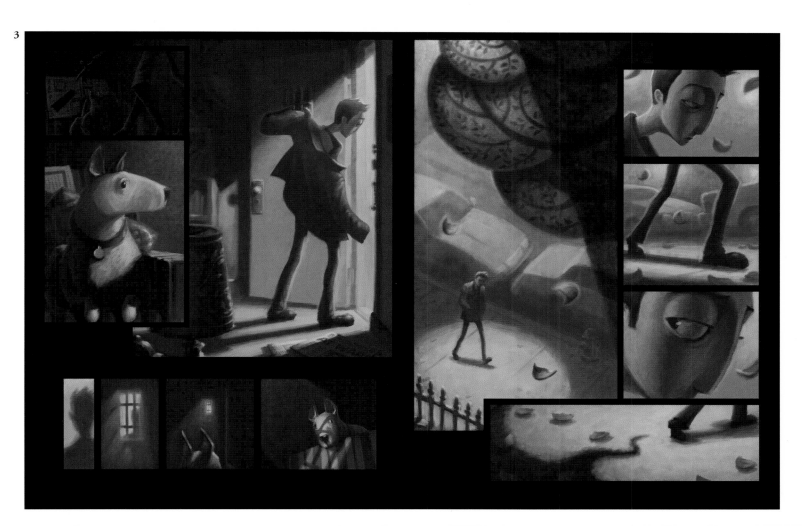

COMICS

1
artist: **Robh Ruppel**
client: Bar Libres
title: Sin & Tonic
medium: Digital

2
artist: **Brandon Peterson**
client: Marvel Entertainment,
Inc.
title: Ultimate Extinction #5
medium: Ink/digital
size: 7"x10¹/₂"

3
artist: **Jay Anacleto/Steve Firchow**
art director: Jim McLauchlin
client: Top Cow Productions
title: Witchblade #92
medium: Graphite/digital
size: 11"x17"

4
artist: **Hoang Nguyen**
client: A Gun & Barrel Publication
title: Hardboiled to the Max
medium: Digital
size: 8¹/₂"x12"

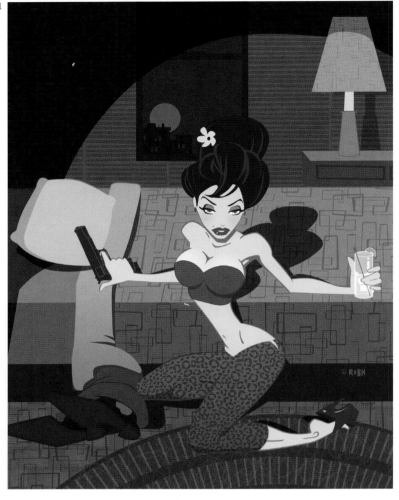

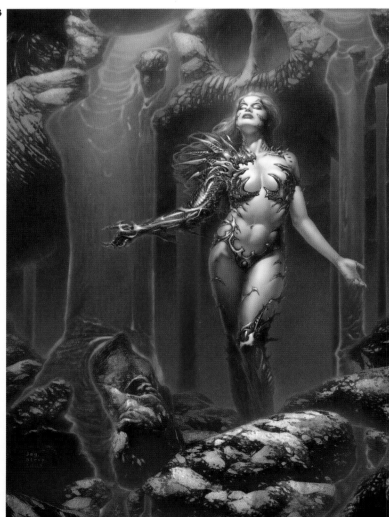

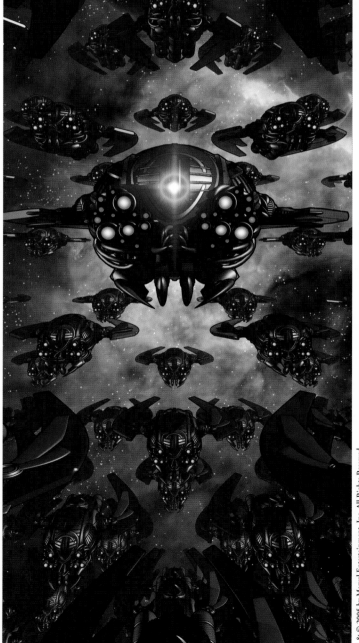

4

$10
Bucks

a Gun and Barrel Publication September

DETECTIVE

MY BABY GONE BAD
a Thrilling Love Triangle
by **Juno Black**

HOANG
NGUYEN 12/05

THE BIG BLACK HUSH
A Bizarre Crime novel
by **Kai Devin**

ONE BILLION BULLETS
Amazing Mystery Novel
by **Thai Dagan**

COMICS

1
artist: **Scott Gustafson**
art director: Geof Darrow
client: Burlyman Entertainment
title: Shaolin Cowboy
 Carry-Out
medium: Oil
size: 16"x19"

2
artist: **Jaime Zollars**
art director: Jeff Brown
client: The Can–Online
title: Molly
medium: Acrylic/collage
size: 7"x10 1/2"

3
artist: **Michael Wm. Kaluta**
art director: Shelly Bond
client: DC Comics/Vertigo
title: Lucifer #70
medium: Ink/watercolor
size: 11 1/2"x17"

1

2

COMICS

1
artist: **Adam Hughes**
client: Dynamic Forces
title: Red Sonja
medium: Pencil/ink/digital
size: 13"x19"

2
artist: **Charles Vess**
art director: Shelly Bond
client: DC Comics/Vertigo
title: Fables: 1001 Nights of Snowfall
medium: Colored inks
size: 10"x15"

3
artist: **Mike Huddleston**
art director: Karen Berger
client: DC Comics/Vertigo
title: Mnemovore #5
medium: Mixed
size: 7"x10$\frac{1}{2}$"

4
artist: **Gary Gianni**
client: King Features Syndicate, Inc.
title: Prince Valiant
medium: Ink

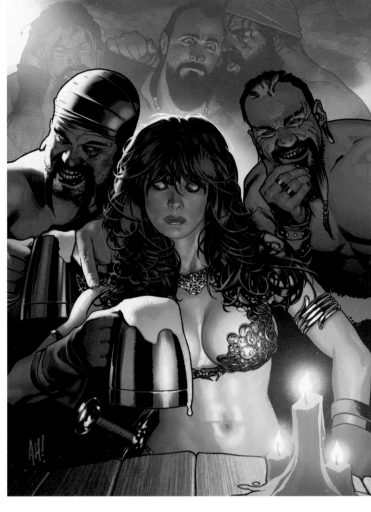

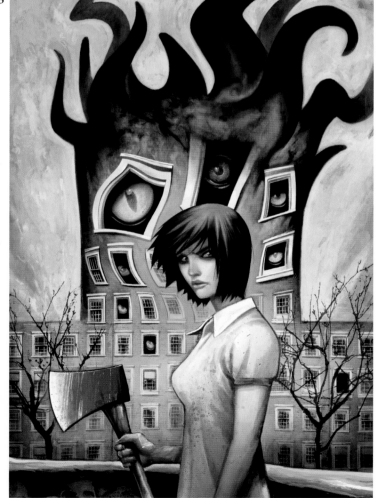

Hal Foster's Prince Valiant®

BY GIANNI AND SCHULTZ

©2005 King Features Syndicate, Inc.

"NO, THE MAELSTROM IS NOT THE WORST OF IT, FOR WITHIN ITS BRINY GRASP HIDES THE HORRID KRAKEN, WHOSE LEAGUE-LONG TENTACLES AND CLASHING JAWS MAKE SHORT WORK OF CARELESS SAILORS AND BRAVE WARRIORS ALIKE!"

3588

VAL IS WELL-PLEASED WITH HIS GRIM NARRATIVE, BUT HIS SON IS UNIMPRESSED. "MOTHER HAS ALREADY SPUN THAT YARN FOR ME, AS THEY TELL IT IN THE MISTY ISLES. DOWN THERE THEY CALL THE MENACES SCYLLA AND CHARYBDIS -- BUT IT'S BASICALLY THE SAME STORY."

AS NATHAN RETURNS TO HIS ADOLESCENT MISERY, VAL SIGHS, "THE WORLD HAS GROWN TOO SMALL WHEN A RIPPING GOOD TALE LIKE THAT NO LONGER INSPIRES AWE. CHILDREN TODAY ARE FAR TOO JADED." SUCH IS THE ETERNAL DIVIDE BETWEEN GENERATIONS.

NEXT WEEK: Sea Wolves

Comics

1
artist: **Kent Williams**
art director: Pernsak Pichetshote
designer: Kent Williams
client: DC Comics/Vertigo
title: The Fountain [cover]
medium: Mixed
size: 12"x14"

2
artist: **Mike Huddleston**
art director: Karen Berger
client: DC Comics/Vertigo
title: Mnemovore #2
medium: Mixed
size: 7"x10¹/₂"

3
artist: **Kent Williams**
art director: Pernsak Pichetshote
designer: Kent Williams
client: DC Comics/Vertigo
title: The Fountain [p. 153]
medium: Mixed
size: 12"x14"

4
artist: **Kent Williams**
art director: Pernsak Pichetshote
designer: Kent Williams
client: DC Comics/Vertigo
title: The Fountain [p. 10]
medium: Mixed
size: 12"x14"

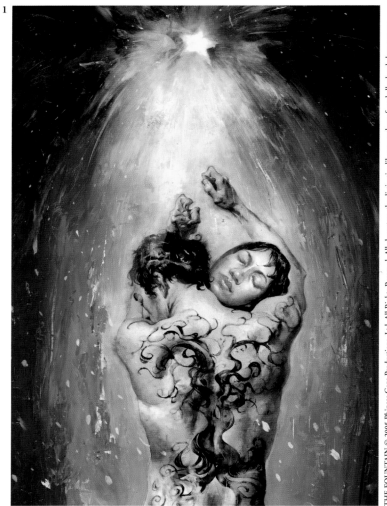

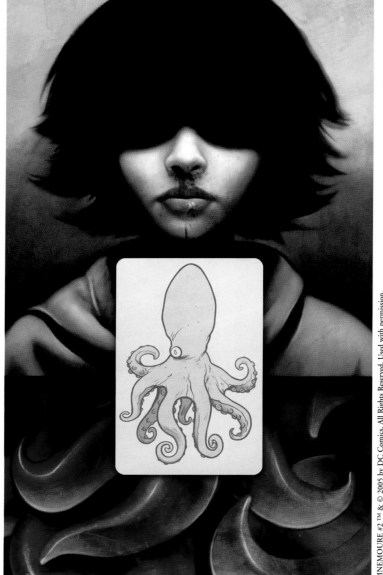

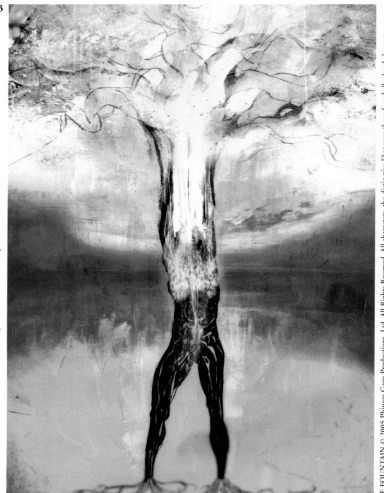

4

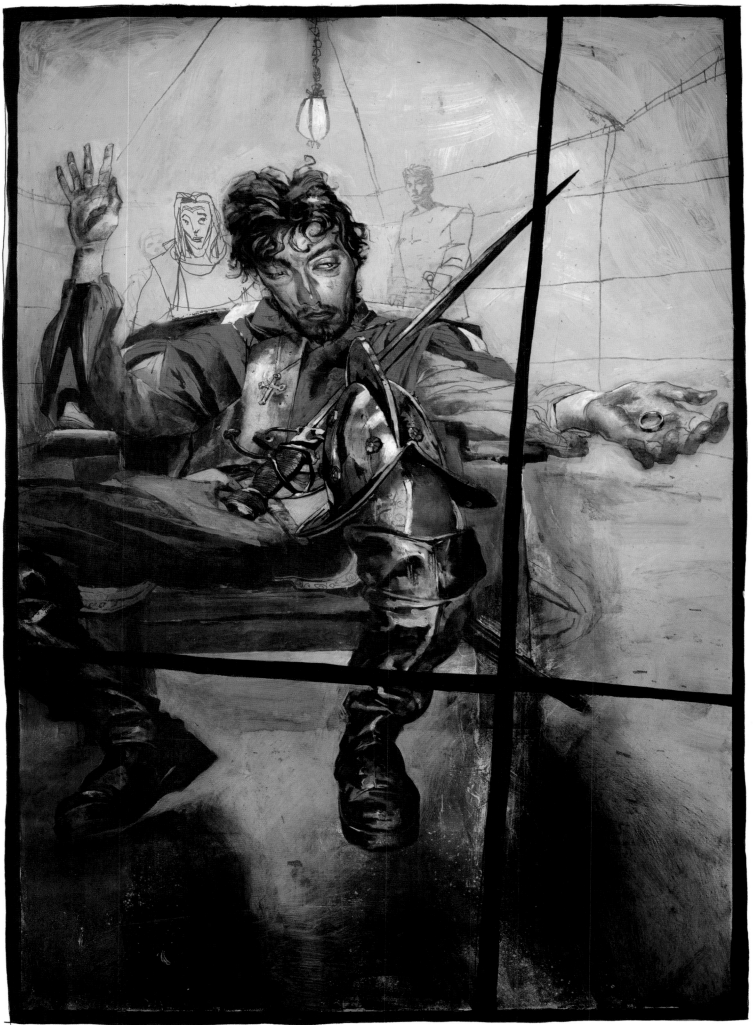

DIMENSIONAL
Gold Award

artist: **Tim Bruckner**

art director: Tim Bruckner/Todd Schorr *designer:* Todd Schorr *client:* Jonathan LeVine Galleries

title: Under Autumn's Tentacled Spell *size:* 14" tall *medium:* Resin

DIMENSIONAL
Silver Award

artist: **Andrew Sinclair**

designer: Andrew Sinclair/Clive Pittman *client:* Ridgeway Sculpture Design *title:* Moodius Centaurus *size:* 36" tall *medium:* Bronze

DIMENSIONAL

1
artist: **Gore Group/Martin Canale**
art director: Martin Canale
designer: Gore Group
client: Palisiades Toys
title: Alien Wall Plaque
medium: Resin
size: 9" round

2
artist: **Rubén Procopio**
art director: Tracy Mark Lee/Rubén Procopio
designer: Mike Mignola
client: Electric Tiki Design
title: Hellboy
medium: Sculpey
size: 12" tall

3
artist: **William Paquet**
client: Paquet Figure Works
title: The Monster
medium: Resin
size: 8" tall

4
artist: **Thomas S. Kuebler**
title: Myron Klinefelter's Revenge
medium: Silicone/mixed
size: Lifesize

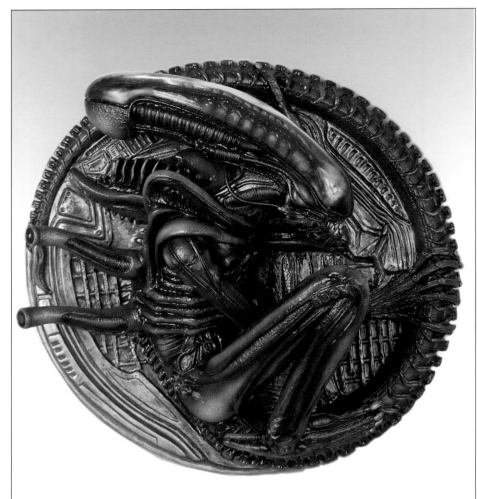

1

2

3

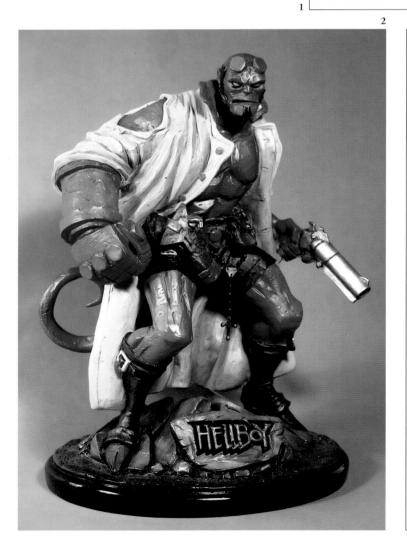

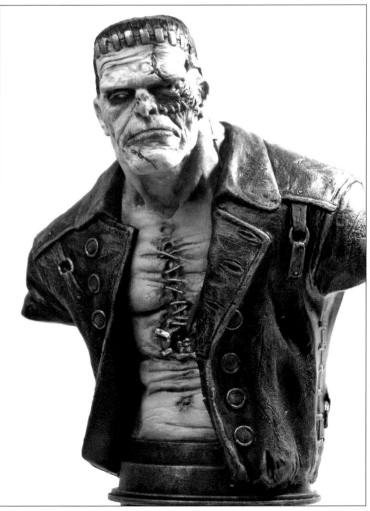

4

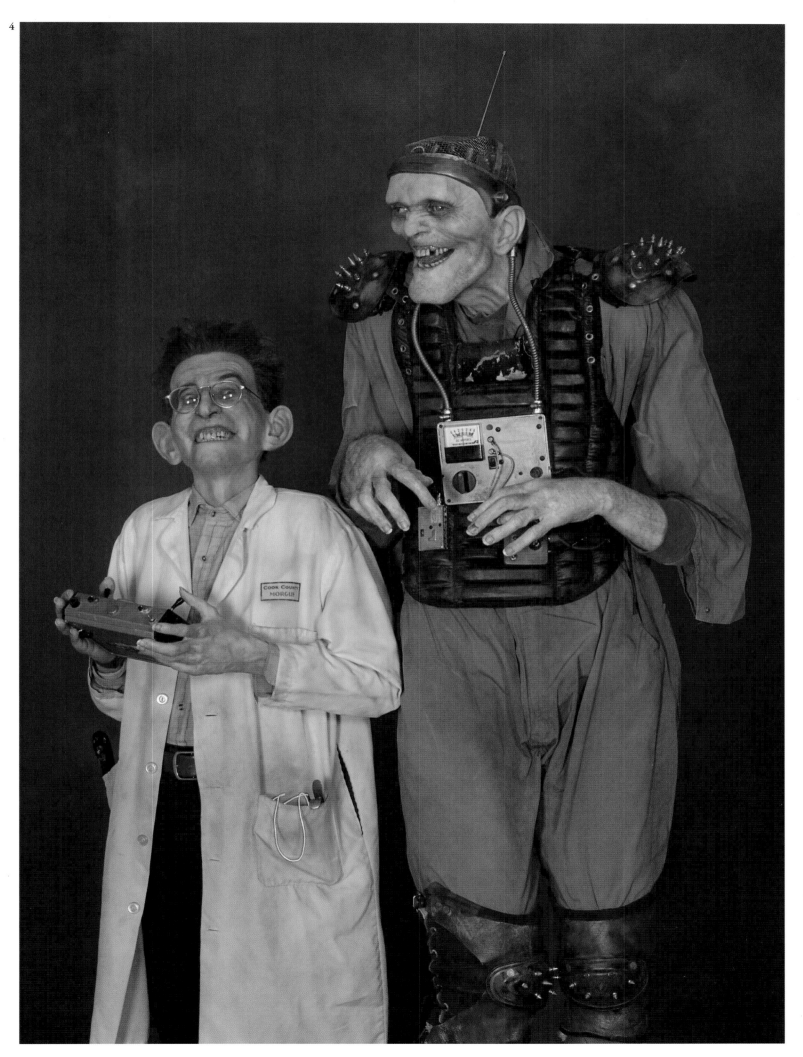

Dimensional

1
artist: **Mike Petryszak**
painter: Dan Perez &
Mike Petryszak
designer: Frank Cho
client: Critical Mass Studios
title: Dejah
medium: Resin
size: 12" tall

2
artist: **Walter O'Neal**
title: Master Embers: God of Fire
medium: Sculpey
size: 13" tall

3
artist: **Pablo Viggiano/**
Martin Canale
art director: Martin Canale
designer: Gore Group
client: Sideshow Collectibles
title: Green Goblin
medium: Mixed
size: 17"H x17"W

4
artist: **Thomas S. Kuebler**
title: Madame Orba
medium: Silicone/mixed
size: Lifesize

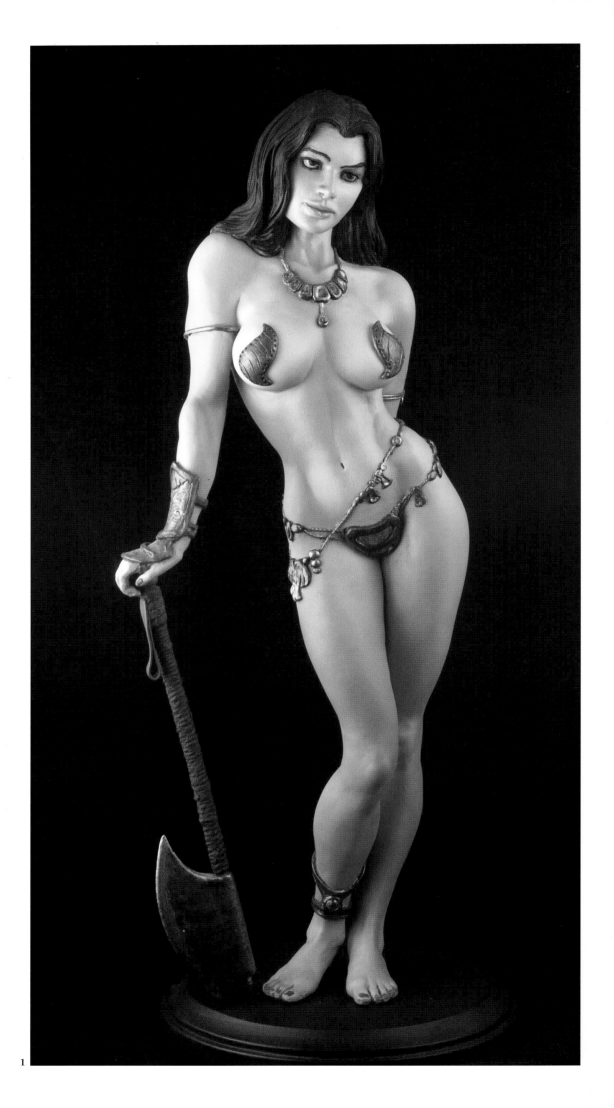

1

2

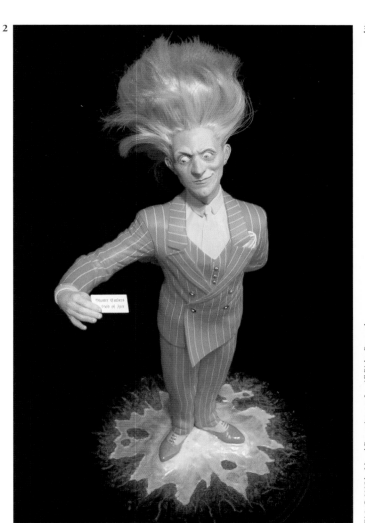

3

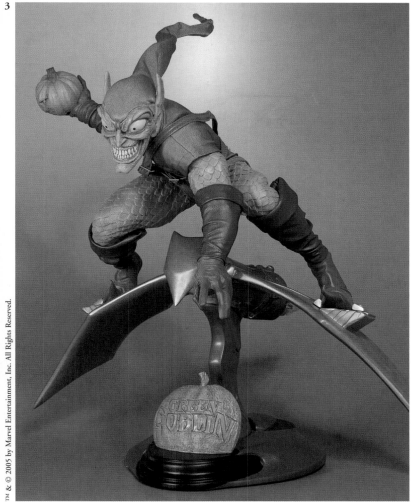

4

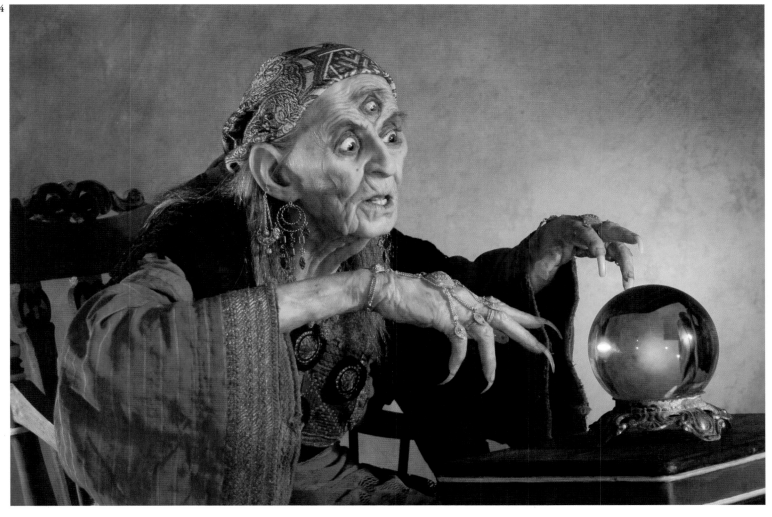

DIMENSIONAL

1
artist: **Tom Taggart**
title: Monsieur Mallah
medium: Sculpey
size: 10" Tall

2
artist: **Dan Hawkins**
title: Animal Animus
medium: Mixed
size: 38"x16"x14"

3
artist: **Melissa Ferreira**
title: After Life
medium: Acrylic on wood, clay,
 & paperclay
size: 18"x7"

4
artist: **Gil Bruvel**
title: The Oracle
medium: Mixed
size: 20"x17"x27"

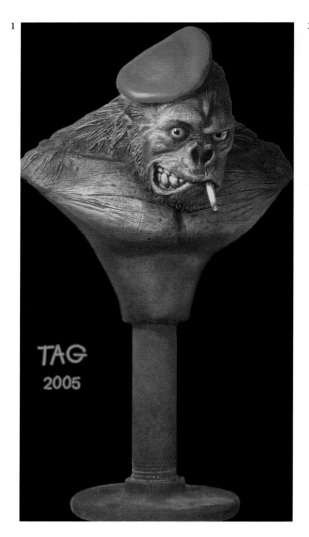

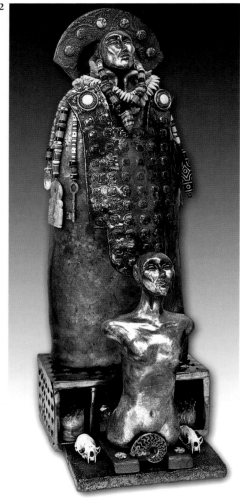

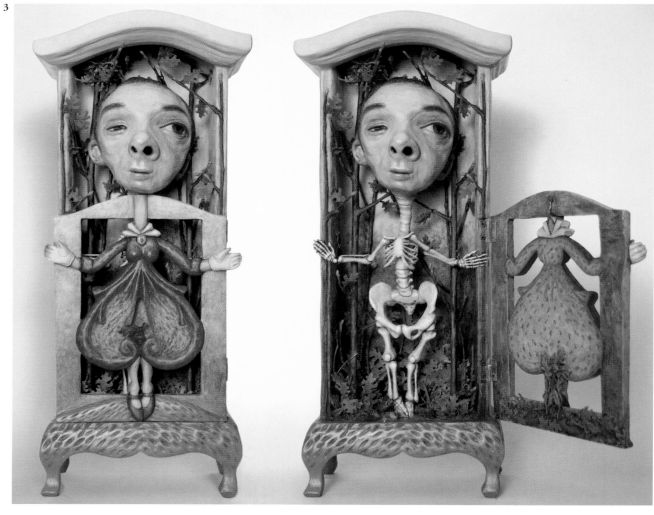

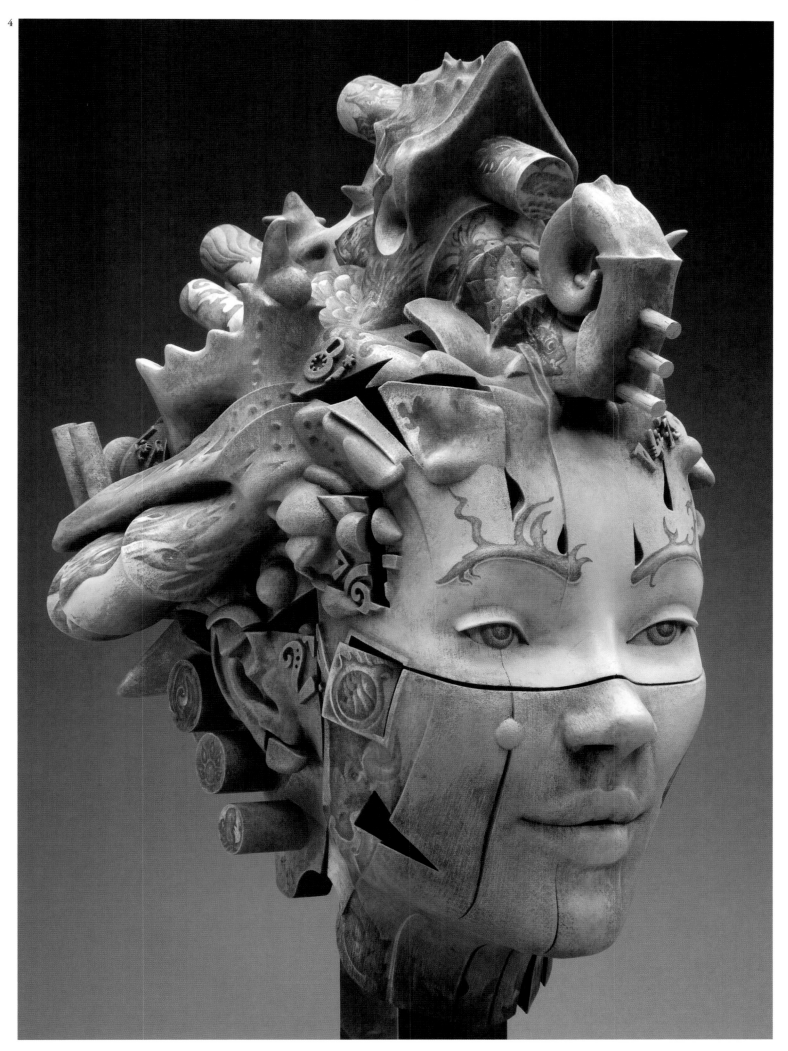

4

Dimensional

1
artist: **Dave Pressler**
client: www.smashoart.com
title: Angry Clobber Monkey
medium: Sculpey *size:* 7"x8"

2
artist: **Mick Wood**
photographer: Joe Wood
title: The Ymith
medium: Resin *size:* 13⁵/₈"Hx21"L

3
artist: **John Winter**
art director: Mike McVey
designer: Matt Wilson
painter: Alison McVey
set builder: Alfonso Falco
photographer: James Davis
client: Privateer Press
title: Deathjack
medium: Painted pewter *size:* 80mm

4
artist: **Alterton**
painter: Norm Platt
title: The Perfect Soldier
medium: Epoxy putty *size:* 12" Tall

5
artist: **Dave Cortés**
art director: Randy Falk
designer: Dave Cortés
painter: Brandy Anderson
client: NECA
title: Marv [Sin City]
medium: Resin *size:* 12" Tall

6
artist: **Dave Cortés**
painter: Brandy Anderson
client: Mezo Toyz
title: King Kong
medium: Resin *size:* 12" Tall

1

2

3

4

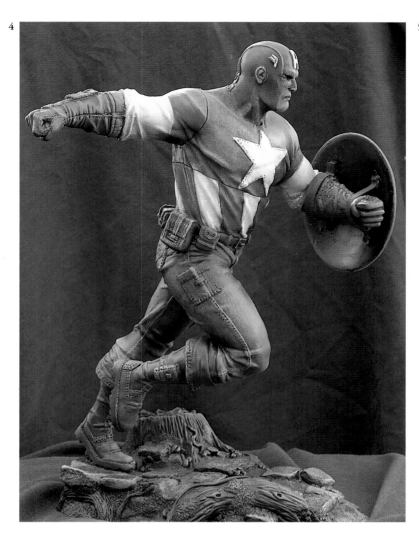

5

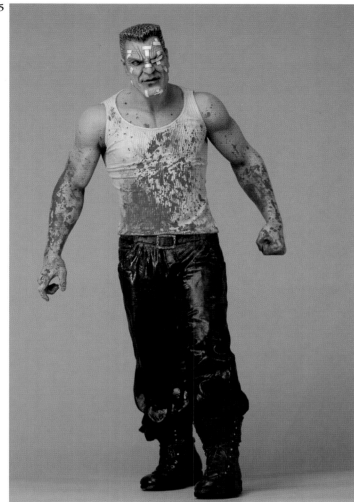

6

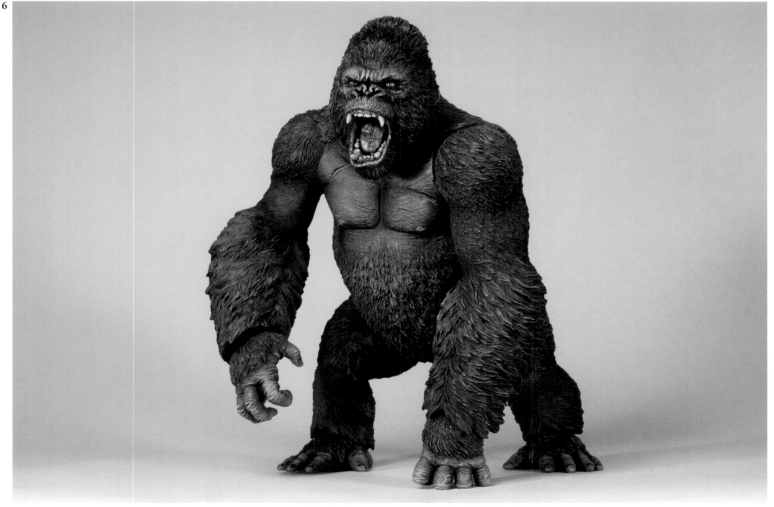

DIMENSIONAL

1
artist: **Schü**
designer: Martin F. Emond
client: Electric Tiki Design
title: Rocker Biker Girl
medium: Sculpey
size: 20" Tall

2
artist: **Barsom**
designer: Andrew Bawidamann
client: Barsomart, Inc.
title: Dirty Martini
medium: Wax & glass
size: 9" Tall

3
artist: **Nathaniel K. Lewis**
title: Sages
medium: Resin
size: 10'x9'

4
artist: **Lawrence Northey**
client: www.robotart.net
title: Jim & George:
 Space Cadets
medium: Metal & glass
size: 30" Tall

5
artist: **Steven Lord**
title: Evolution
medium: Wood, resin,
 acrylic paint
size: 4'Hx2'W

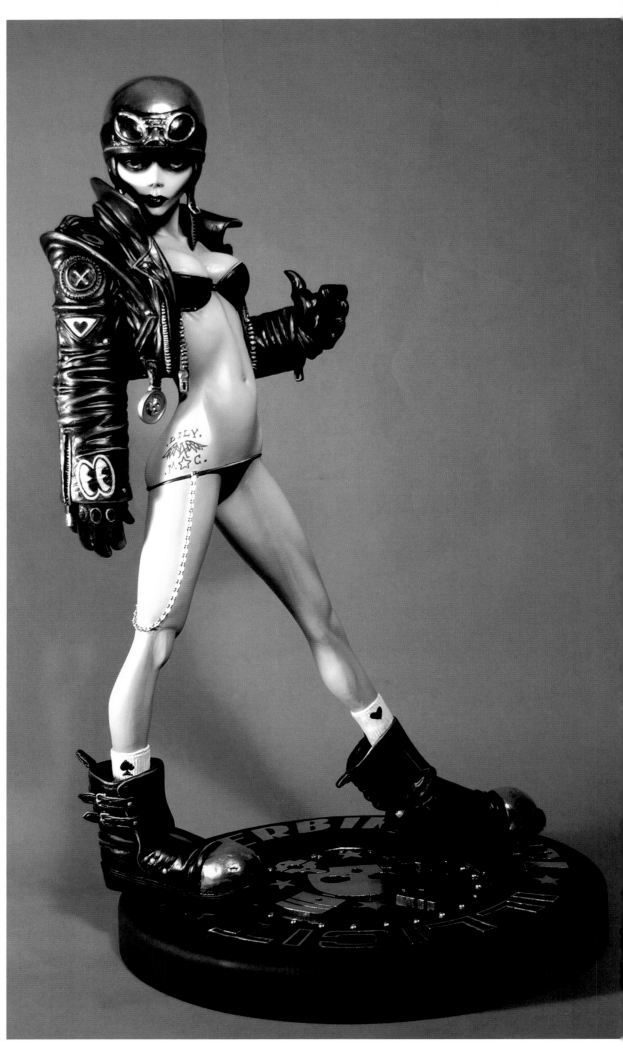

1

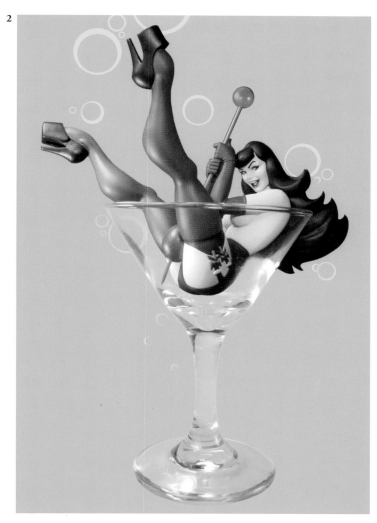

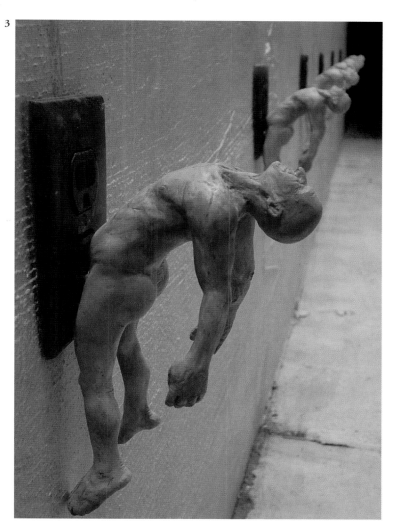

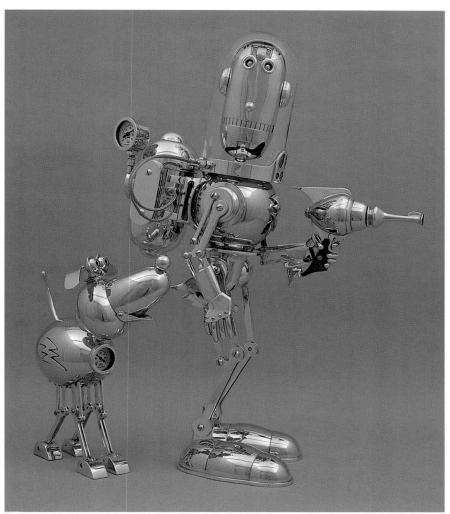

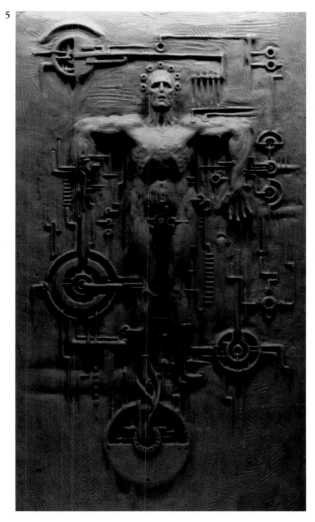

Dimensional

1
artist: **Jonathan Matthews**
art director: Shawn Knapp
designer: Mike Mignola
client: DC Comics/DC Direct
title: Batman
medium: Painted resin
size: 8" Tall

2
artist: **Jonathan Matthews**
art director: Shawn Knapp
designer: Mike Mignola
client: DC Comics/DC Direct
title: Gotham by Gaslight
medium: Painted resin
size: 7" Tall

3
artist: **Tim Bruckner**
art director: Jim Fletcher
designer: Alex Ross
client: DC Comics/DC Direct
title: The Joker
medium: Resin
size: 7" Tall

4
artist: **James Shoop**
art director: Jim Fletcher
designer: Ed McGuinness
painter: Kim Murphy
client: DC Comics/DC Direct
title: Superman & Batman
medium: Blow
size: 8 1/4"H x 6 1/2"W x 6 1/2"D

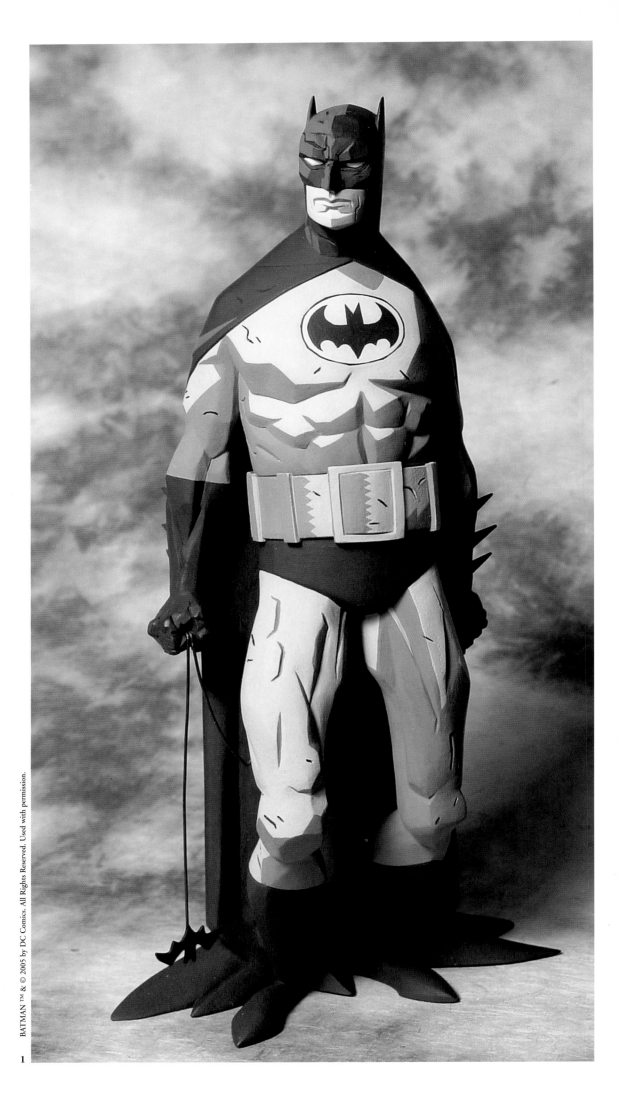

1

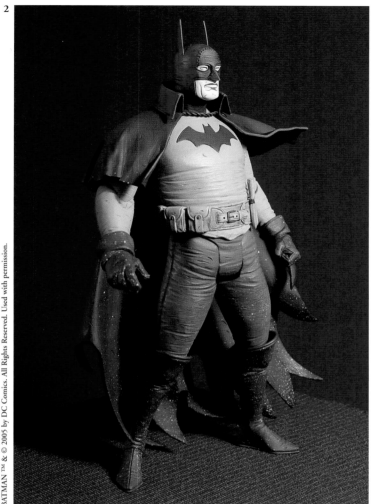

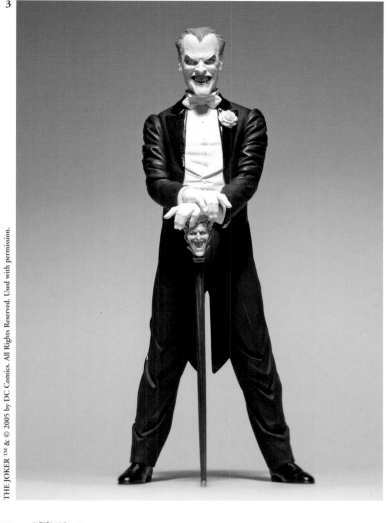

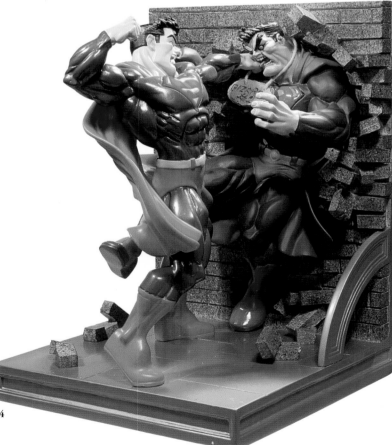

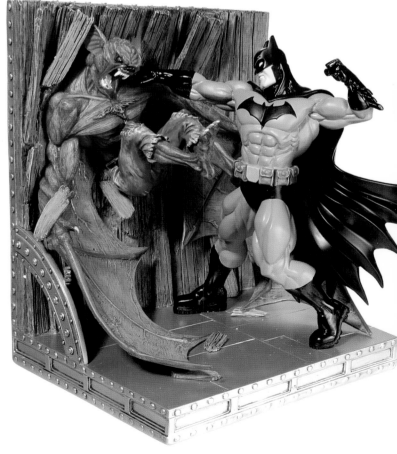

DIMENSIONAL

1
artist: **William Paquet**
art director: Frank Miller
designer: William Paquet
client: Dynamic Forces
title: Marv
medium: Cold-cast porcelain
size: 11$\frac{1}{2}$" Tall

2
artist: **Tim Bruckner**
client: The Art Farm, Inc.
title: La Belle et la Bete
medium: Resin
size: 18"Hx9$\frac{5}{8}$"W

3
artist: **Richard A. Moore III**
photographer: Brian McIernon
client: www.rmooresculptures.com
title: Don't Make Me...
medium: Bronze
size: $\frac{3}{4}$ Lifesize

4
artist: **Gore Group**
art director: Martin Canale
designer: Sideshow/Gore Group
client: Sideshow Collectibles
title: General Grievous
medium: Mixed
size: 25"Hx18"Wx18"D

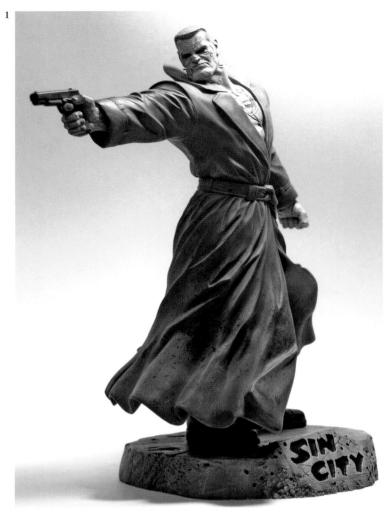

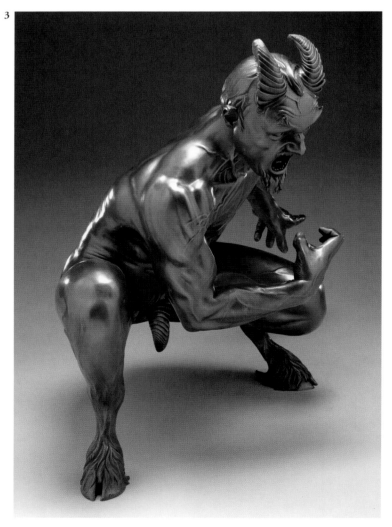

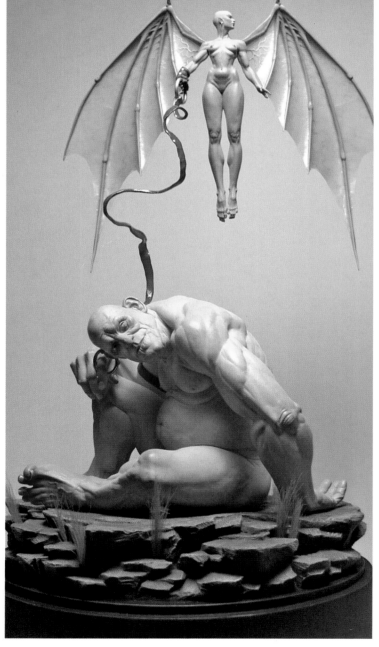

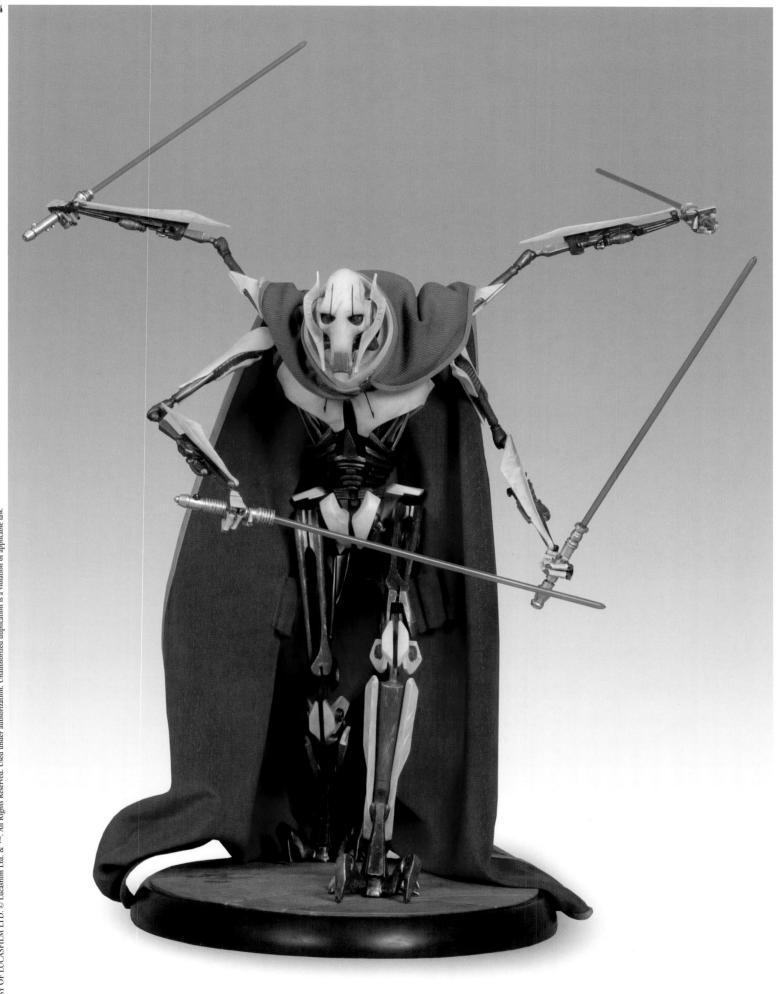

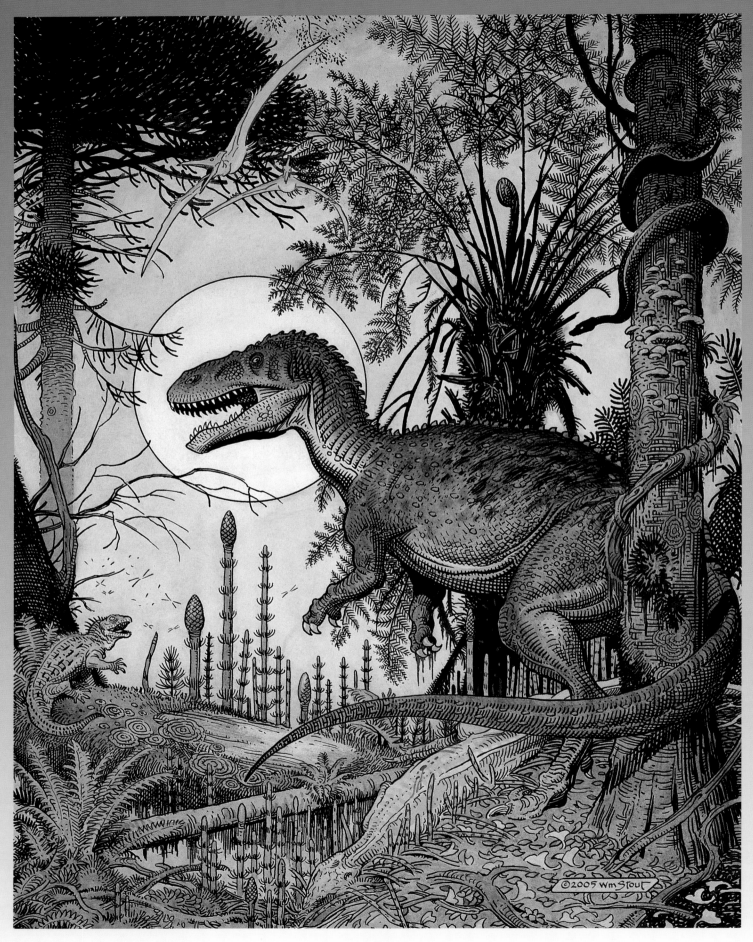

artist: **William Stout**

art director: Mike Fredericks *designer:* William Stout *client:* Prehistoric Times *title:* Antarctic Megalosaur

size: 10"x15" *medium:* Ink & watercolor on board

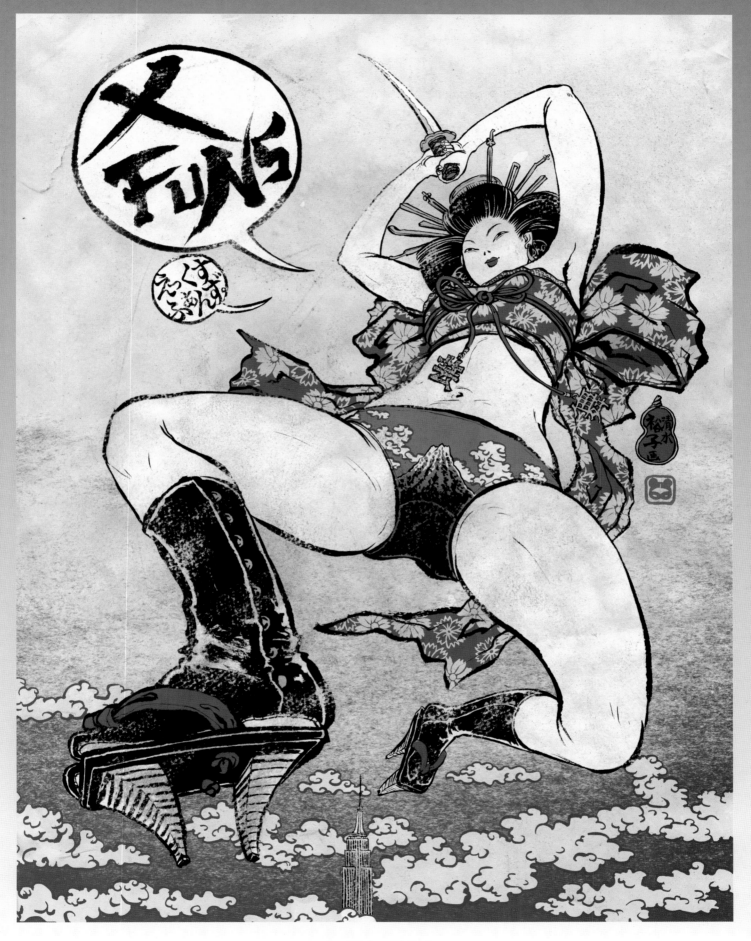

artist: **Yuko Shimizu**

art director: Johnson Lee *client:* X-Funs *title:* Revenge of the Geisha Girl *size:* 13"x17" *medium:* Ink/digital

EDITORIAL

1
artist: **Anita Kunz**
art director: Françoise Mouly
client: The New Yorker
title: Like Mother, Like Daughter
medium: Mixed
size: 11"x14"

2
artist: **Peter de Sève**
art director: Françoise Mouly
client: The New Yorker
title: Easter Egg
medium: Watercolor/ink
size: 8¹/2"x11"

3
artist: **Peter de Sève**
art director: Françoise Mouly
client: The New Yorker
title: Beach Bum
medium: Watercolor/ink
size: 8¹/2"x11"

4
artist: **Peter de Sève**
art director: Françoise Mouly
client: The New Yorker
title: Two by Two
medium: Watercolor/ink
size: 8¹/2"x11"

4

EDITORIAL

1
artist: **Craig Elliott**
art director: Carl Gnam
client: Realms of Fantasy
title: Heart of Ice
medium: Oil/digital

2
artist: **David Ho**
art director: Clay Turner
client: NRA
title: Washington's Newest
 Monument
medium: Digital

3
artist: **Brian Horton**
art director: Carl Gnam
client: Realms of Fantasy
title: Cold Drake
medium: Digital
size: 8"x10"

4
artist: **Chris Spollen**
title: Rockets In the
 Meadowlands
medium: Mixed/digital
size: 12"x16"

5
artist: **Viktor Koen**
client: Van Goor Publishers
title: Blood Moon
medium: Digital
size: 9³/8"x17"

6
artist: **Chris Spollen**
title: Watergates
medium: Mixed/digital
size: 12"x16"

7
artist: **Mark Evans**
art director: Gordan Van Gelder
client: Magazine of Fantasy &
 Science Fiction
title: Painful Upgrade
medium: Digital
size: 8"x12¹/2"

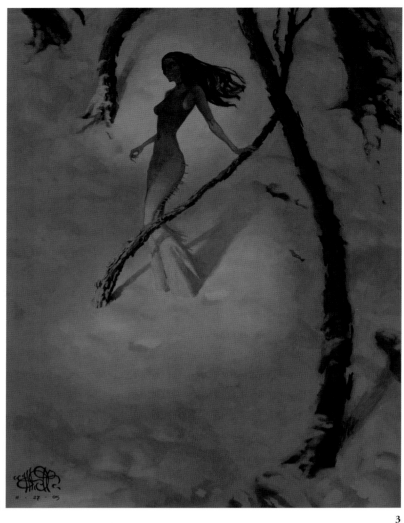

1

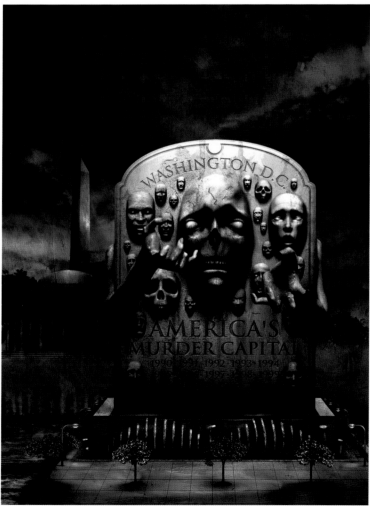

2

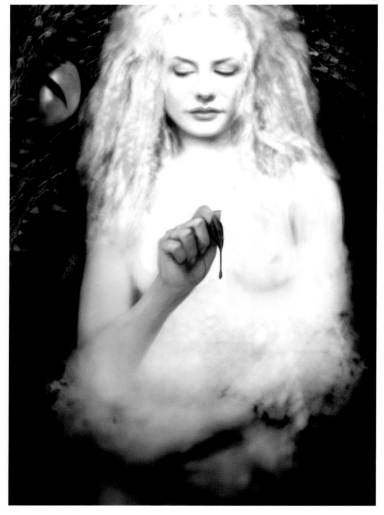

3

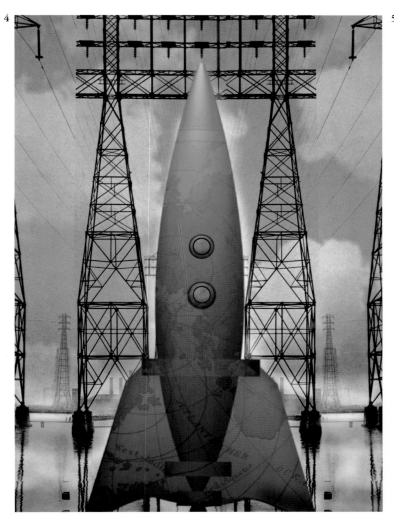

1
artist: **Denise Leite**
art director: Tom Staebler
designer: Tom Staebler
client: Playboy Magazine
title: Weight of the Moon

2
artist: **Phil Hale**
art director: Tom Staebler
designer: Tom Staebler
client: Playboy Magazine
title: The Swift Passage
 of the Animals

3
artist: **Eric Fortune**
art director: Carl Gnam
client: Realms of Fantasy
title: Undine
medium: Acrylic
size: $10^{1}/2$"x$14^{1}/2$"

1

2

3

EDITORIAL

3

4

5

1
artist: **Philip Straub**
client: CG Society
title: Monolith
medium: Digital
size: 13$^5/_8$"x6$^1/_2$"

2
artist: **Omar Rayyan**
art director: Ron McCutchan
client: Cricket Magazine
title: Enchanted Mountain
medium: Watercolor
size: 11"x6"

3
artist: **Richard Bernal**
art director: Sue Becvk
client: Cricket Magazine
title: ...Baby's Sleeping...
medium: Oil
size: 20"x12"

4
artist: **James Gurney**
client: Top Fantasy [China]
title: Ride to Atlantis
medium: Oil
size: 18"x24"

4

1
artist: **Yuko Shimizu**
art director: Mark Murphy
client: Murphy Design
title: Panda Girl: The First
 Asian-American Superheroine
medium: Ink/digital
size: 18"x18"

2
artist: **Yuko Shimizu**
art director: Tom Staebler
designer: Rob Wilson
client: Playboy Magazine
title: Seven Deadly Disasters

3
artist: **Jeff Faerber**
art director: Frank Reynoso
designer: Jed Brandt
client: Indypendent
title: Under the Eye
medium: Mixed
size: 14"x20"

4
artist: **Janet Woolley**
art director: Mike Di Ioia
client: Penthouse
title: Girl Talk, Everything But...
medium: Photomontage/digital

5
artist: **Dave McKean**
art director: Tom Staebler
designer: Tom Staebler
client: Playboy Magazine
title: The Fisherman and the Jinn

1

2
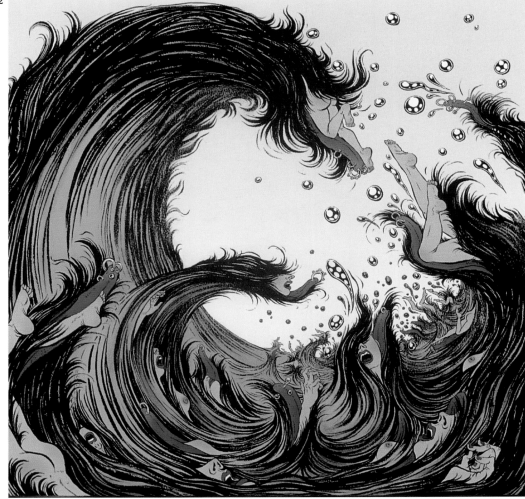

3

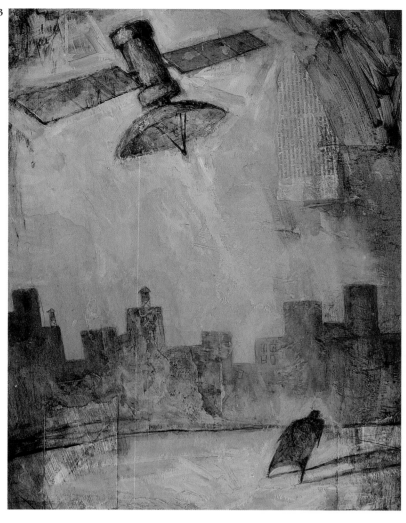

4

5

EDITORIAL

1
artist: **Scott Gustafson**
art director: Susan Beck
designer: Scott Gustafson
client: Lady Bug Magazine
title: Juggling Jester
medium: Acrylic
size: 13¼"x16½"

2
artist: **William Stout**
art director: Michael Stein
designer: William Stout
client: Filmfax
title: Mighty Kong
medium: Oil on canvas
size: 18"x24"

3
artist: **Michael Knapp**
art director: Charles Dixon III
client: Diversity, Inc.
title: Employee Rentention & Salaries
medium: Digital
size: 9"x12"

4
artist: **Omar Rayyan**
art director: Ron McCutchan
client: Cricket Magazine
title: Enchanted Mountain
medium: Watercolor
size: 8"x10"

EDITORIAL

1
artist: **Joseph Daniel Fiedler**
art director: Billie Bishop
client: Arizona Highways Magazine
title: Rattlesnake
medium: Mixed
size: 8"x8"

2
artist: **Jon Foster**
art director: Chris Klein
client: National Geographic
medium: Oil/digital

3
artist: **Owen Richardson**
art director: Declan Fahy
client: Esquire
title: Killing Yourself to Live
medium: Digital
size: 8¹/2"x11"

1

2

3

artist: **Cos Koniotis**

client: Sabertooth Games *title:* Warriors of Khorne *medium:* Digital

artist: Daniel Dociu

client: ArenaNet/Guild Wars *title:* Jade Sea Walker II *size:* 13"x19" *medium:* Digital

1
artist: **Justin Sweet**
art director: Grant Major
client: Walt Disney Studios
title: White Witch Battle
medium: Digital

2
artist: **Justin Sweet**
art director: Grant Major
client: Walt Disney Studios
title: Aslan on Hill
medium: Digital

3
artist: **Justin Sweet**
art director: Marcelo Anciano
client: Wandering Star
title: Kull in Valusia
medium: Oil
size: 32"x48"

INSTITUTIONAL

1
artist: **Séverine Pineaux**
client: Sidh & Banshee
title: The Ball Dress
medium: Oil on canvas
size: 61"x50"

2
artist: **Eric Fortune**
art director: Elliott De Luca
client: Washington National
 Opera
title: Vesper Sicilians
medium: Acrylic
size: 20"x30"

3
artist: **Mark A. Nelson**
client: Grazing Dinosaur Press
title: KW: Catfish
medium: Pencil/digital
size: 10"x13"

4
artist: **Mark A. Nelson**
client: Grazing Dinosaur Press
title: E2: Snakebird
medium: Pencil/digital
size: 10"x13"

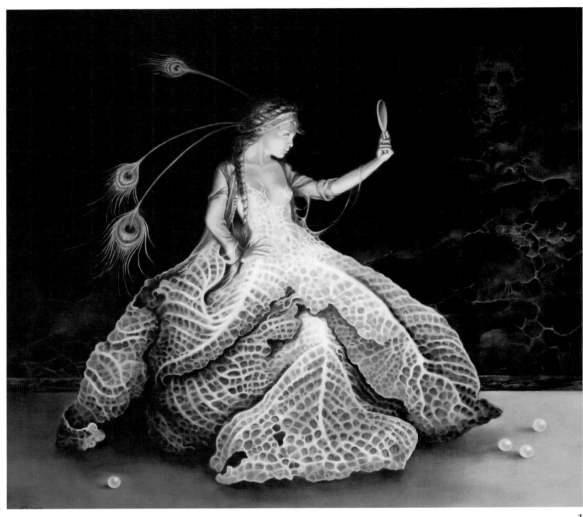

1

2

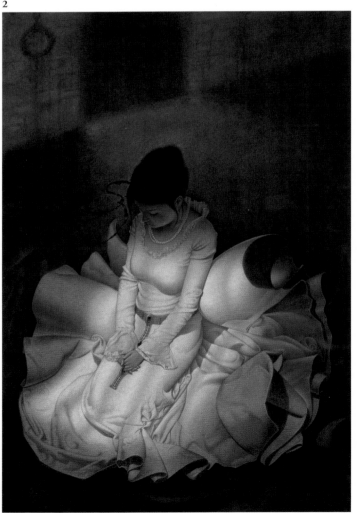

3

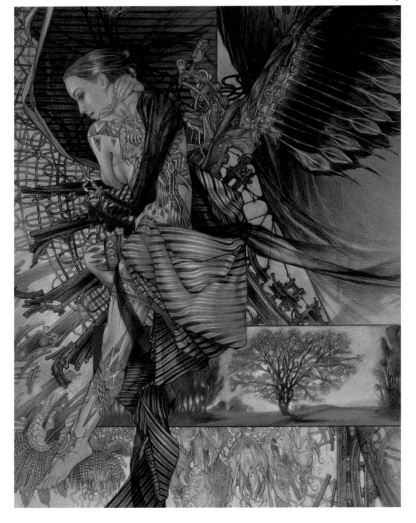

4

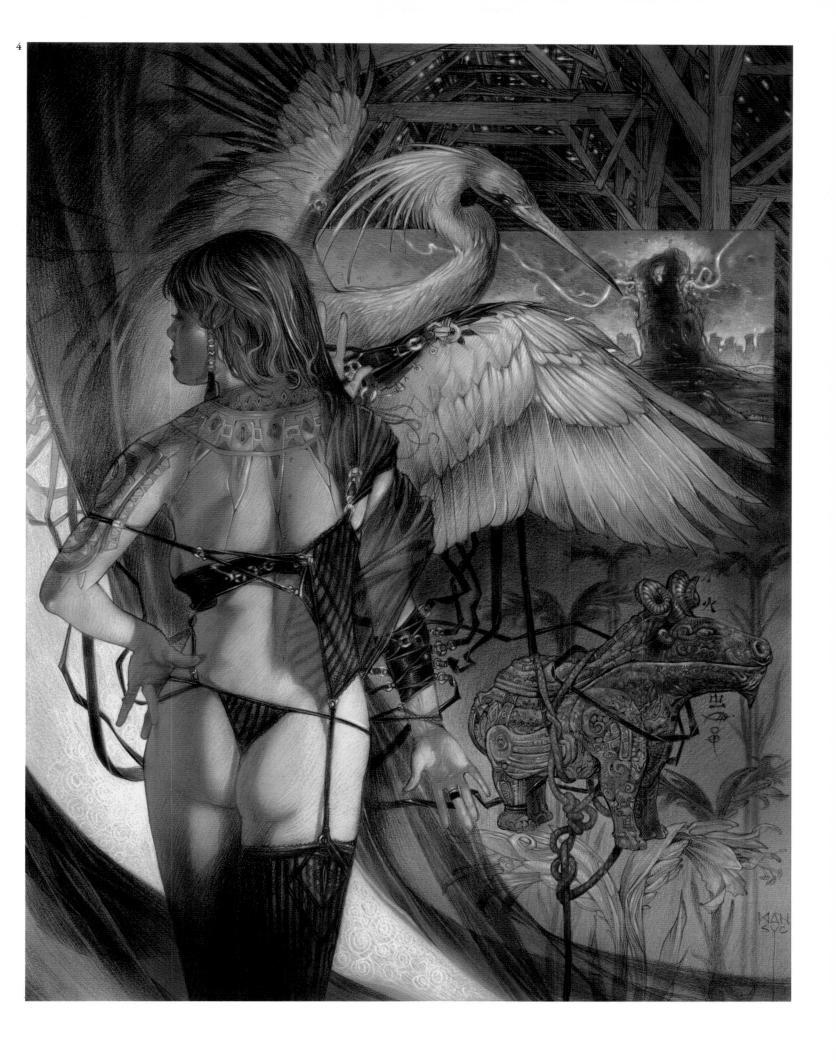

Institutional

1
artist: **Daniel Dociu**
client: ArenaNet/Guild Wars
title: Jade Sea Crawler I
medium: Digital
size: 13"x19"

2
artist: **Andrew Jones**
art director: Marko Djuvdjevic
client: Tomer
title: Enclosed in Proximity
medium: Digital

3
artist: **Daniel Dociu**
client: ArenaNet/Guild Wars
title: Crawler Leg
medium: Digital
size: 19"x13"

4
artist: **Andrew Jones**
art director: Massive Black
client: ConceptArt.org
title: Lesser Evil
medium: Digital/Painter 9

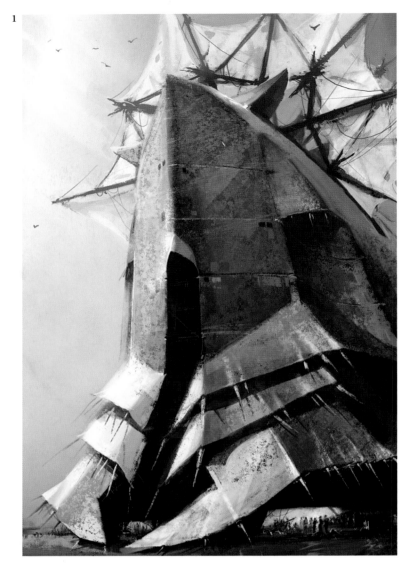

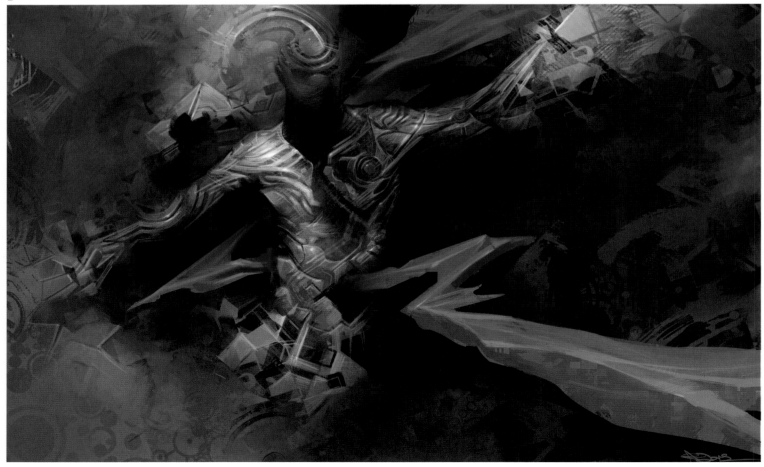

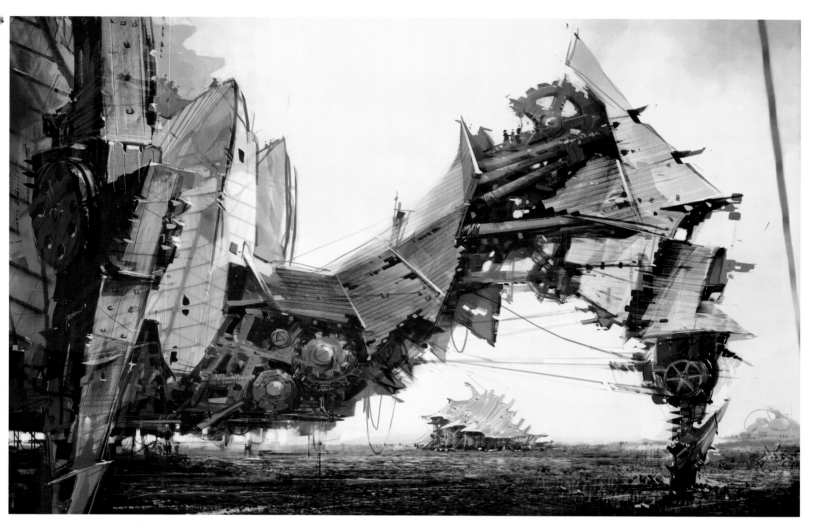

4

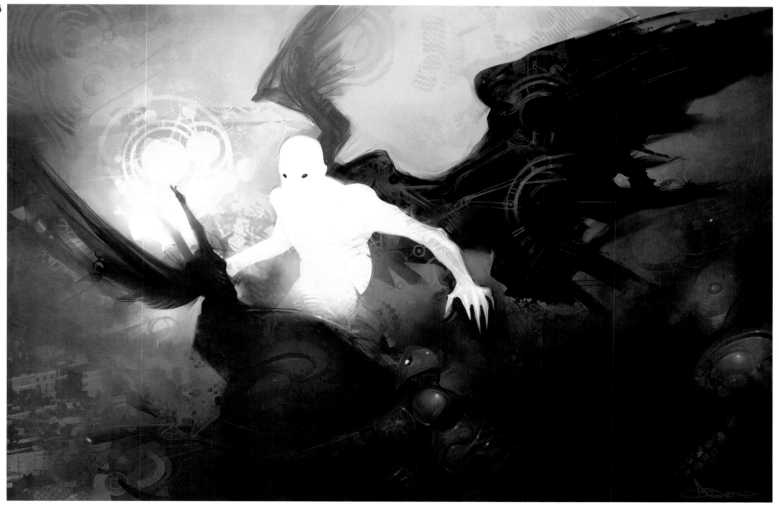

INSTITUTIONAL

1
artist: **John Van Fleet**
art director: Dawn Murin
client: Wizards of the Coast
title: Demon Rushmore
medium: Mixed
size: 8¹/₂"x5"

2
artist: **Will Bullas**
art director: Scott Usher
client: Greenwich Workshop, Inc.
title: Hare of the Dog
medium: Watercolor
size: 34"x16"

3
artist: **David de Ramón**
art director: Blas Rico
client: AzulFaroDiez
medium: Digital
size: 14"x7"

4
artist: **Stephen Player**
client: The Cunning Artificer–U.K.
title: "If you haven't got
a ha'penny..." [Terry Pratchett
Christmas Card]
medium: Watercolor
size: 10"x14"

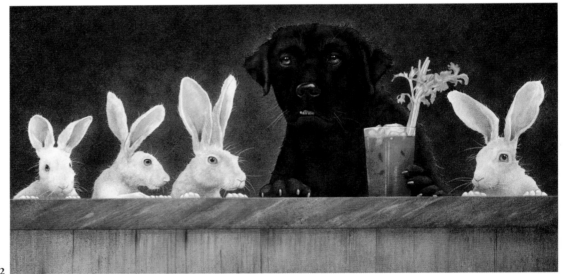

1

2

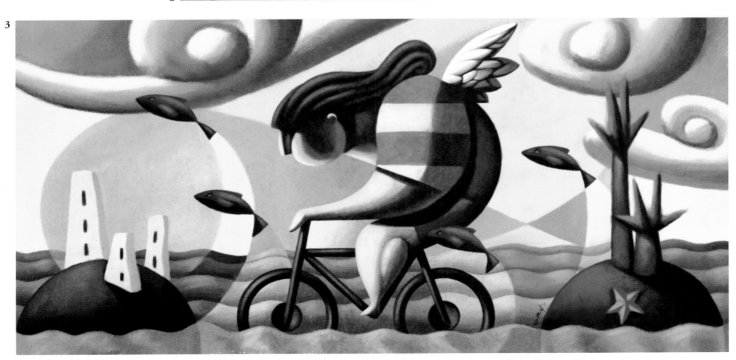

3

4

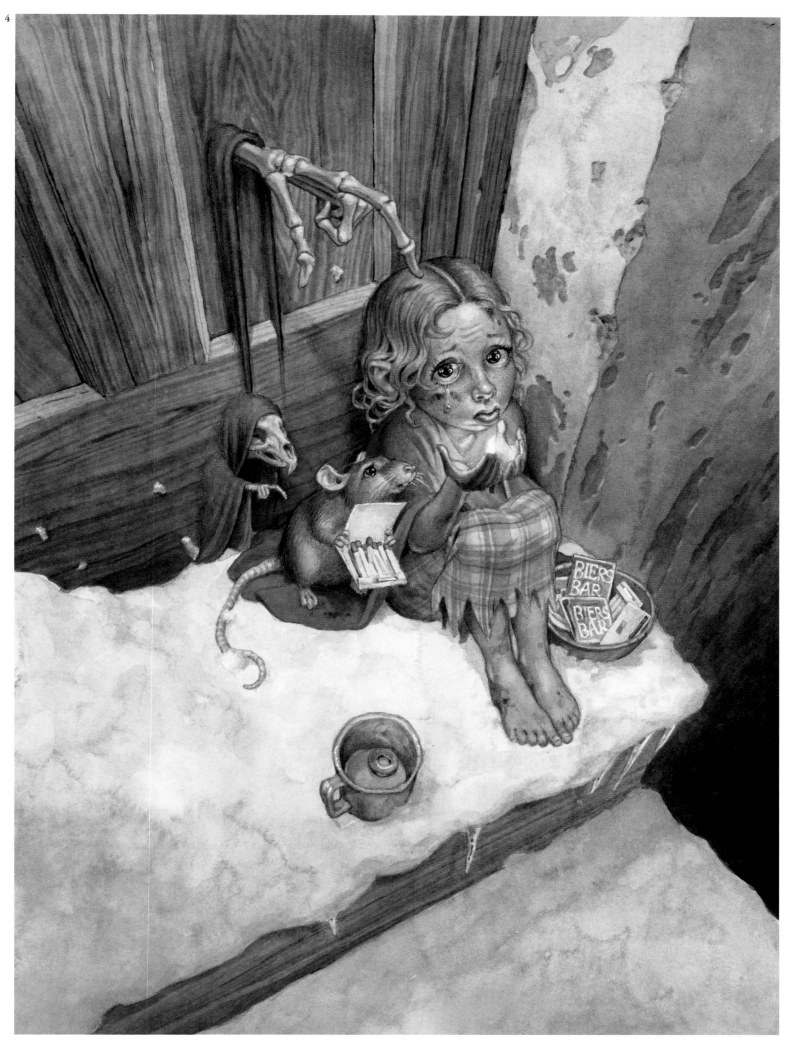

INSTITUTIONAL

1
artist: **Scott Bakal**
title: Halo: On Target
medium: Digital/Painter 9
size: 8"x8"

2
artist: **Scott Bakal**
title: Halo: Prostitute
medium: Digital/Painter 9
size: 8"x8"

3
artist: **Dan L. Henderson**
title: Rapture of the Deep
medium: Charcoal/digital
size: 20"x26"

4
artist: **Jonathan Wayshak**
art director: Wedge Antilles
client: Scrapbook M
title: The Girl Who Loved Powerglide
medium: Crayon

5
artist: **Serg S**
client: Deadlinestudios.com
title: Gas Mask
medium: Digital
size: 7"x10"

6
artist: **Leah Palmer Preiss**
title: Hot Guitarist Illustrated
medium: Mixed
size: 5"x7"

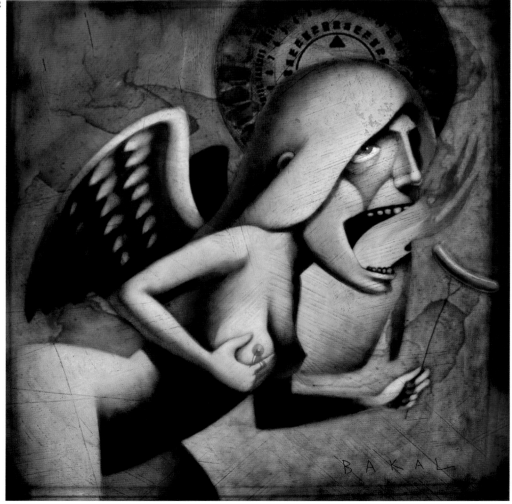

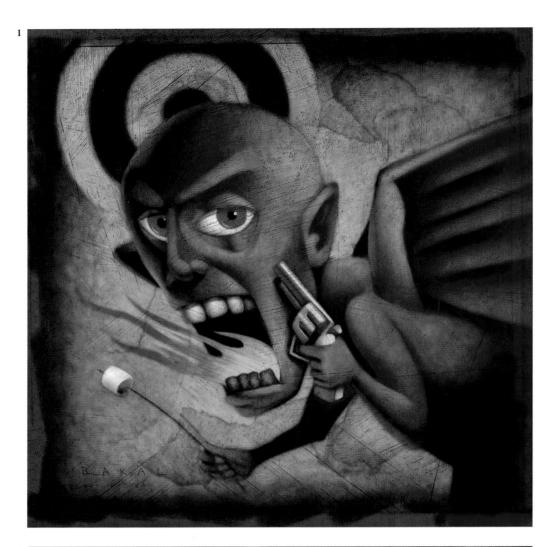

3

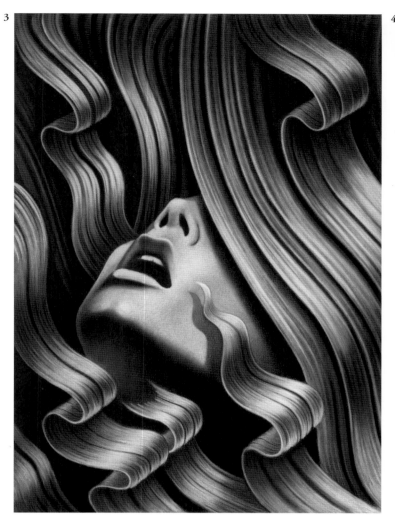

4

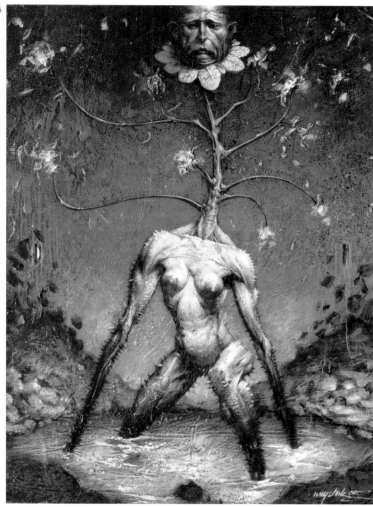

5

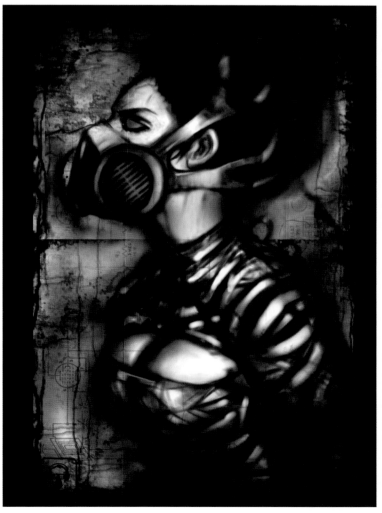

6

1
artist: **Scott M Fischer**
art director: Jeremy Cranford
client: Wizards of the Coast
title: Serra Avenger
medium: Mixed on canvas
size: 22"x28"

2
artist: **Scott M Fischer**
art director: Jeremy Cranford
client: Wizards of the Coast
title: Snap
medium: Mixed on canvas
size: 22"x36"

3
artist: **Scott M Fischer**
art director: Jeremy Cranford
client: Wizards of the Coast
title: Savra
medium: Mixed on paper
size: 17"x24"

4
artist: **Scott M Fischer**
art director: Jeremy Cranford
client: Wizards of the Coast
title: Telling Time
medium: Mixed on paper
size: 15"x24"

1
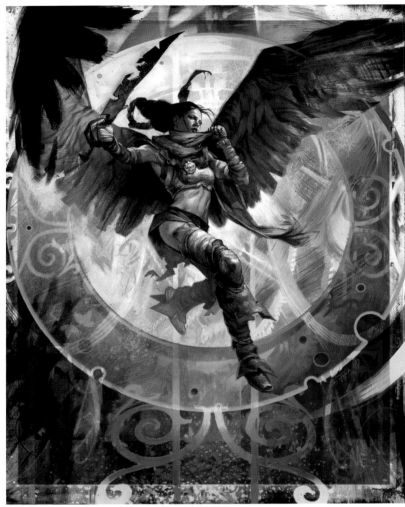

2
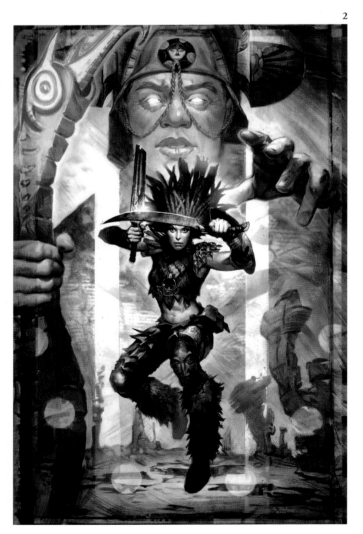

3
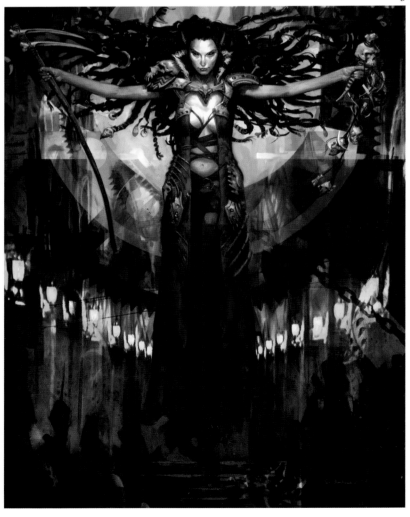

4

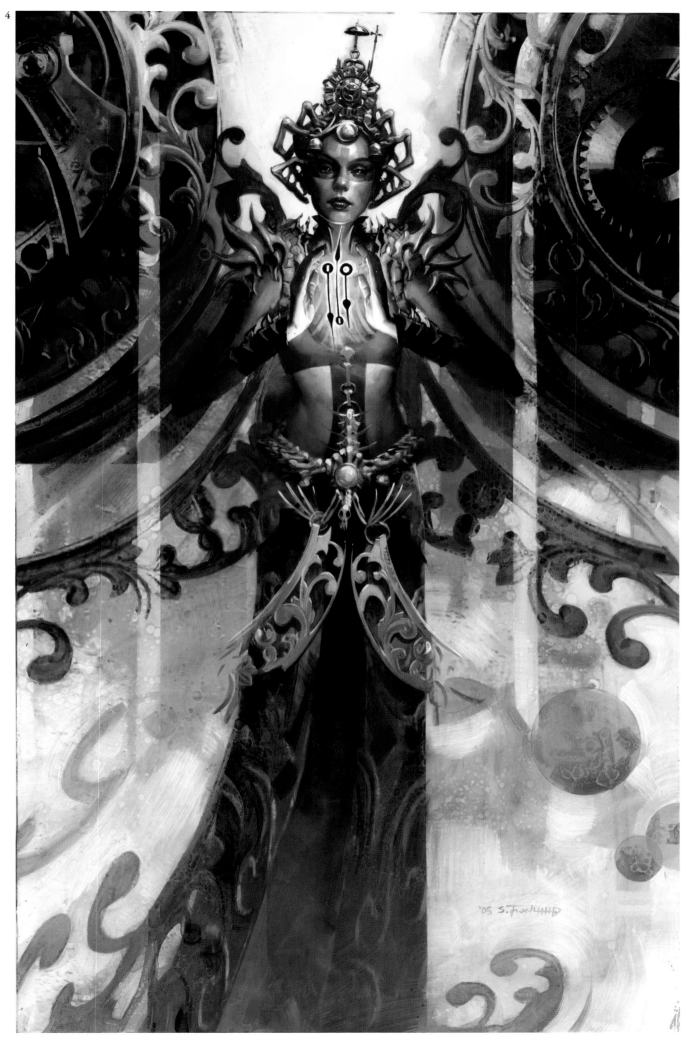

'05 S. Fischer

INSTITUTIONAL

1
artist: **Anthony S. Waters**
art director: Jeremy Cranford
client: Wizards of the Coast
title: Ravnica Underground
medium: Digital
size: 14"x6¹/₂"

2
artist: **Cyril VanderHaegen**
art director: Jeremy Cranford
client: Wizards of the Coast
title: Ciro, Dimir Lobotomist
medium: Digital

3
artist: **Dok Whitson**
art director: Joe Shoopack
client: Sony Online Entertainment
title: Lore Cahpter Six Mural
medium: Pencil/digital
size: 9"x5"

4
artist: **Melvyn Grant**
client: Curious-Hen Gallery
title: The Path of the Beast
medium: Oil/digital
size: 30"x20"

5
artist: **Michael Komarck**
art director: Christian T. Petersen
client: Fantasy Flight Games
title: Lord of the Rings: The
Confrontation
medium: Digital

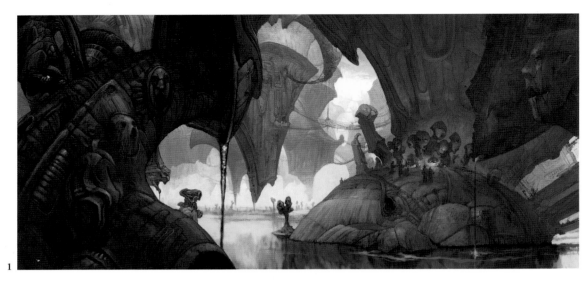

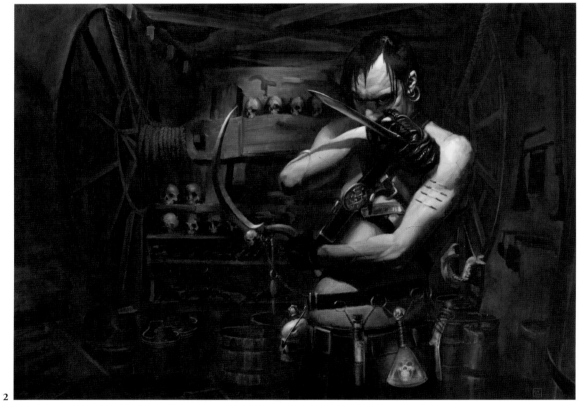

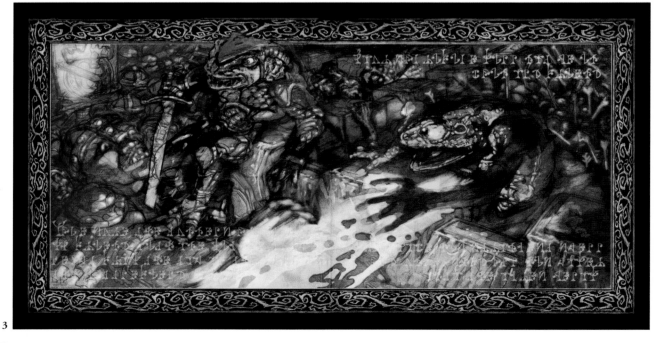

4

5

1
artist: **Anthony S. Waters**
art director: Jesper Myrfoas
client: Hidden City Games
title: Shuffling Zombie
medium: Digital
size: 8"x8"

2
artist: **Francis Tsai**
art director: Farzad Varahramyan
client: High Moon Studios
title: Sunlight
medium: Digital
size: 10_2"x$5^1/_2$"

3
artist: **Vance Kovacs**
art director: Jay Beard
client: Bottle Rocket
title: The Fallen Ones
medium: Digital

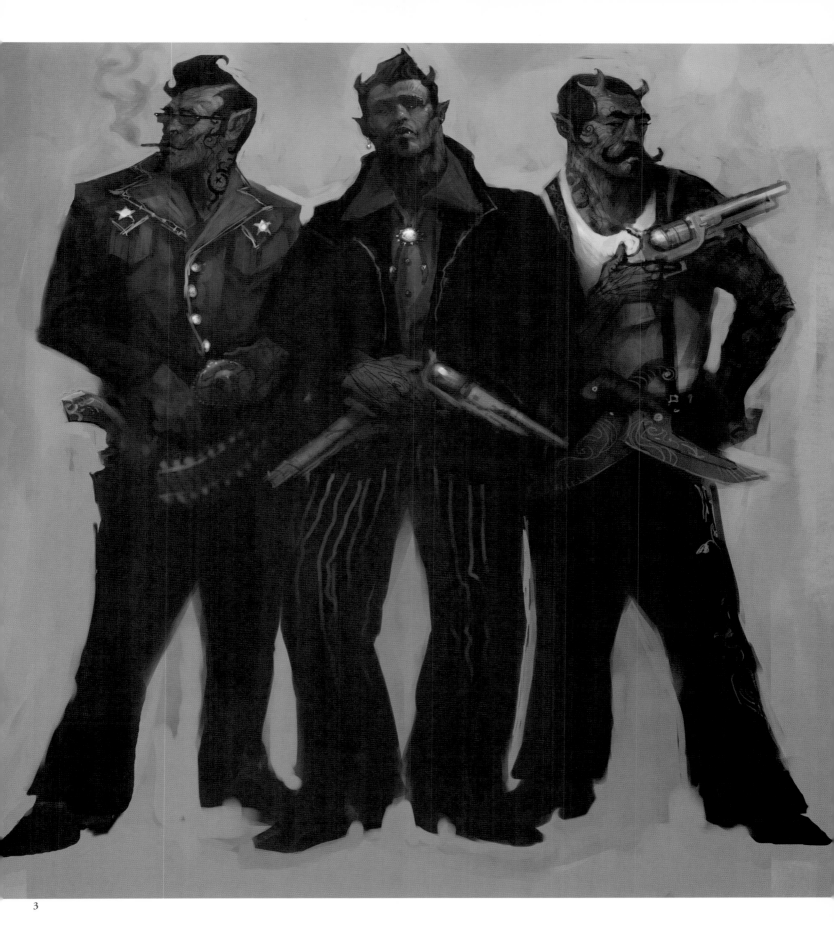

3

INSTITUTIONAL

1
artist: **Ted Terranova**
client: www.terranovaart.com
title: The War Machine
medium: Digital
size: 11"x17"

2
artist: **Douglas Klauba**
client: Pulp Planet Publishing
title: To Be Continued...
medium: Acrylic
size: 39¹/2"x18"

3
artist: **Raymond Swanland**
art director: Matt Hexemer
client: Apparatus, Inc./Sims
 Snowboards
title: Wrecking Ball
medium: Digital

4
artist: **Matt Dixon**
title: The Machine
medium: Digital
size: 11"x17"

5
artist: **Vance Kovacs**
art director: Jay Beard
client: Bottle Rocket Entertainment
title: Cap
medium: Digital

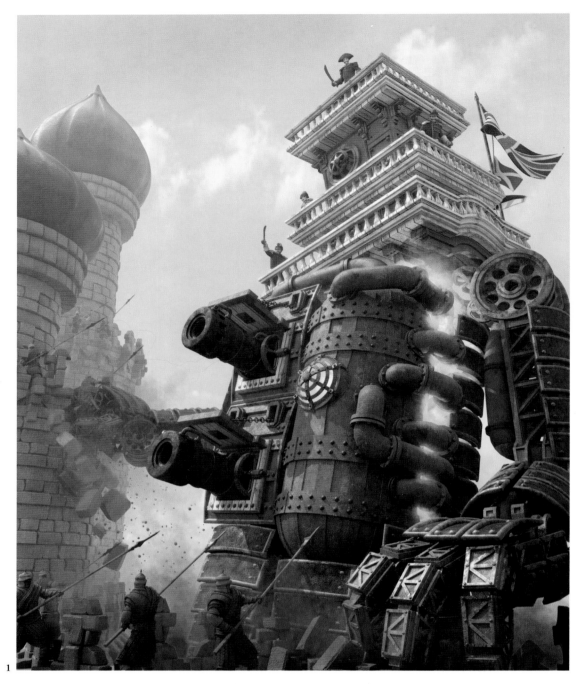

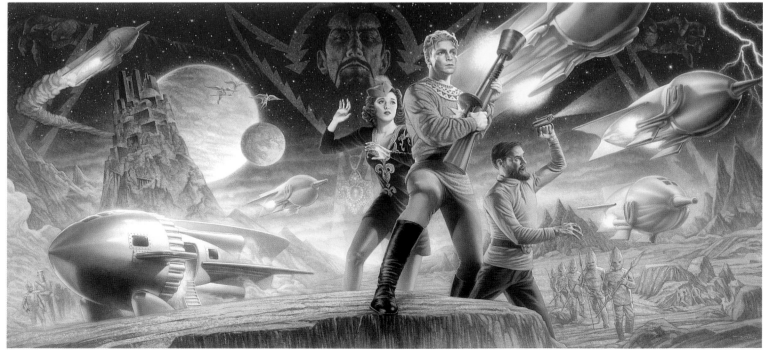

3

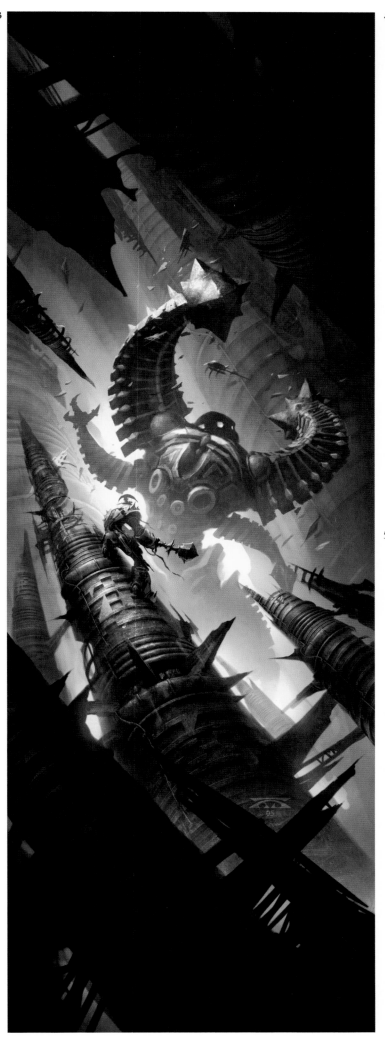

4

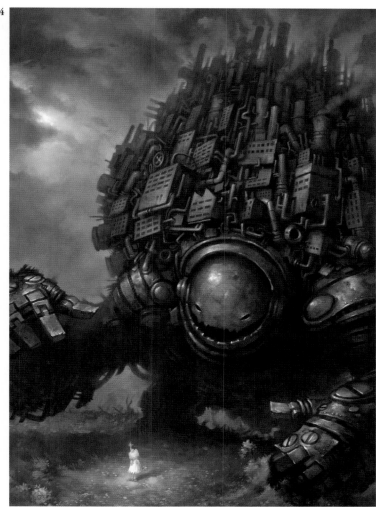

5

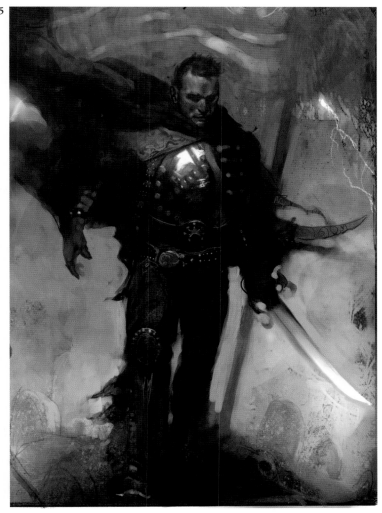

INSTITUTIONAL

1
artist: **Montgomery S. Kane**
title: In the Water Caves
medium: Oil
size: 36"x24"

2
artist: **John Dickenson**
art director: Jay Beard
client: Bottle Rocket Entertainment
title: Rise of the Kasai
medium: Digital
size: 11"x4"

3
artist: **Matt Stewart**
art director: Angi Sullins
client: Duirwaigh Publishing, Inc.
title: Horn of Boromir
medium: Oil
size: 48"x30"

4
artist: **Greg Staples**
art director: Justin Walsh
client: Triking
title: The Death of Chu Chulainn
medium: Digital
size: 25"x19"

5
artist: **Greg Staples**
art director: Jeremy Cranford
client: Wizards of the Coast
title: Hell's Caretaker
medium: Oil on canvas
size: 20"x16"

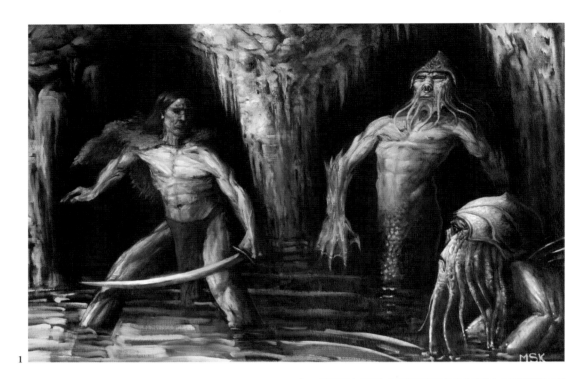

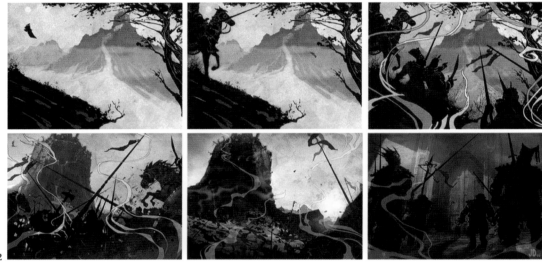

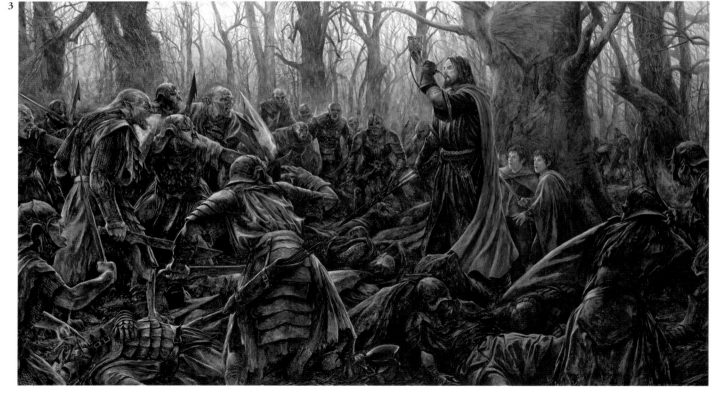

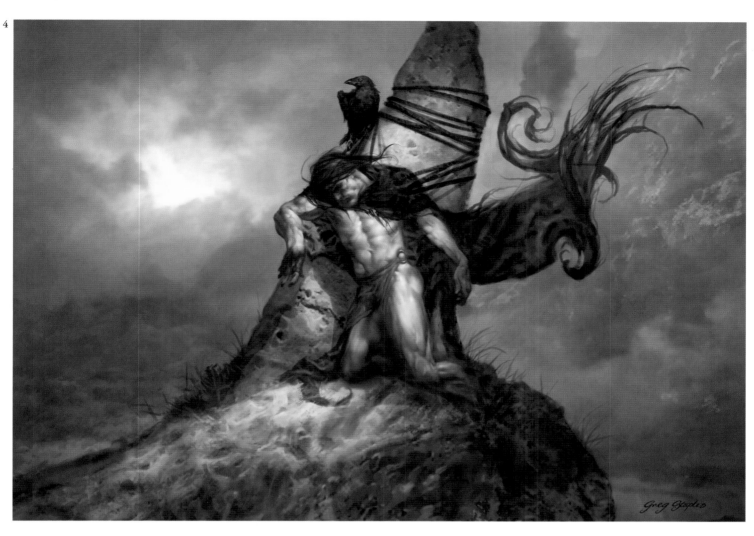

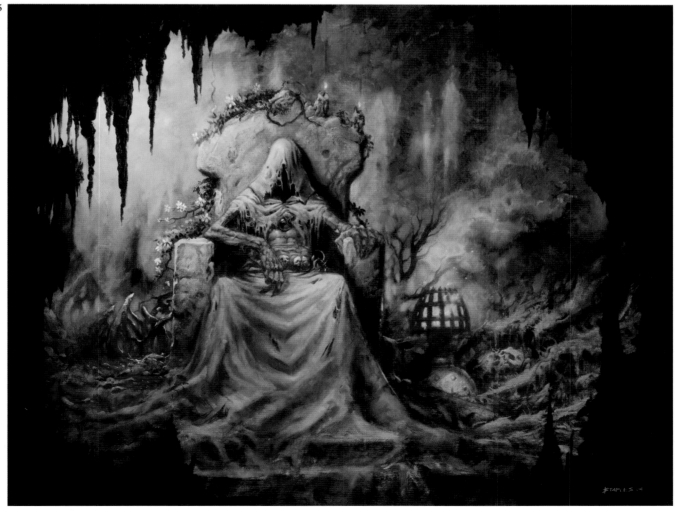

1
artist: **Ken Dewar**
client: Artistsoftheworld.com
title: Star Gazer
size: 29"x28"

2
artist: **Rob Alexander**
art director: Jeremy Cranford
client: Wizards of the Coast
title: The World Beneath
medium: Mixed *size:* 18"x12"

3
artist: **Jim Burns**
art director: Colin Harris
client: WorldCon: Glasgow 2005
title: Interaction Poster
medium: Acrylic *size:* 36"x18"

4
artist: **Stephan Martiniere**
art director: P.J. Haarsma
client: The Softwire's Rings of Orbis
title: Madam Lee
medium: Digital *size:* 8"x10"

5
artist: **Michael Kwong**
client: Locomotive Productions, Ltd.
title: Shanghai, 1972
medium: Acrylic *size:* 11"x18"

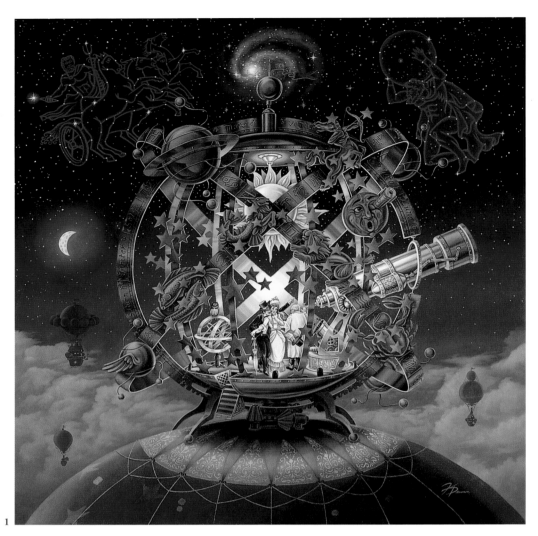

1

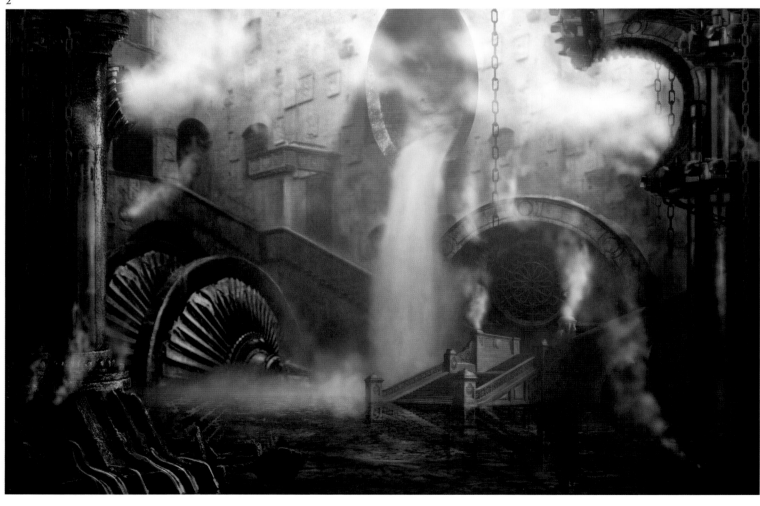

2

3

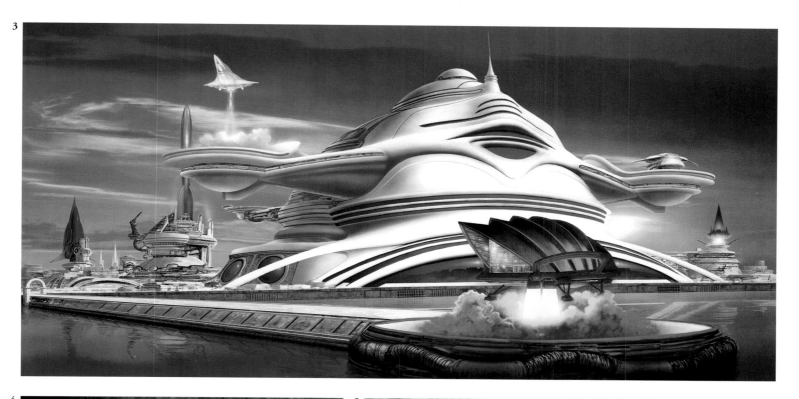

4

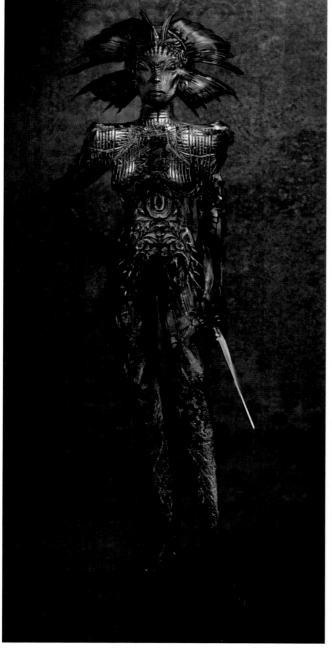

5

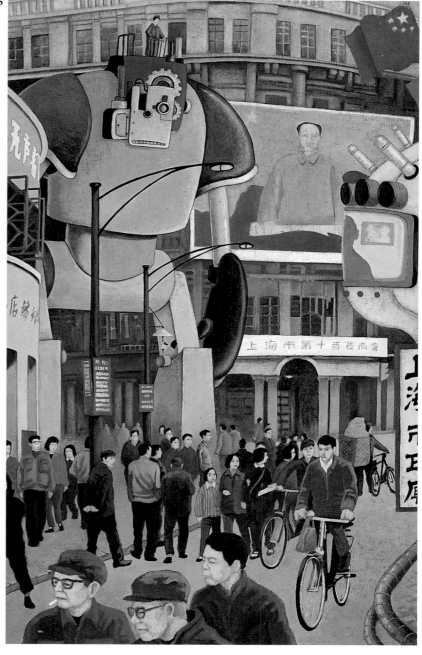

INSTITUTIONAL

1
artist: **Eric Bowman**
title: Boxcar Blues
medium: Oil
size: 14"x14"

2
artist: **Lee Moyer**
art director: Andrew Mighore
designer: Lee Moyer
client: H.P. Lovecraft Film Festival
title: Lovecraft: 2005
medium: Ink/digital
size: 11"x17"

3
artist: **Mark Covell**
title: Incantation
medium: Digital

4
artist: **Joe Ciardiello**
title: Poe
medium: Pen & ink
size: 9¹/₄"x13¹/₄"

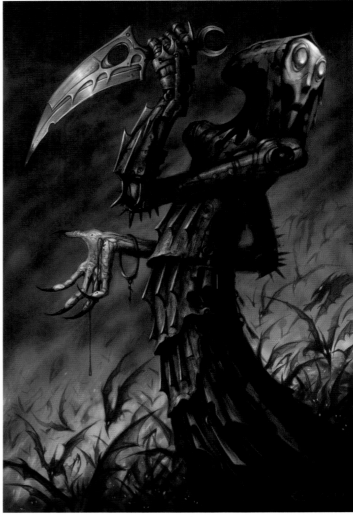

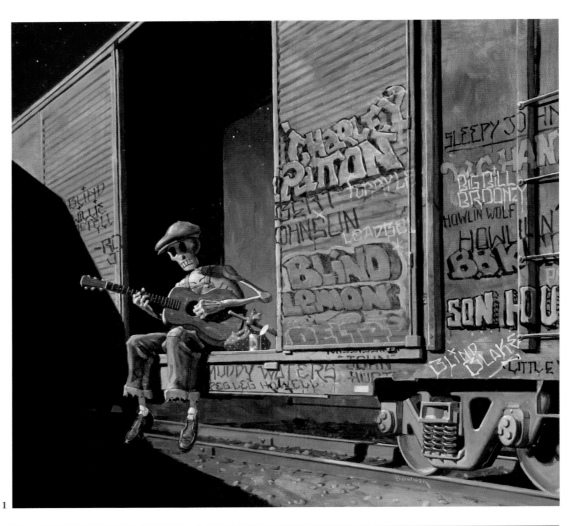

Nevermore

Edgar Allan Poe

4

INSTITUTIONAL

1
artist: **Don Maitz**
art director: Corry Cote
designer: Dan Veale
client: Tide-Mark Press
title: Mining the Stores
medium: Oil on masonite
size: 17"x21 1/2"

2
artist: **Chris Beatrice**
title: The Girl in the
 Iron Shoes
medium: Digital
size: 7 1/2"x10"

3
artist: **Ian Daniels**
art director: Angi Sullins
client: Duirwaigh Publishing,
 Inc.
title: Prophet
medium: Acrylic
size: 18"x24"

4
artist: **Andrew S. Arconti**
title: Halloween Mourning
 Portrait #1
medium: Digital
size: 11"x19"

5
artist: **Ed Org**
client: Ed Org Fine Prints
title: The Horns of Elfland
medium: Pencil
size: 8"x13"

6
artist: **Gregory Manchess**
art director: Chris Rovillo
client: Rovillo & Reitmayer
title: Unwrap the Joy!
medium: Oil
size: 36"x20"

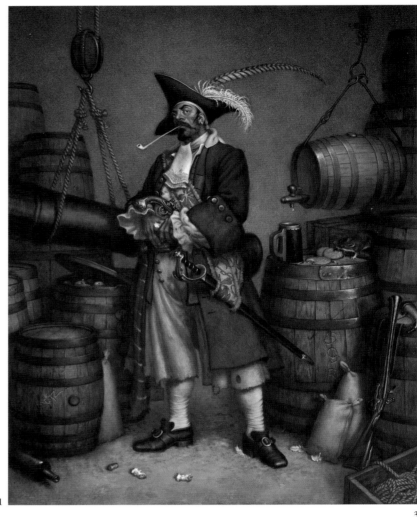

1

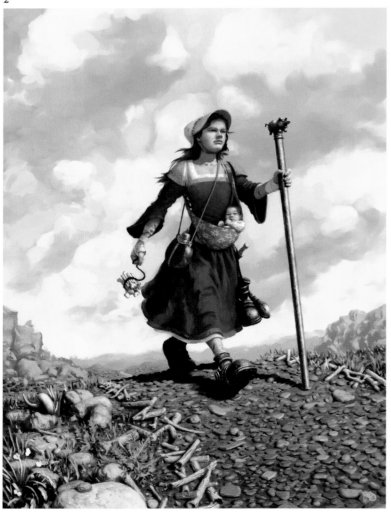

2

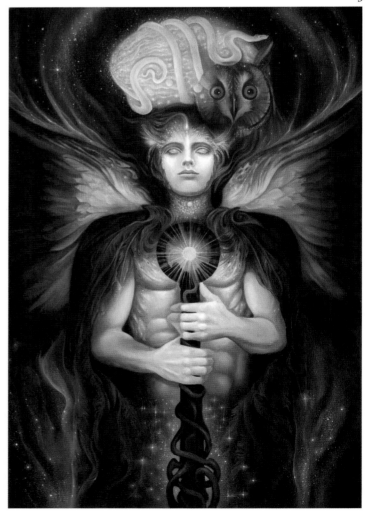

3

4

5

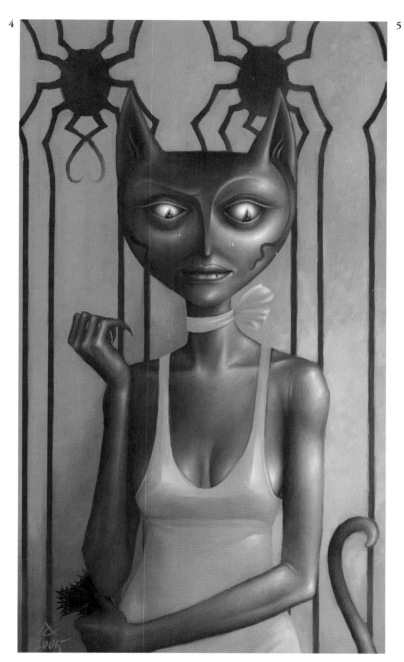

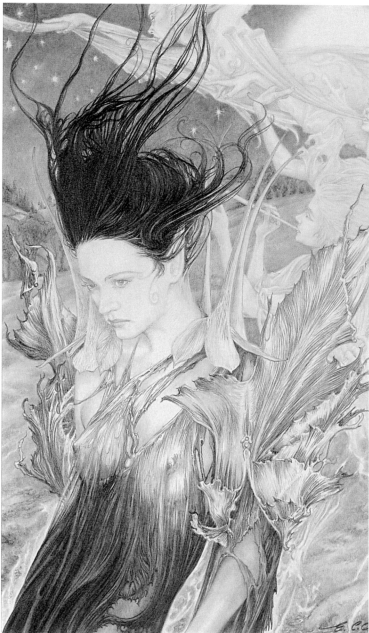

6

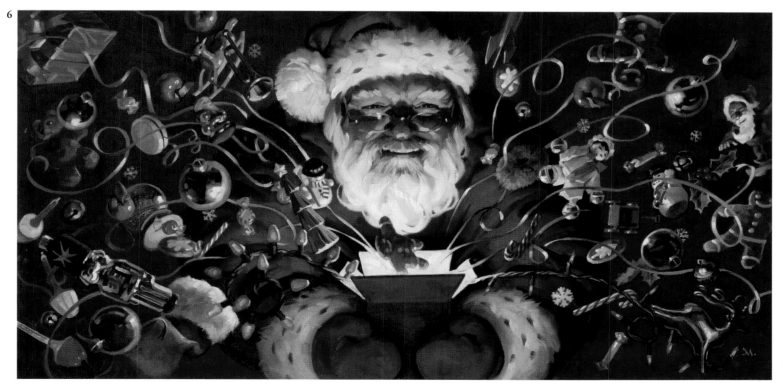

1
artist: **Ian Miller**
art director: Jesper Myrfors
client: Clout Fantasy™ Collectable
 Throwing Game
title: Mech Raven
medium: Mixed
size: 8"x8"

2
artist: **Steven Belledin**
art director: Jesper Myrfors
client: Hidden City Games
title: Fury of Nature
medium: Oil
size: 6"x6"

3
artist: **Victoria Francés**
client: Norma Editorial
title: Favole
medium: Color pencil/ink
size: 14"x20"

4
artist: **Andrew S. Arconti**
title: Locus Desperatus
medium: Digital
size: 6"x9¹/₂"

5
artist: **Joshua Hagler**
art director: Dawn Murin
client: Wizards of the Coast
title: Callow Believer
medium: Mixed/digital
size: 11"x6¹/₂"

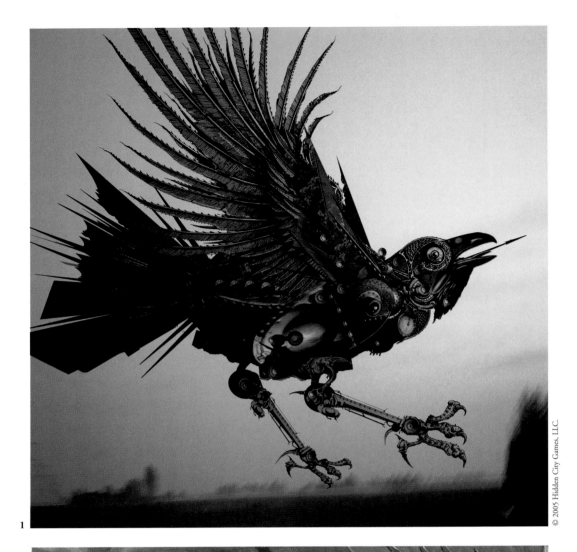

1

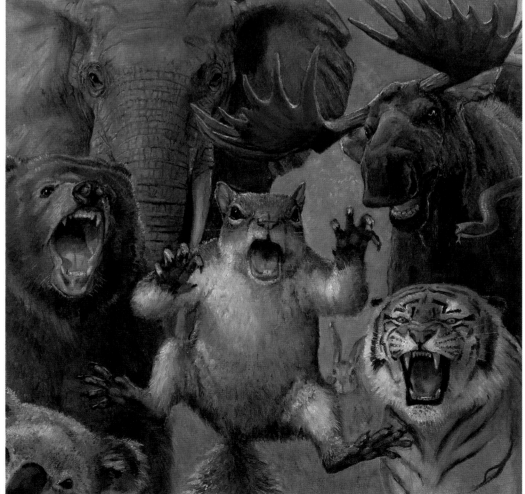

2

3

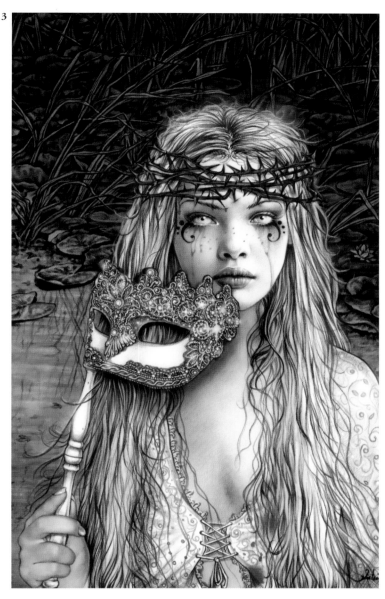

4

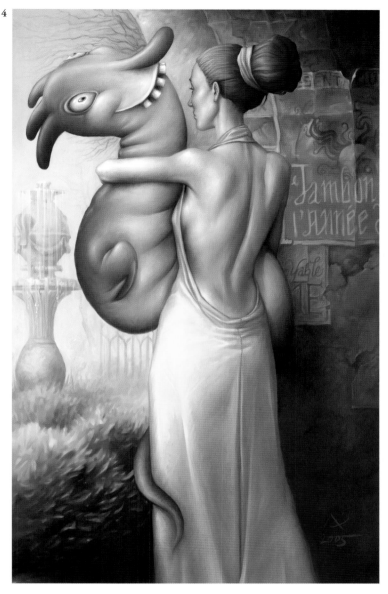

5

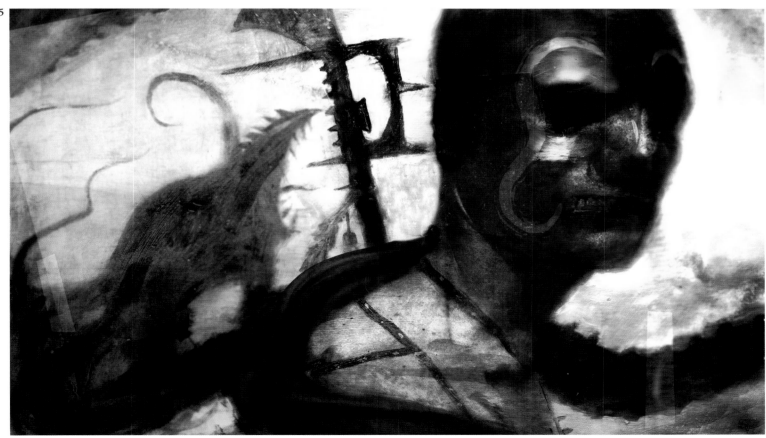

INSTITUTIONAL

1
artist: **Rebecca Guay**
art director: Terese Nielsen
client: Angel Quest
title: Angel of Dreams
medium: Oil/gouache
size: 15"x22"

2
artist: **Dave McKean**
client: Warner Bros.: Lestat
title: Lestat Playbill Cover
medium: Mixed
size: 9"x12"

3
artist: **Daniele Scerra**
client: Synthe
title: Rianimatrice
medium: Digital
size: 8"x12"

4
artist: **Paul Bonner**
art director: Jean Bey
client: Rackham
title: Cadwallon
medium: Watercolor
size: 23$\frac{1}{2}$"x15$\frac{3}{4}$"

5
artist: **Paul Bonner**
art director: Jean Bey
client: Rackham
title: Daï–Bakemonos
medium: Watercolor
size: 21$\frac{1}{4}$"x15$\frac{1}{8}$"

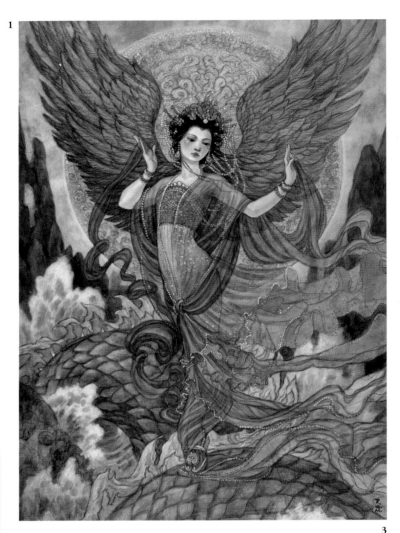

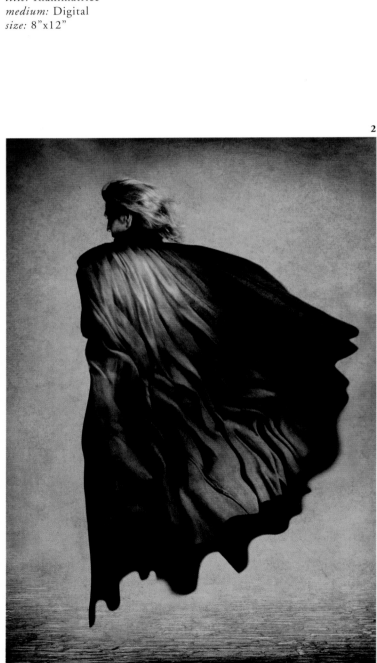

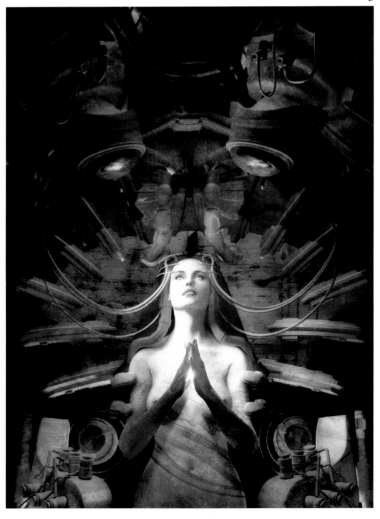

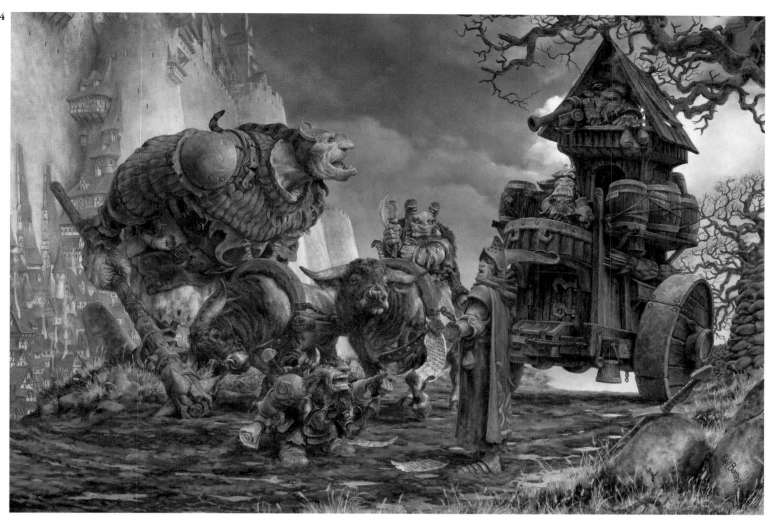

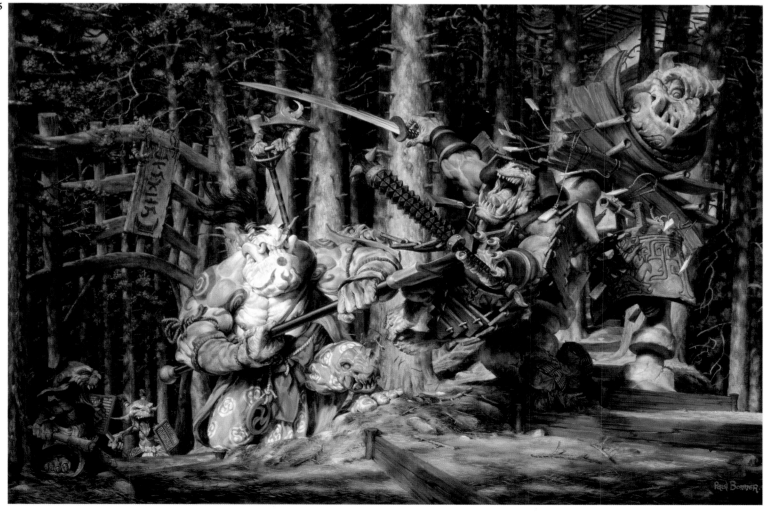

INSTITUTIONAL

1
artist: **Kharlamov Sergey**
title: Conscience

2
artist: **John Dickenson**
art director: Jay Beard
3D adaptation: Baz Pringle
client: Bottle Rocket Entertainment
title: Mesa Drive
medium: Digital *size:* 7"x10"

3
artist: **Andrew Bawidamann**
title: Tigermadchen
medium: Digital *size:* 18"x24"

4
artist: **Daren Bader**
art director: Dawn Murin
client: Wizards of the Coast
title: Goatboy
medium: Digital *size:* 8"x4"

5
artist: **Volkan Baga**
art director: Jeremy Cranford
client: Wizards of the Coast
title: Soul Suck
medium: Oil on paper *size:* 18"x25"

1

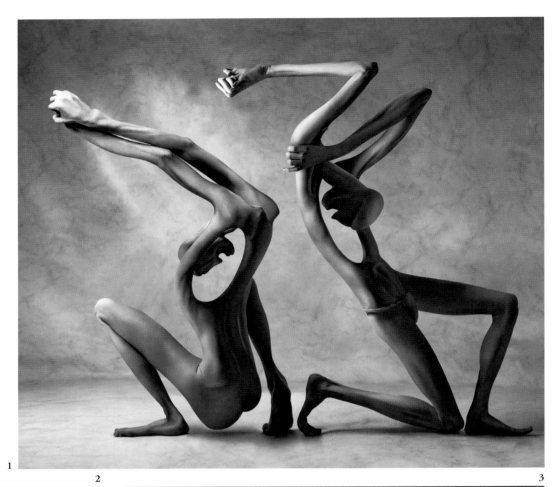

2

3

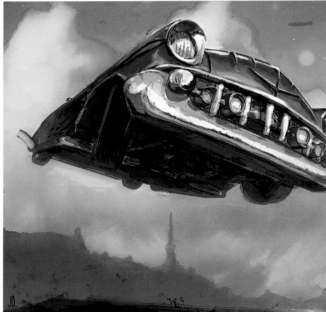

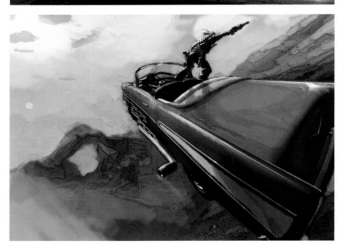

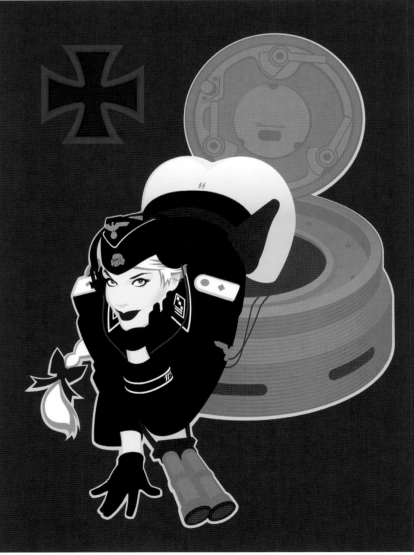

INSTITUTIONAL

1
artist: **Jerry LoFaro**
art director: Jeff Chandler
designer: Brian Fitzgerald
client: International Masters
 Publishing
title: Phoenix #2
medium: Digital
size: 9"x12"

2
artist: **Richard Laurent**
art director: Cheryl Jefferson
title: The Big Sweep
medium: Oil on canvas
size: 20"x16"

3
artist: **Nestor Taylor**
title: Bestiario
medium: Acrylic
size: 36"x27"

1

2

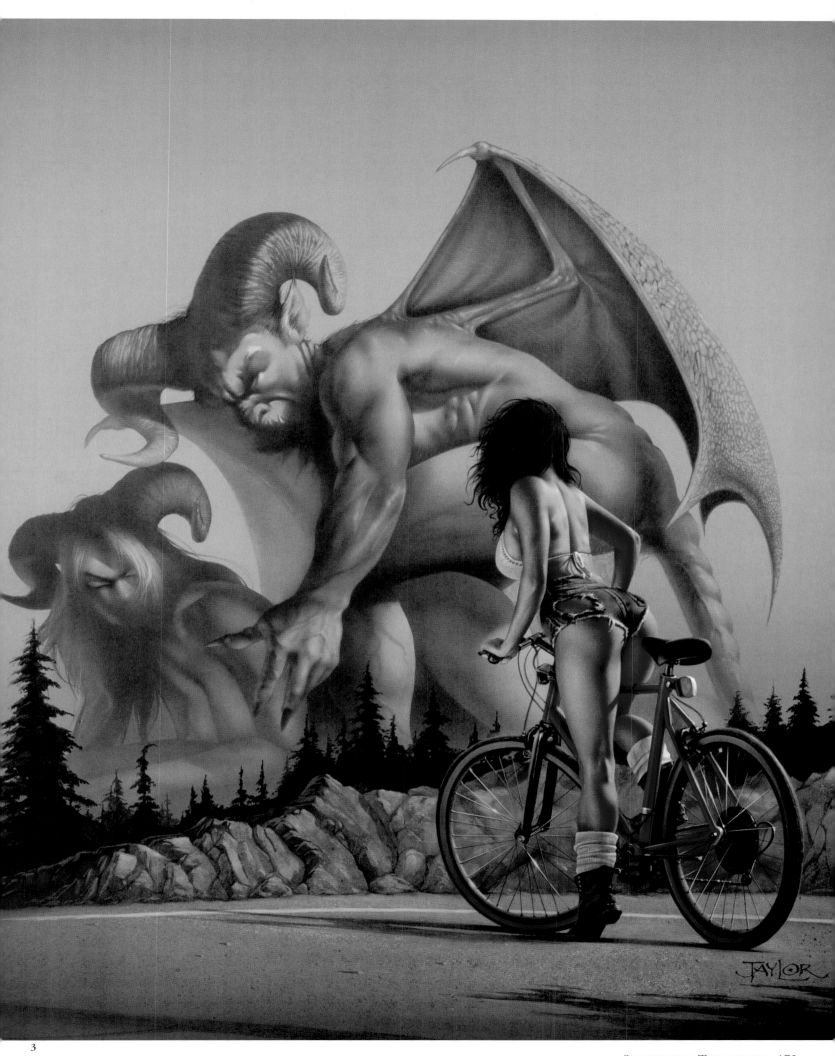

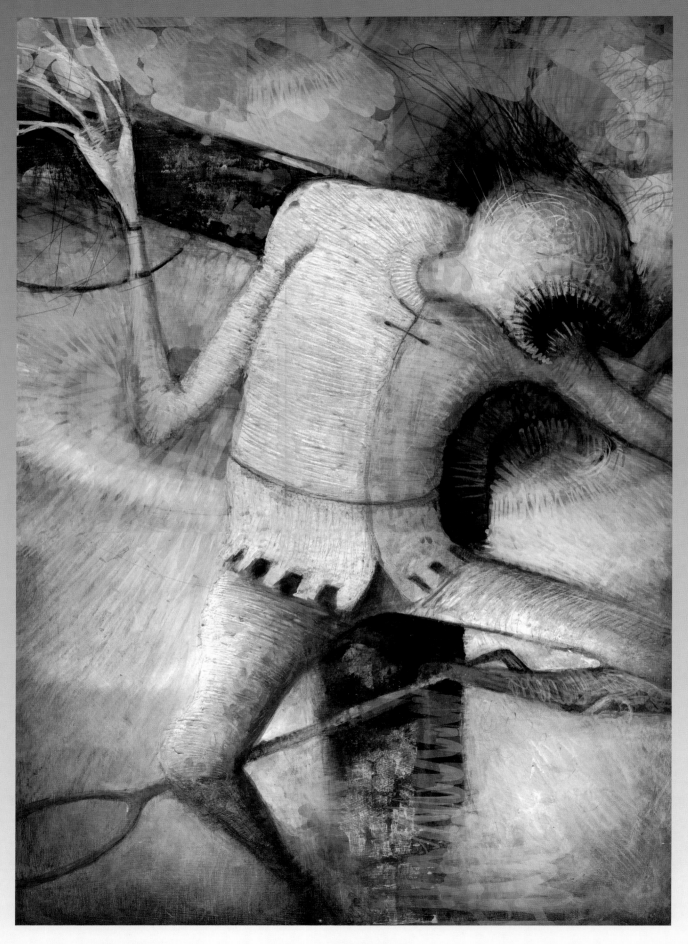

artist: **August Hall**

title: Burning Man *size:* 13"x17" *medium:* Mixed

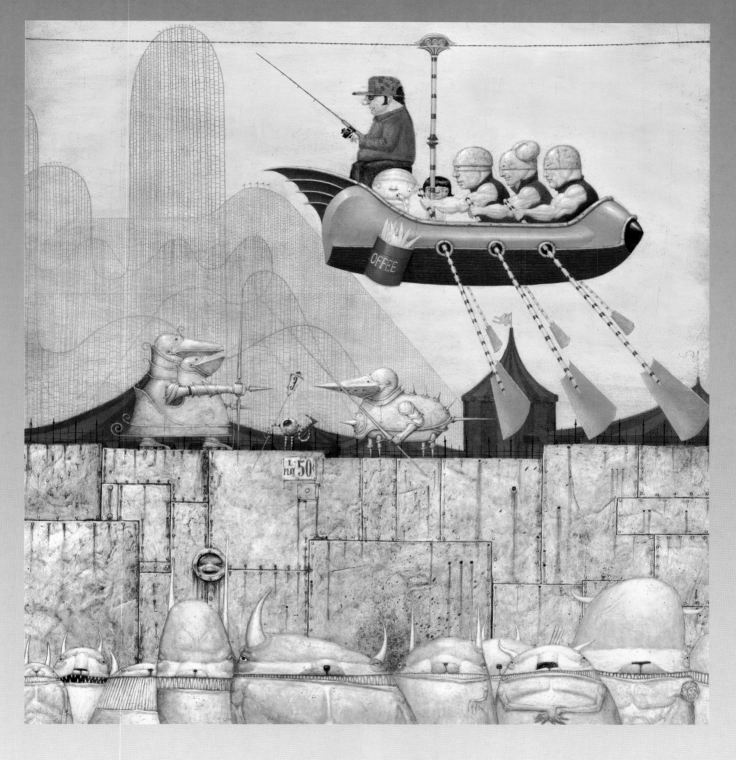

artist: **William Carman**

title: Carnivore Pond *size:* 22"x24" *medium:* Acrylic

1
artist: **Steven Kenny**
title: Constellation I
medium: Oil on linen
size: 24"x20"

2
artist: **Steven Kenny**
title: The Cooper's Wife
medium: Oil on linen
size: 26"x36"

3
artist: **Ørdeal**
title: Anny
medium: Photo/digital
size: 5"x7"

4
artist: **Steven Kenny**
title: The Wreath
medium: Oil on linen
size: 32"x48"

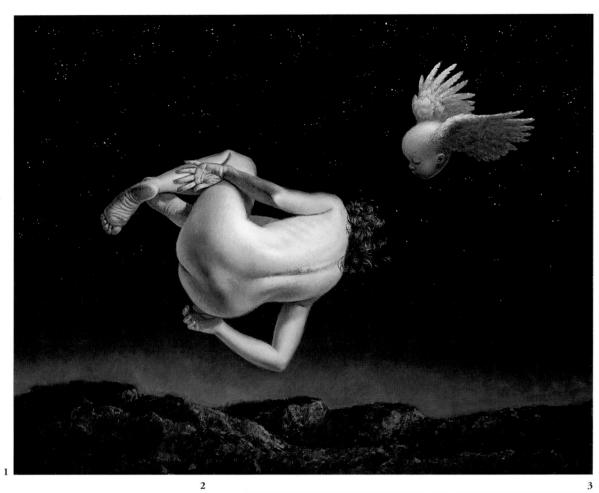

1

2

3

4

UNPUBLISHED

1
artist: **Caniglia**
title: Birth of Sunrise
medium: Oil on board
size: 16"x20"

2
artist: **Steven Stahlberg**
title: The Trapper
medium: Digital/2D

3
artist: **Michael Whelan**
art director: Robert Wiener
client: Donald M. Grant: Publisher
title: The Man in Black
medium: Oil on canvas
size: 40"x25"

4
artist: **Stephen Hickman**
client: Richard Lee
title: Sea of Vaynu
medium: Oil
size: 46"x30"

1

2

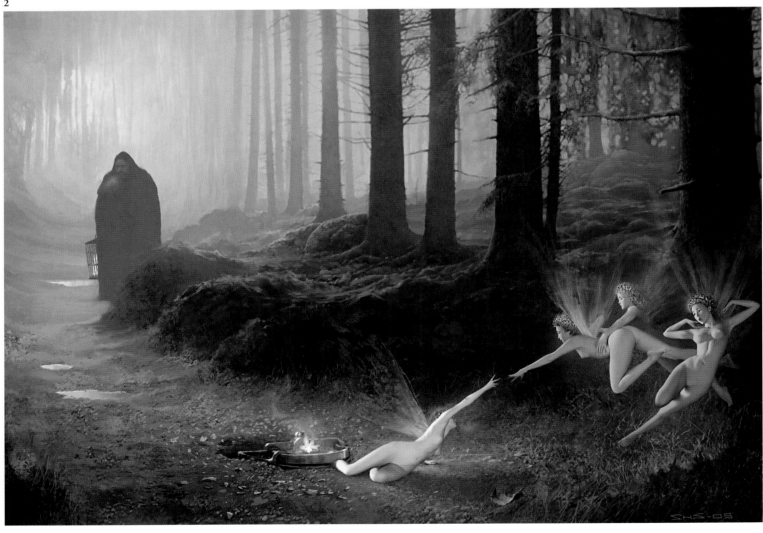

3

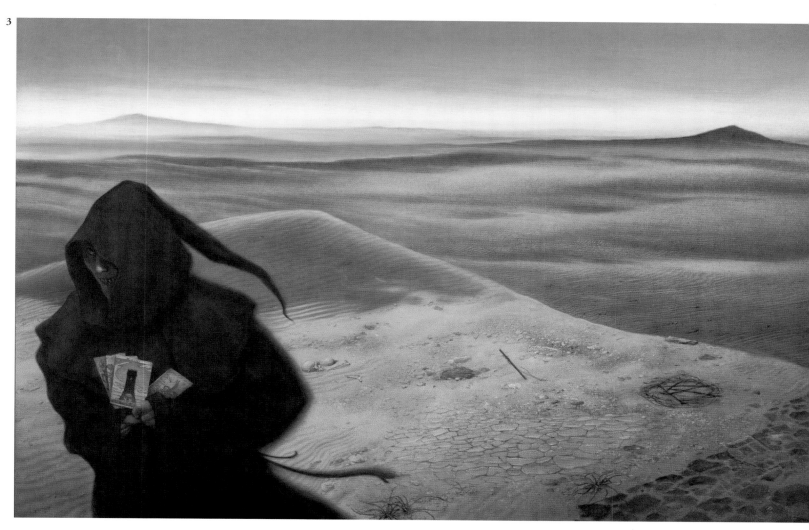

4

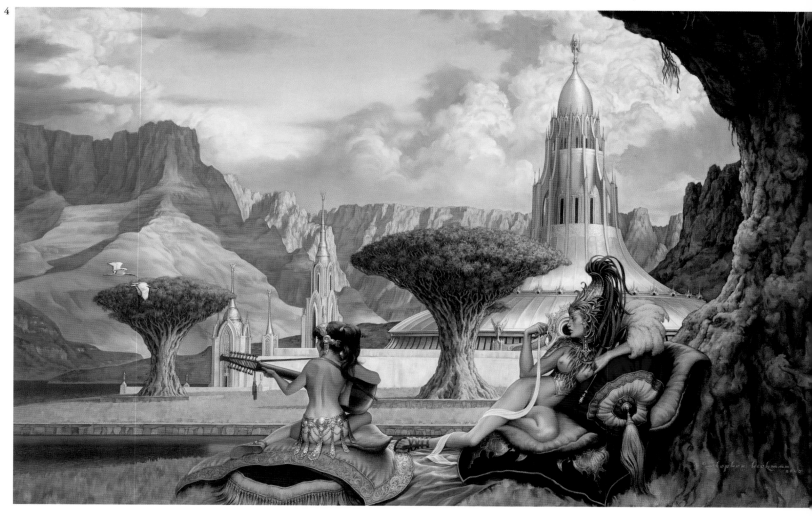

UNPUBLISHED

1
artist: **Scott Altmann**
title: Crawlers
medium: Oil on linen
size: 16"x20"

2
artist: **Robh Ruppel**
client: Bar Libres
title: Psycho Babylon
medium: digital

3
artist: **Tracy Mark Lee**
title: "I am trouble..."
medium: Ink/digital
size: 11"x17"

4
artist: **Steven Stahlberg**
title: Psycho Girlfriend
medium: Digital/3D

4

1
artist: **Dave Stevens**
title: Demon of Carpathia [in progress]
medium: Oil on canvas
size: 15"x30"

2
artist: **Caleb M. Prochnow**
art director: Joseph Thiel
client: Ringling School of Art & Design
title: The Destruction of a Man
medium: Mixed
size: 8³/8"x11¹/2"

3
artist: **Peter Forystek**
client: www.peterforystek.com
title: Trail of Judgement
medium: Oil
size: 9"x12"

4
artist: **K.D. Matheson**
title: Thoth
medium: Acrylic on paper
size: 48"x72"

5
artist: **John Mahoney**
title: Mechanical Darkness
medium: Digital
size: 8"x7¹/4"

1

2

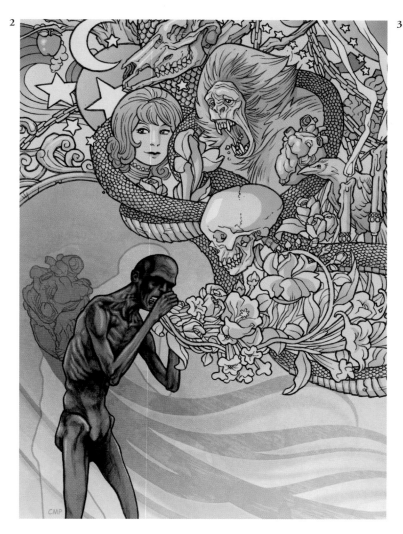

3

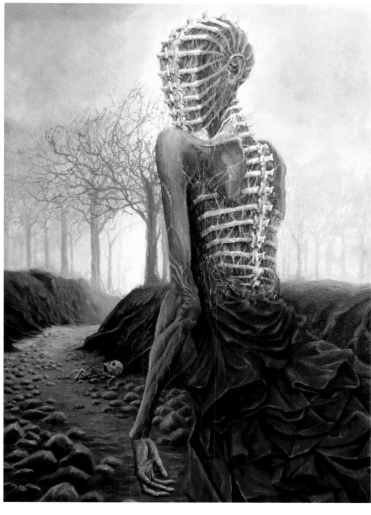

4

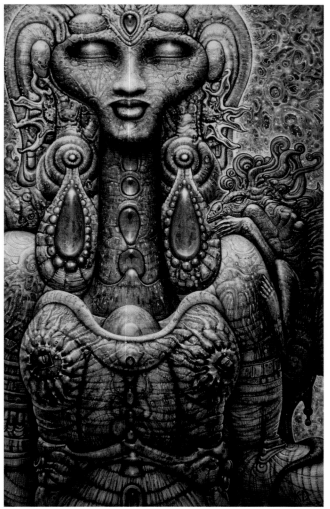

5

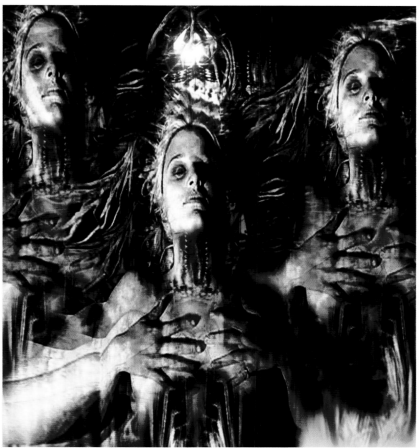

UNPUBLISHED

1
artist: **Ken Keirns**
title: Men Are From Mars,
 Women Are From Hell
medium: Oil on panel
size: 31"x35"

2
artist: **Joe Vaux**
title: Tribute
medium: Acrylic on wood
size: 32"x20"

3
artist: **Travis Louie**
title: Stan "The Whoozawhatsis"
medium: Acrylic on board
size: 5"x7"

4
artist: **Tomislav Torjanac**
title: Dorothy
medium: Oil/digital
size: 11$\frac{3}{4}$"x16$\frac{1}{2}$"

5
artist: **Oleg Zatler**
title: It's All In a Head
medium: Mixed/digital
size: 14"x20"

6
artist: **Bruce Holwerda**
title: Easy Rider
medium: Acrylic/digital
size: 18"x24"

1

2

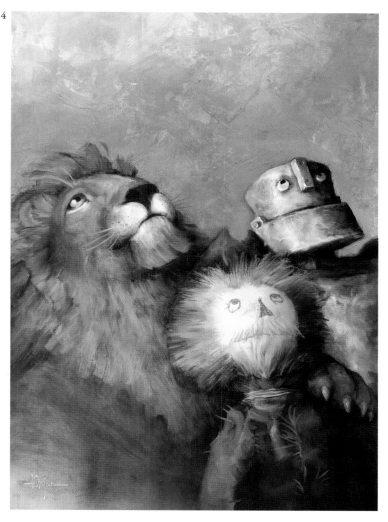

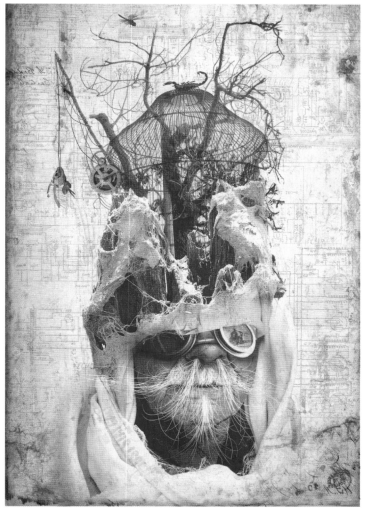

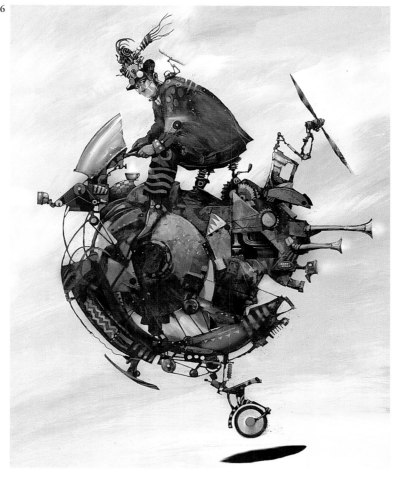

1
artist: **Ken Wong**
title: The Mock Turtle's Story
medium: Digital

2
artist: **Raúl Cruz**
client: Arte Ambiental
title: Mech Tamer
medium: Digital
size: 19$\frac{1}{2}$"x15$\frac{1}{2}$"

3
artist: **Philip Straub**
title: The Conjuring
medium: Digital
size: 18"x10"

4
artist: **Marc Gabbana**
title: Bio-Mek Breakfast
medium: Digital

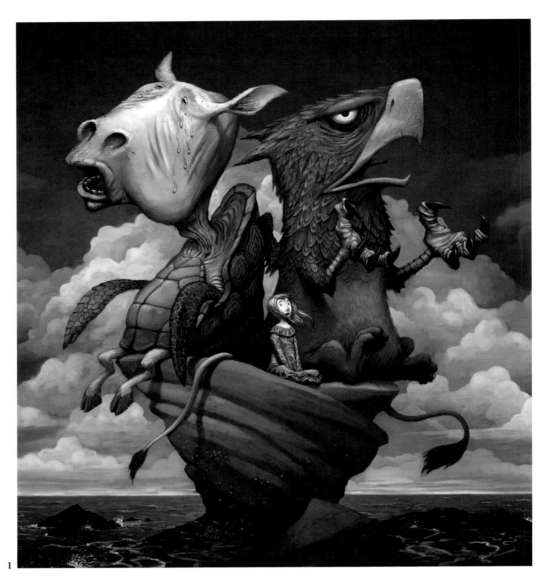

1

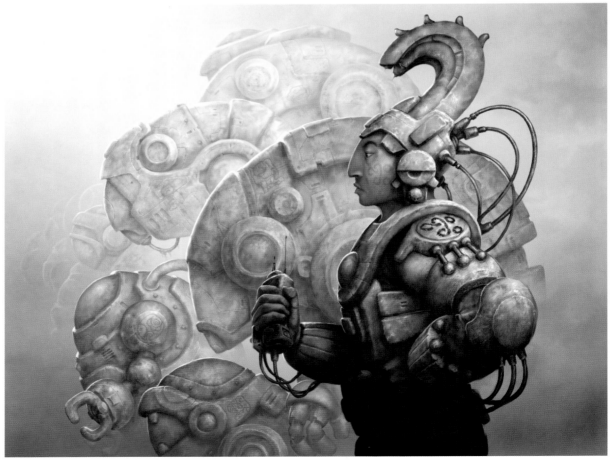

2

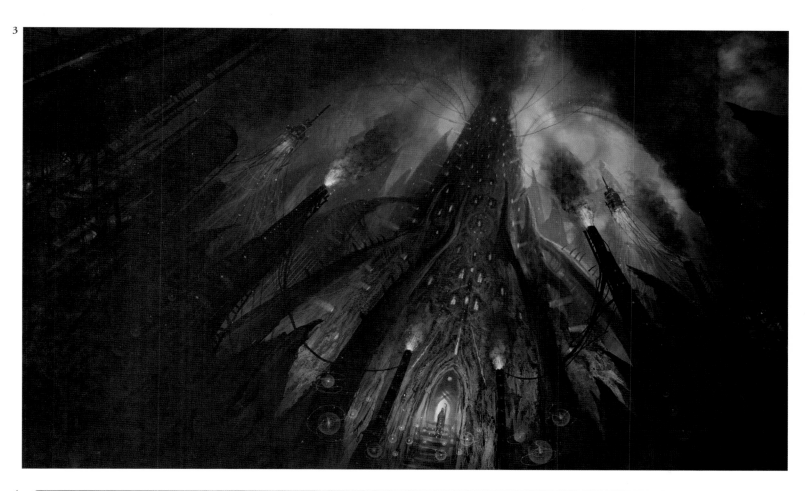

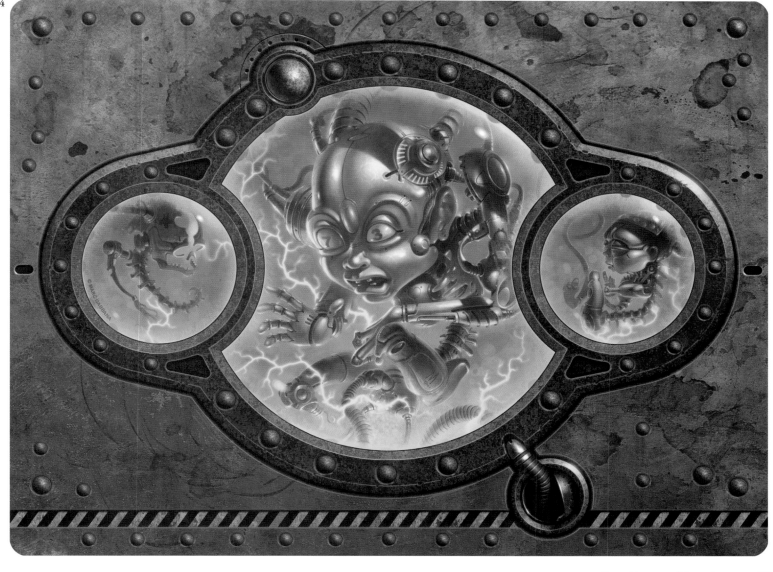

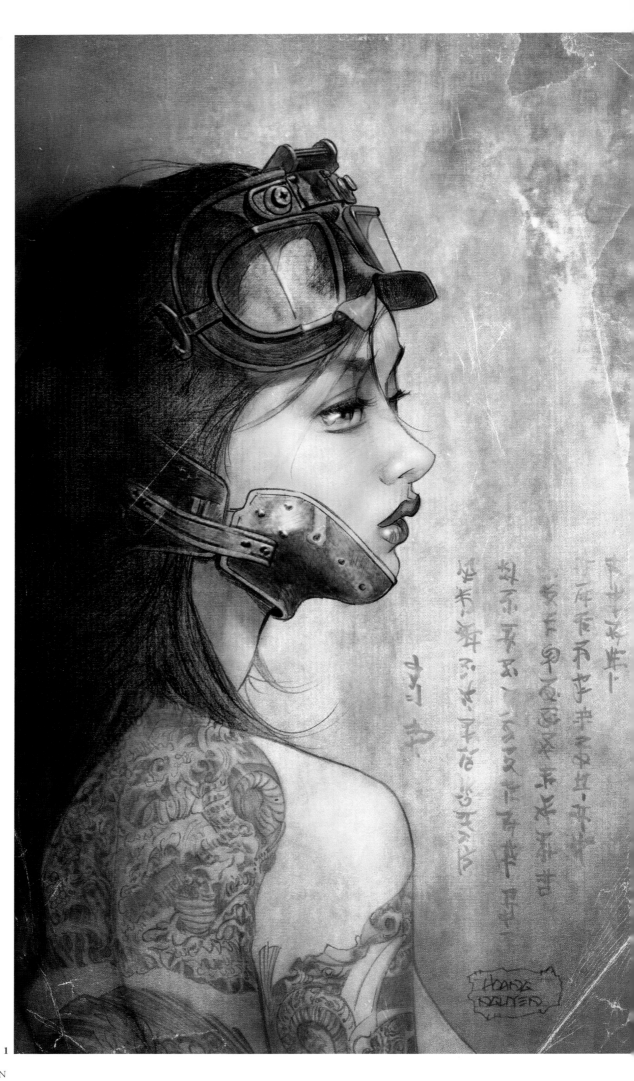

1

2

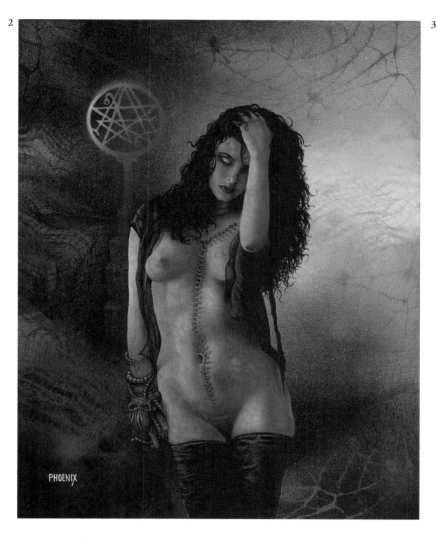

3

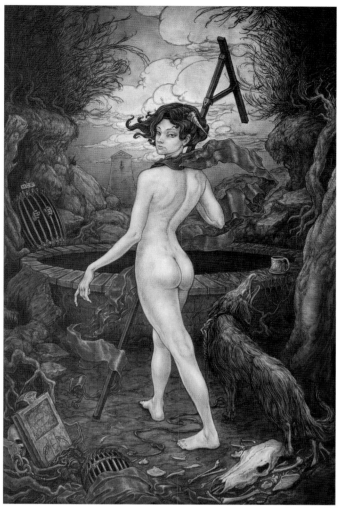

4

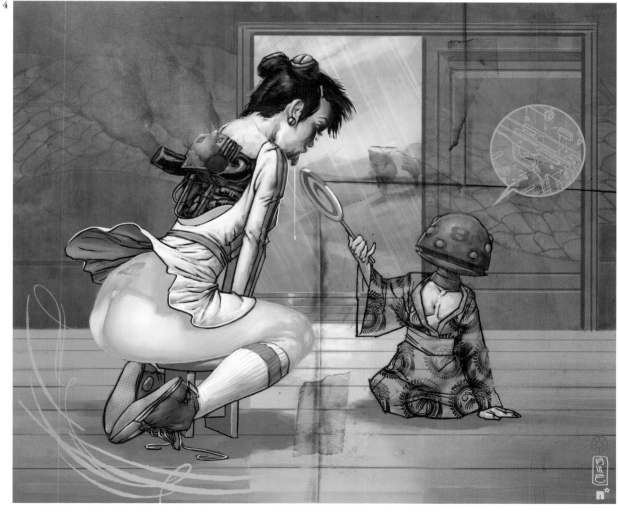

UNPUBLISHED

1
artist: **Christopher McInerney**
title: Death
medium: Digital
size: 8"x10"

2
artist: **Tony Weinstock**
title: Peril Anne: Forest of Spies
medium: Acrylic
size: 9¹/4"x14¹/8"

3
artist: **Pierre Droal**
title: Min, The Patriarch
medium: Digital
size: 9¹/4"x12³/8"

4
artist: **João P.A. Ruas**
title: Dracula, Jr.
medium: Pencil/digital
size: 8¹/4"x11¹/2"

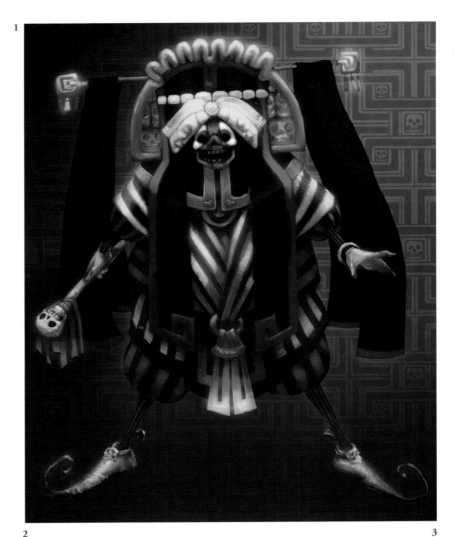

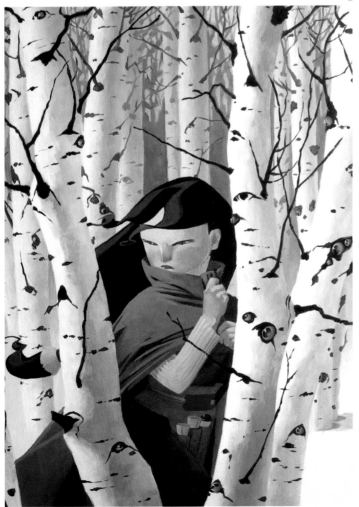

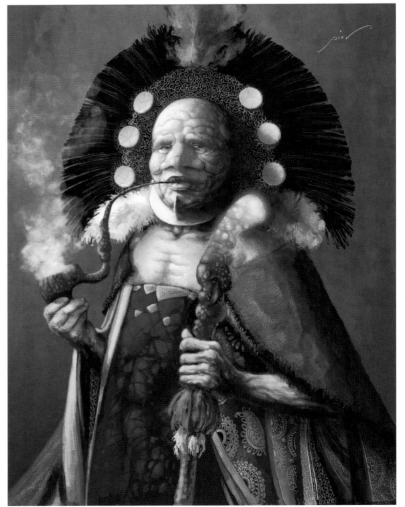

4

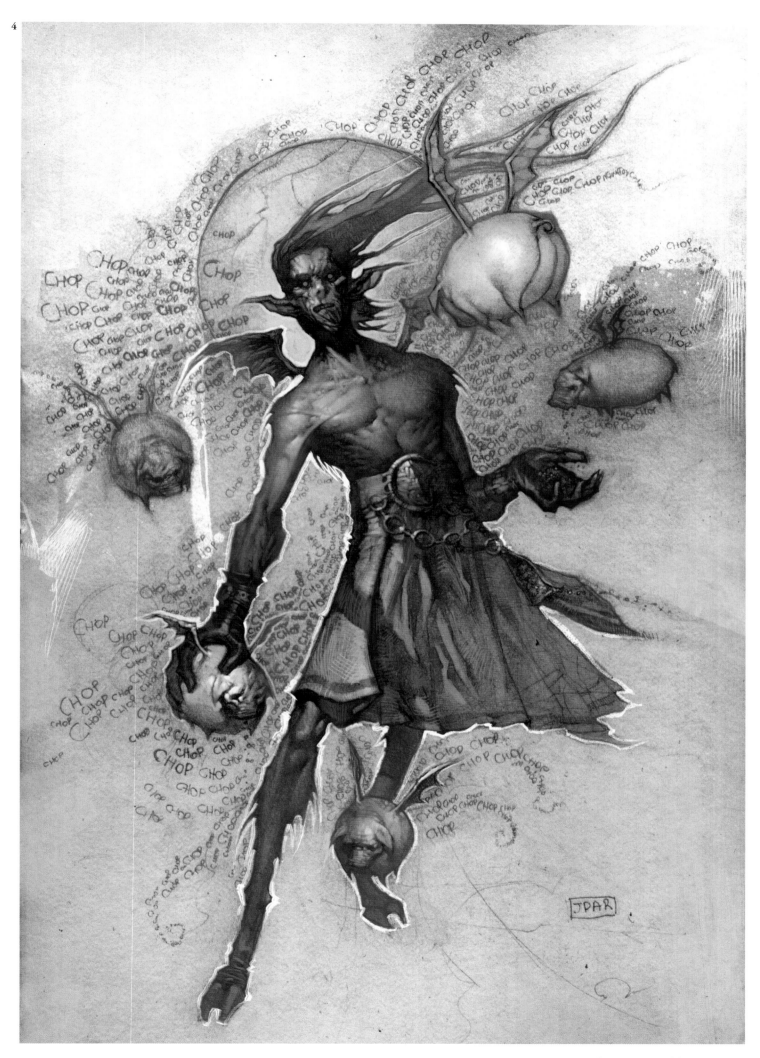

UNPUBLISHED

1
artist: **Coro**
client: Massive Black
title: Street Medium 1
medium: Digital/PhotoShop

2
artist: **Scott Altmann**
title: The Demon Prince
medium: Oil on board
size: 38"x28"

3
artist: **Burton**
title: Winter Boy
medium: Digital

4
artist: **E.M. Gist**
client: Watts Atelier
title: Iron Womb
medium: Oil on masonite
size: 24"x36"

5
artist: **Elio Guevara**
client: elioguevara.com
title: Ella-machine
medium: Oil/mixed
size: 18"x24"

6
artist: **Chet Zar**
title: Interloper 2
medium: Oil on canvas
size: 11"x14"

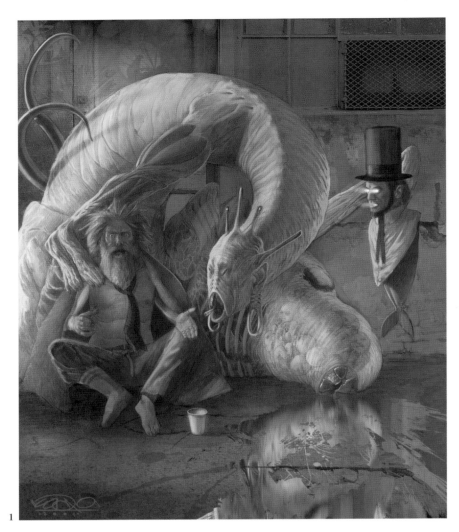

1

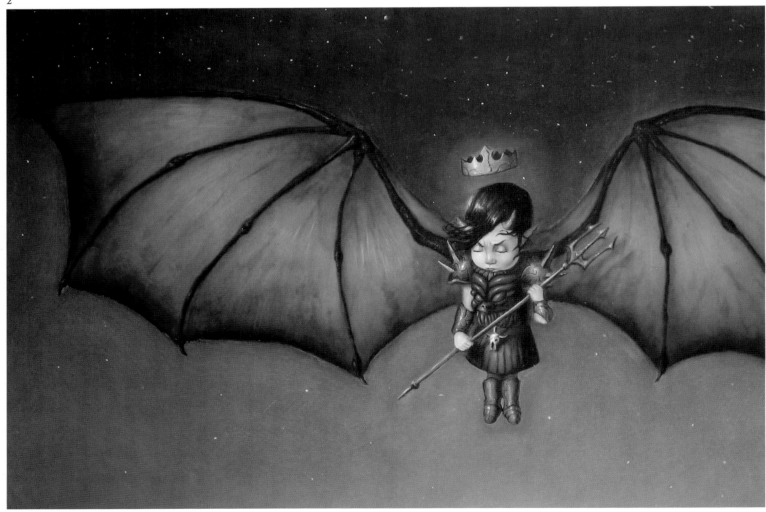

2

UNPUBLISHED

1
artist: **Thomas Fluharty**
title: I'm Your Father
medium: Oil
size: 12"x18"

2
artist: **Wei Ming**
title: Unpredictable Contact 2
medium: Digital
size: 24"x8"

3
artist: **Jon Foster**
title: Mr. Tubs
medium: Oil
size: 20"x30"

4
artist: **Brian Despain**
client: Lunarboy Gallery
title: Rise of the Red Star
medium: Digital
size: 6"x8"

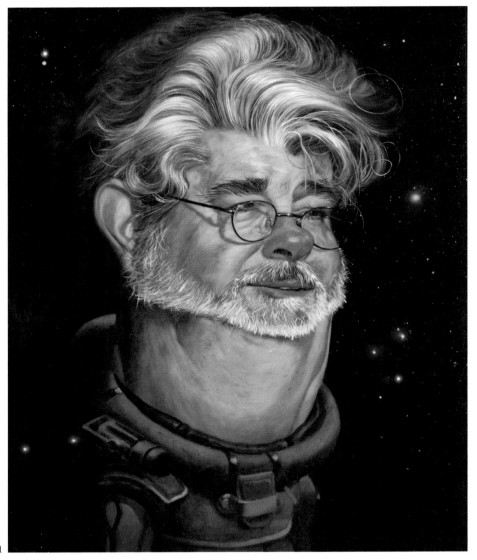

1

2

3

4

1

2

3

4

5

UNPUBLISHED

1
artist: **Dave Dorman**
title: Headless Horseman
medium: Oil/acrylic
size: 10"x15"

2
artist: **Colin Fix**
title: Roundup
medium: Mixed/digital

3
artist: **Emmanuel Malin**
title: 3 Witches
medium: Mixed/digital
size: 27"x19"

4
artist: **Jason Courtney**
title: Jimmy Went In to Visit the Pigoons
medium: Digital
size: 8"x5¹/₂"

1

2

3

4

1
artist: **Ben Dhaliwal**
title: The Mask of the Red Death
medium: Watercolor on paper
size: 12"x11³/₄"

2
artist: **Felipe Echevarria**
title: Beseechment
medium: Acrylic
size: 24"x36"

3
artist: **Craig Phillips**
client: Umi Yama
title: Sagittarius
medium: Pen and ink

4
artist: **Todd Lockwood**
title: The Thief
medium: Digital
size: 15"x20"

1

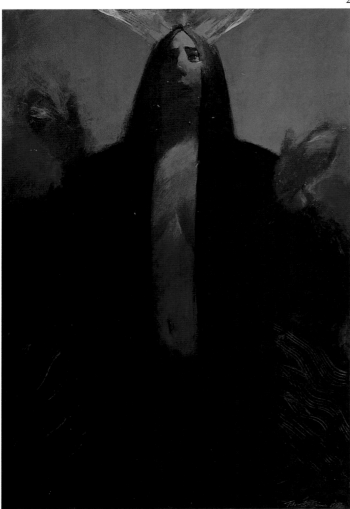

2

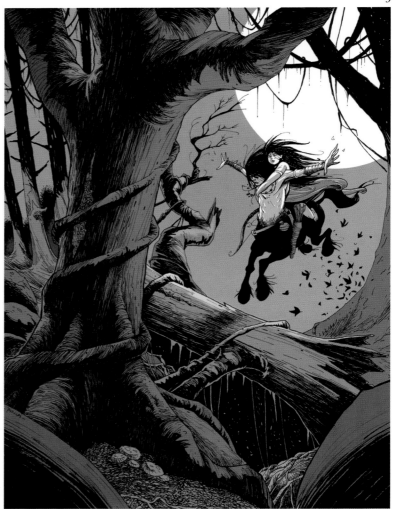

3

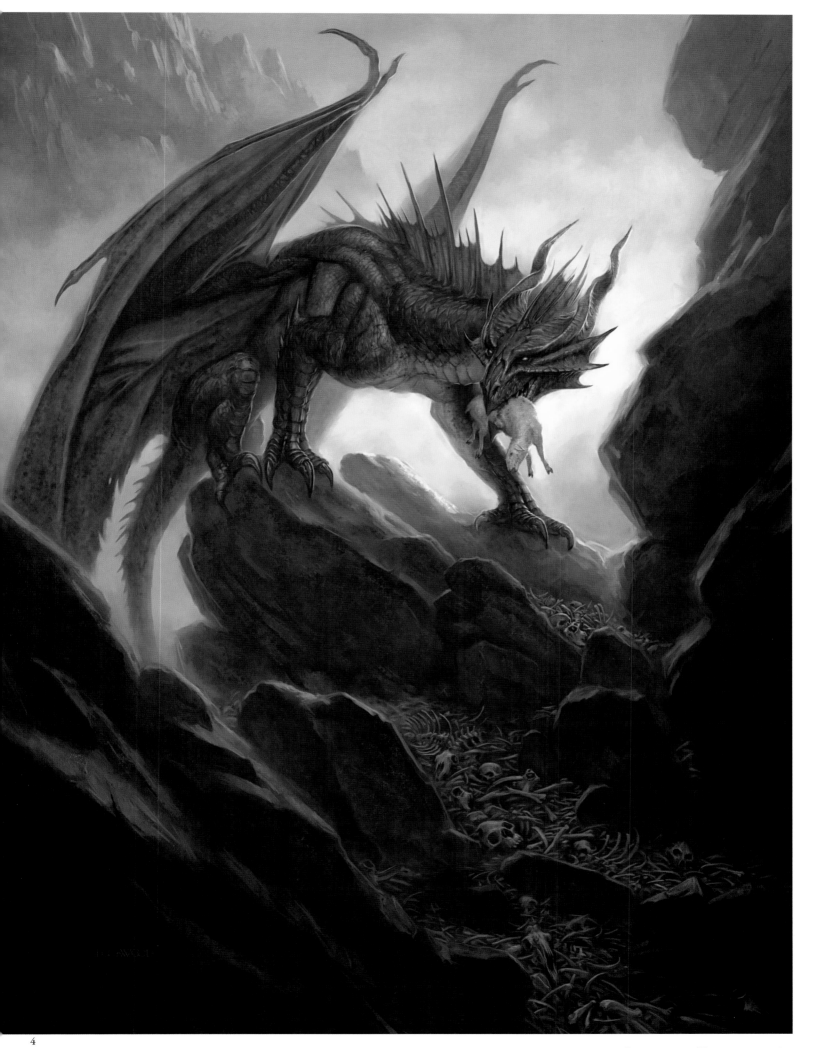

1
artist: "Kino" Scialabba
title: Hope
medium: Mixed
size: 48"x75"

2
artist: **Jon Sullivan**
medium: Digital
size: 17"x11"

3
artist: **Jasmine Becket-Griffith**
title: Funeral For a Long Dead Knight
medium: Acrylic on canvas
size: 30"x12"

4
artist: **John Van Fleet**
title: Mr. Grin
medium: Mixed
size: 49"x11"

5
artist: **Daarken**
medium: Digital/PhotoShop
size: 9"x5"

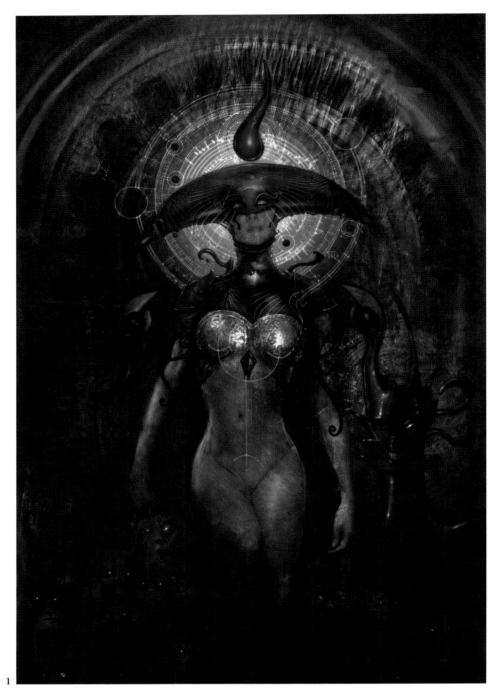

1

2

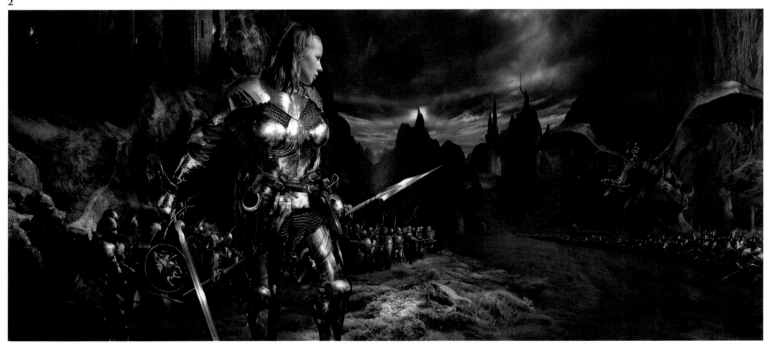

3

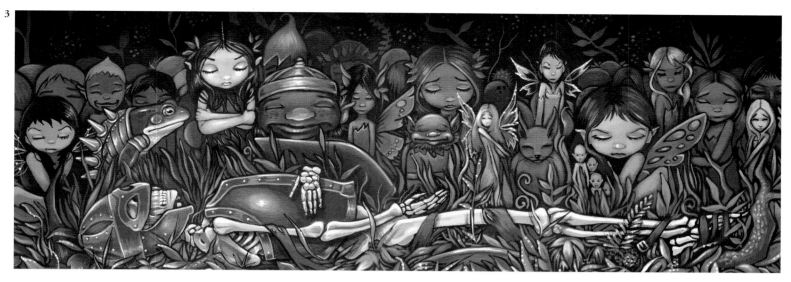

4

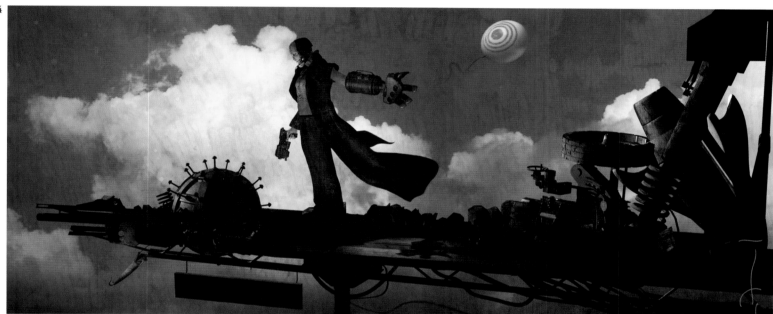

5

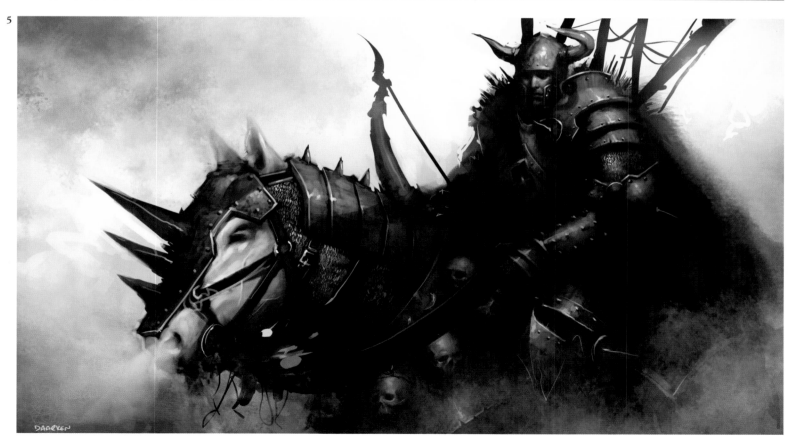

UNPUBLISHED

1
artist: **Robin Chyo**
title: War In Peace
medium: Digital
size: 13^{1}/3"x20"

2
artist: **Jason Newhouse**
title: Red Cape & Rockets
medium: Digital
size: 6"x10"

3
artist: **Dennis Brown**
title: Superhero Bobby & Freddi Smogface
medium: Acrylic
size: 12"x16"

4
artist: **Shaun Tan**
title: Tales From Outer Suburbia:
 The Water Buffalo
medium: Oil
size: 20"x30"

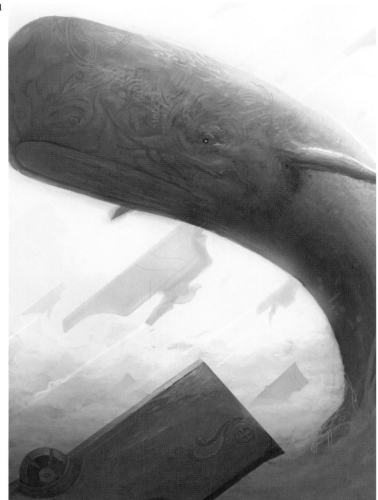

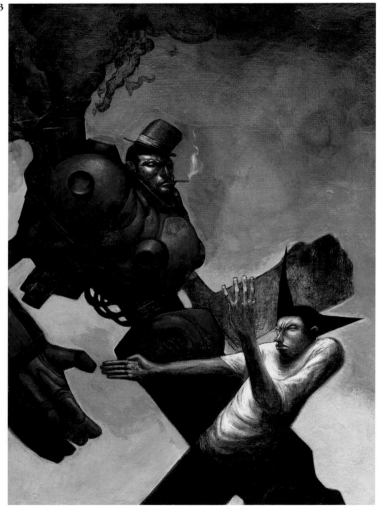

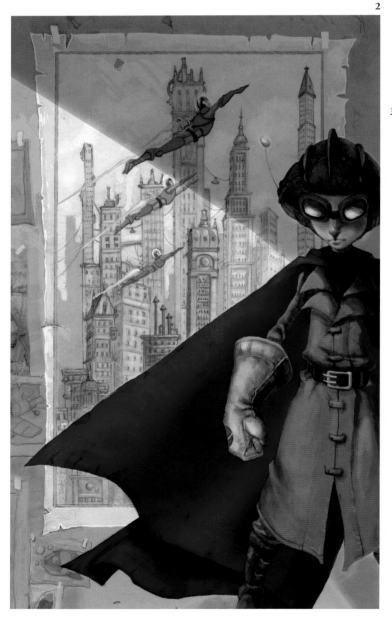

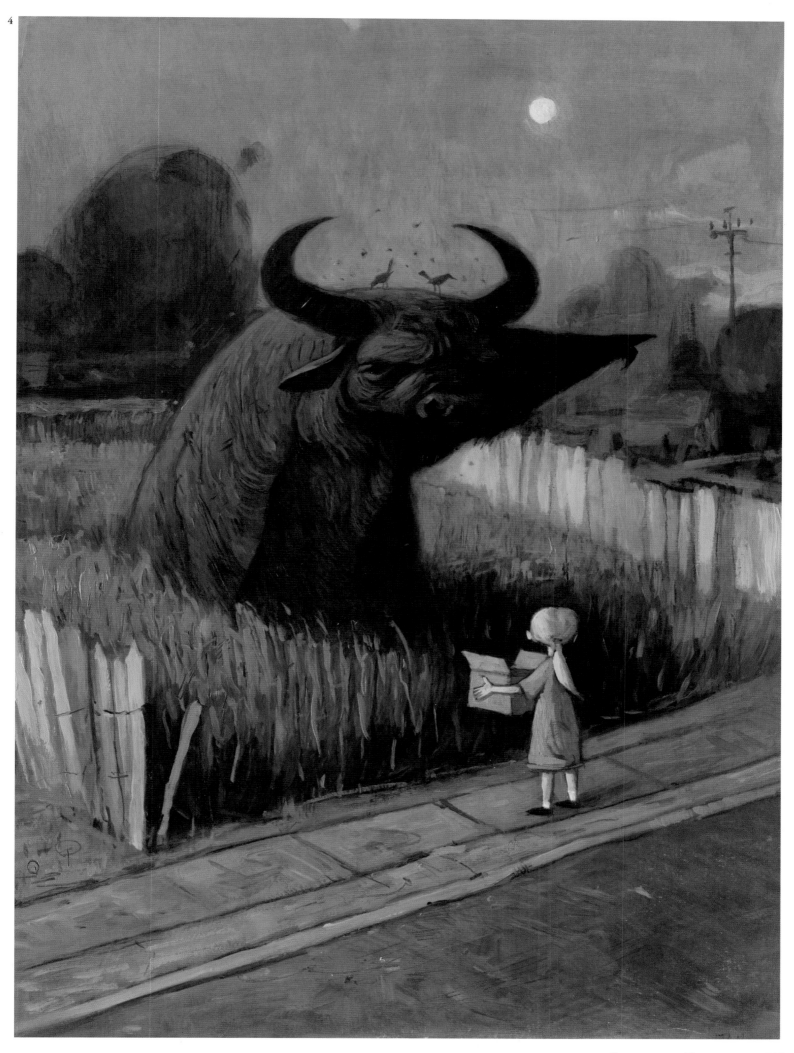

1
artist: **Daisuke Dice Tsutsumi**
client: Simplestroke.com
title: Self Portrait
medium: Mixed
size: 12"x12"

2
artist: **Jacques Crane**
art director: Steven Kloepfer
client: Jacquesthemonkey.com
title: Wicked
medium: Oil on paper
size: 16"x20"

3
artist: **Jos. A. Smith**
title: Boxcar Full of Dreams—
 Leaking
medium: Watercolor on paper
size: 22"x16"

4
artist: **Jos. A. Smith**
title: Prison Train
medium: Watercolor on paper
size: 22"x16"

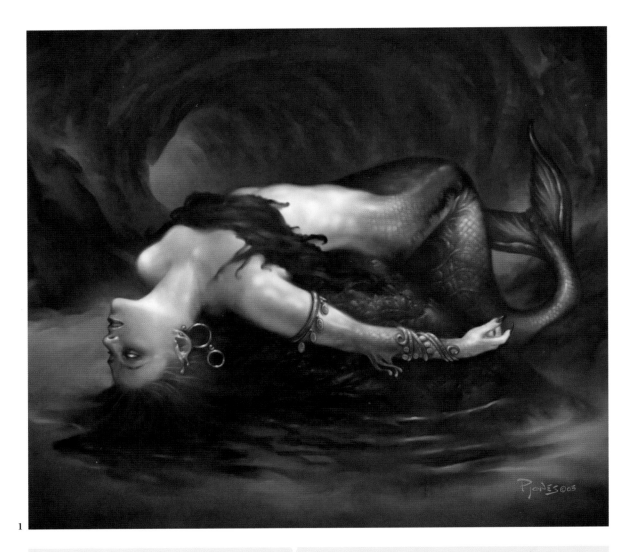

1

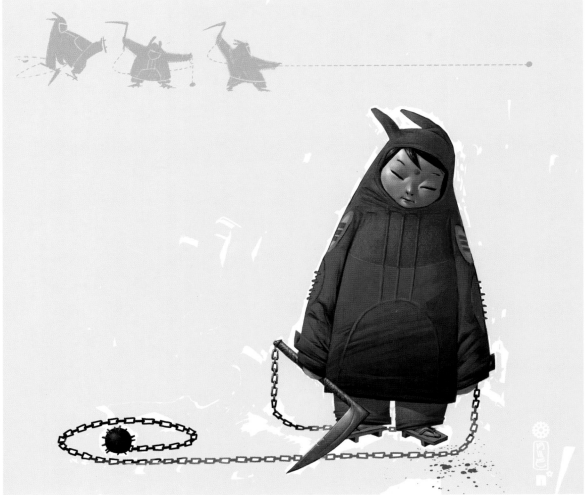

2

3
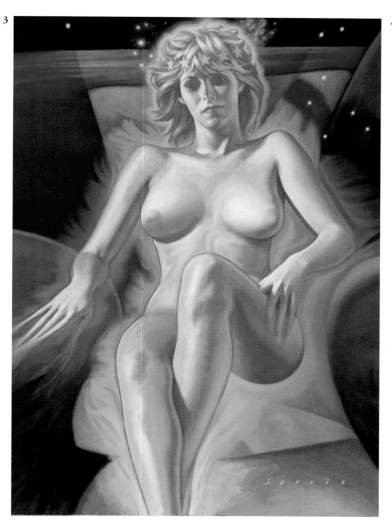

4
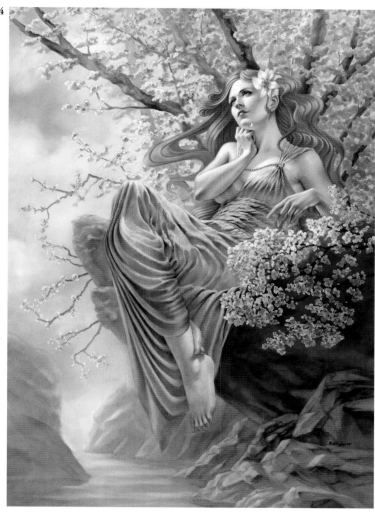

5
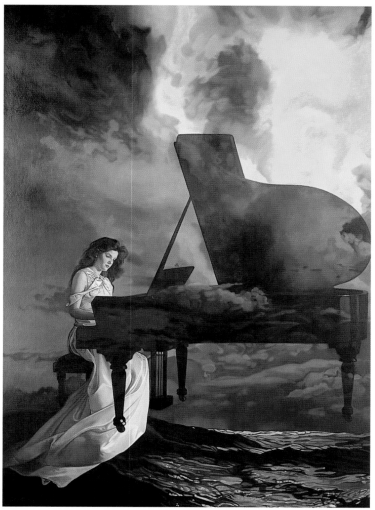

6
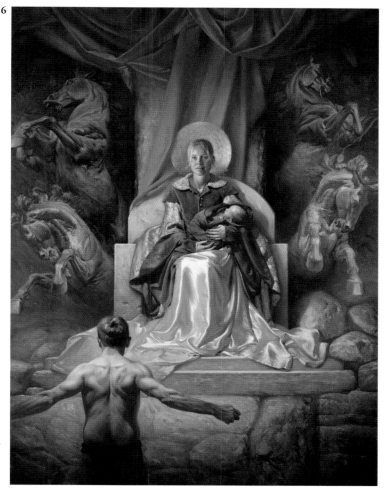

UNPUBLISHED

1
artist: **Matt Gaser**
title: Garga's Concern
medium: Digital *size:* 17"x13"

2
artist: **Robert Craig**
title: Jinx's Quandary
medium: Acrylic *size:* 20"x16"

3
artist: **Shaun Tan**
title: Tales From Outer Suburbia:
 Sunday Afternoon
medium: Oil *size:* 40"x20"

4
artist: **Raoul Vitale**
title: Wild Life
medium: Oil *size:* 13"x19"

5
artist: **Thomas A. Gieseke**
title: Cerberus and the Hydra
medium: Acrylic *size:* 30"x40"

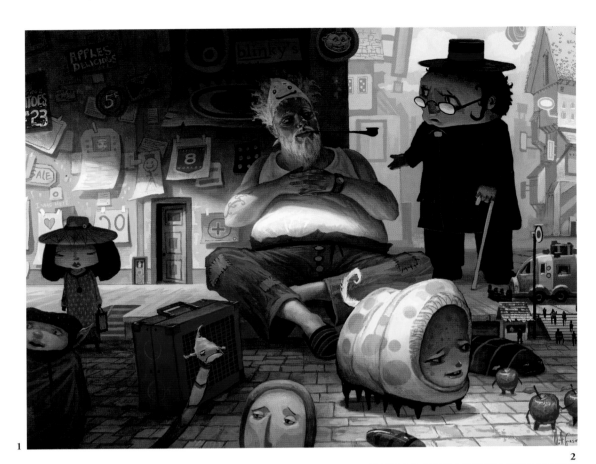

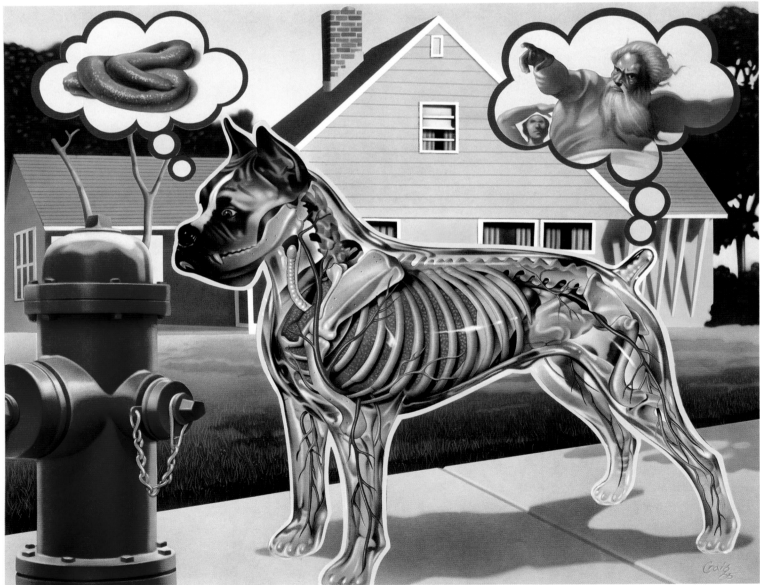

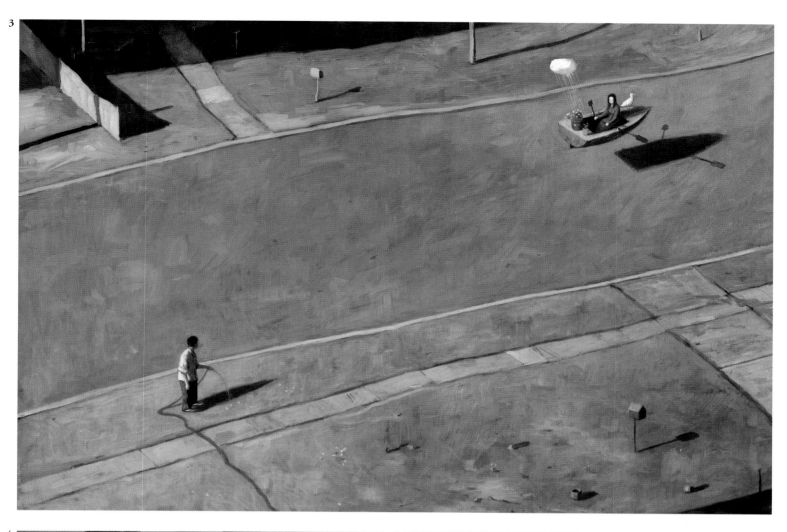

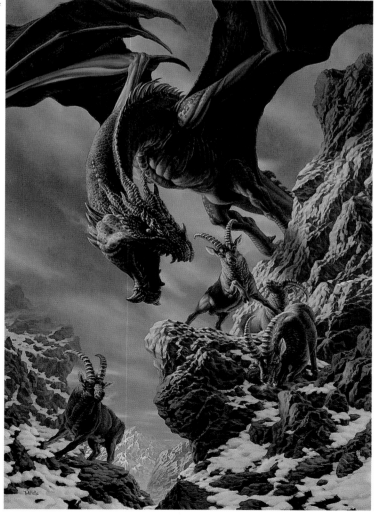

Unpublished

1
artist: **William Carman**
title: Earless Emily's Security Squad
medium: Acrylic/oil
size: 12"x16"

2
artist: **Christian Alzmann**
title: Listening
medium: Mixed/digital
size: 8"x15"

3
artist: **Dave DeVries** [after Max Peralta]
designer: Max Peralta
client: The Monster Engine 2
title: The Good Man
medium: Acrylic/mixed
size: 10"x16^{1}/2"

4
artist: **Coro**
client: Massive Black
title: 5 Sense
medium: Digital/PhotoShop

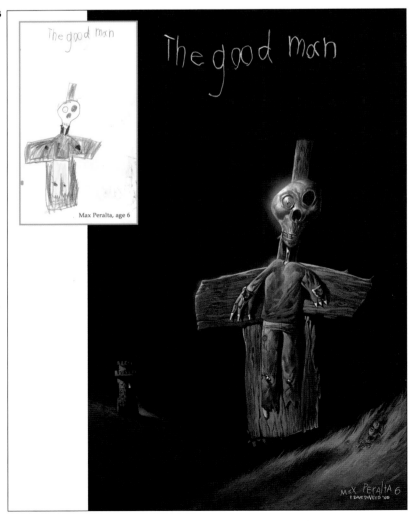

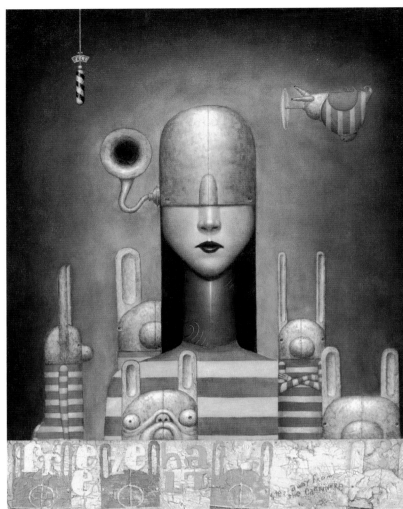

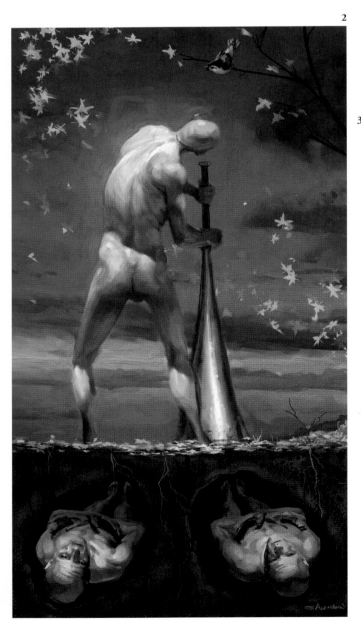

Max Peralta, age 6

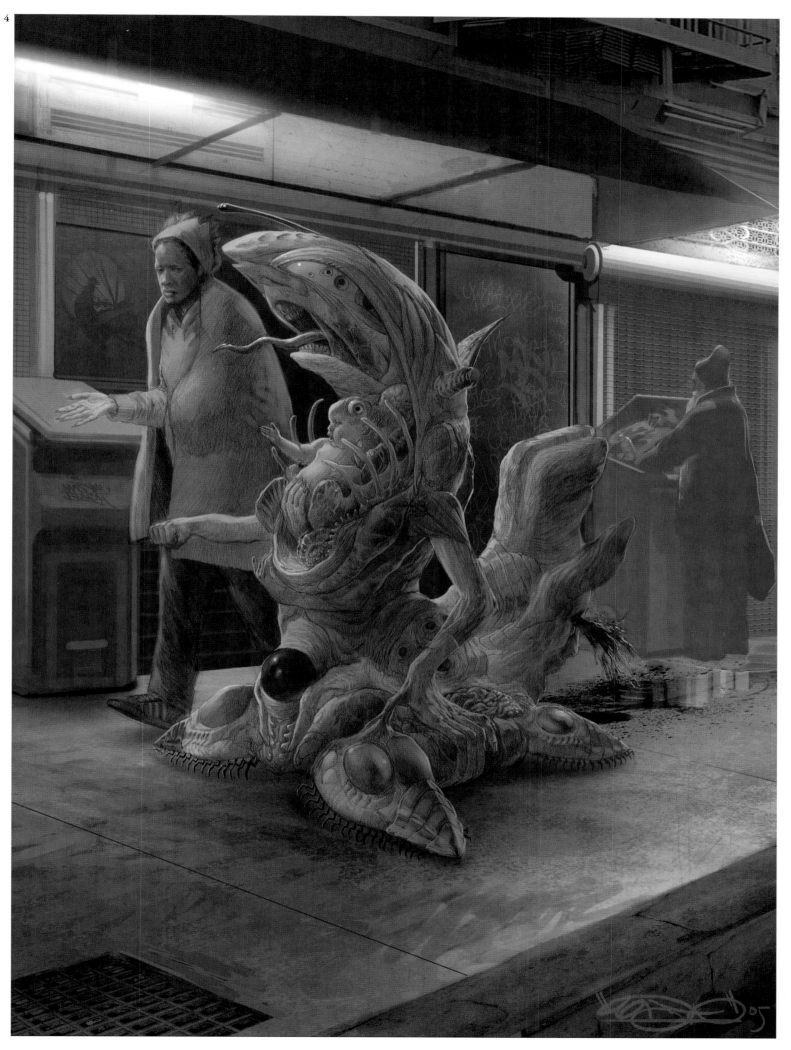

1
artist: **Steven Tabbutt**
title: Praise the Hero
medium: Oil on canvas
size: 8"x11"

2
artist: **August Hall**
title: Planet Hell
medium: Mixed
size: 3'x6'

3
artist: **Richard Hescox**
title: Mirage
medium: Oil
size: 24"x40"

4
artist: **Nic Klein**
title: VS
medium: Mixed/digital

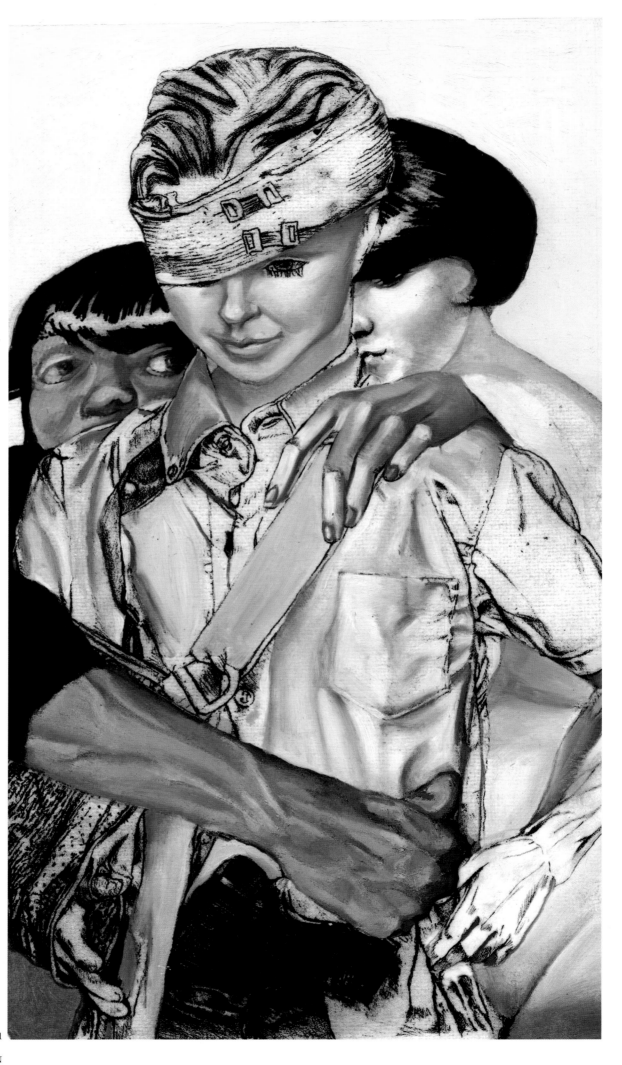

1

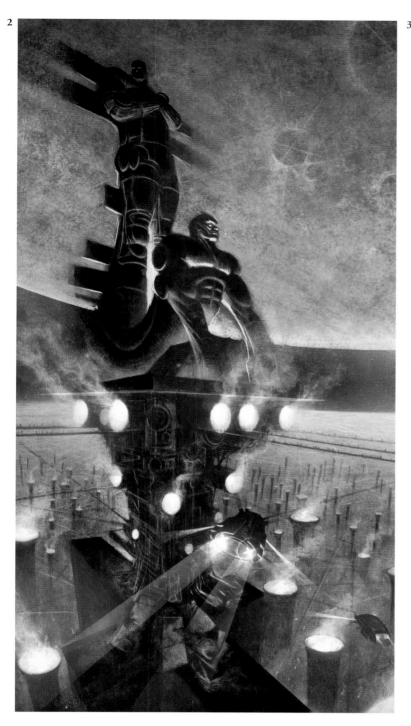

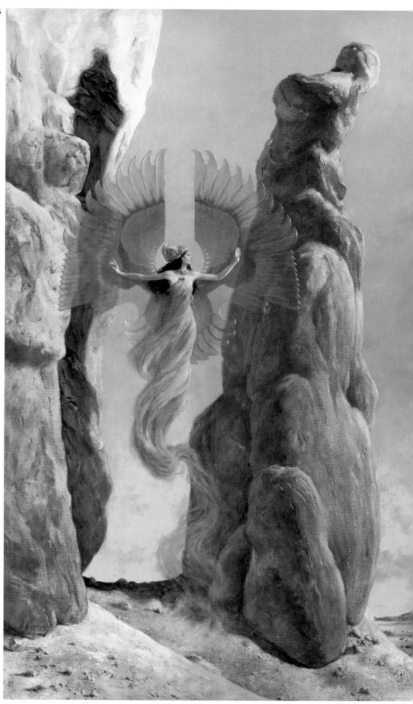

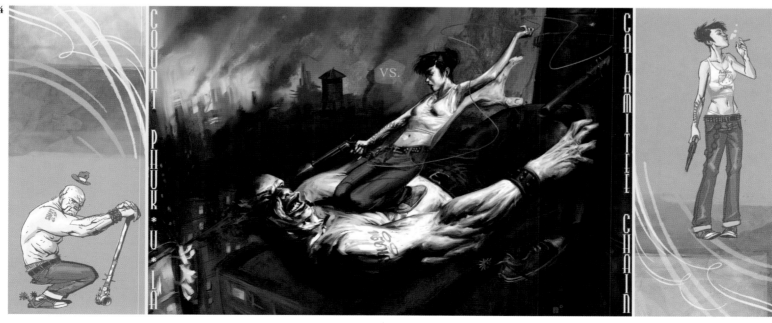

1
artist: **Raúl Cruz**
title: Fatal Vanity
medium: Acrylic
size: 35"x47"

2
artist: **Jason Chan**
title: The Neighbors
medium: Digital
size: 11"x6^{1}/4"

3
artist: **David Bowers**
client: Halcyon Gallery
title: Crocodile Tears
medium: Oil on linen
size: 19"x16"

4
artist: **Tony Weinstock**
title: Lunchline
medium: Gouache
size: 19"x9^{5}/8"

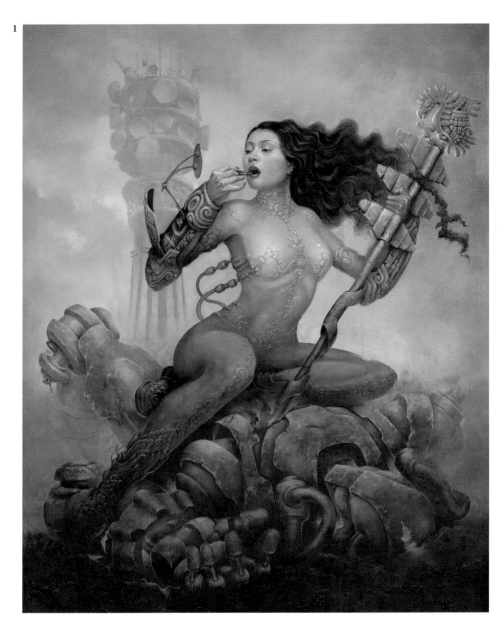

1
artist: **Michaël Zancan**
title: Queen of Technical Nonsense
medium: Oil on canvas
size: 18"x22"

2
artist: **Richard Hescox**
title: The Portal of Dreams
medium: Oil
size: 24"x30"

3
artist: **Jason Chan**
title: Wish
medium: Digital
size: 15^1/$_2$"x20"

4
artist: **David Bowers**
client: Halcyon Gallery
title: Mother Nature
medium: Oil on linen
size: 12"x16"

1

2

3

4

1
artist: **Kamala Dolphin-Kingsley**
title: Albino Chameleon & Bee
medium: Mixed
size: 28"x22"

2
artist: **Mike Hill**
title: The Heavy Unit
medium: Digital/PhotoShop

3
artist: **Les Edwards**
title: Icarus
medium: Oil
size: 14"x21"

4
artist: **Michael Whelan**
client: Tree's Place Gallery
title: Empire of Dreams
medium: Acrylic on panel
size: 22"x28"

1

2

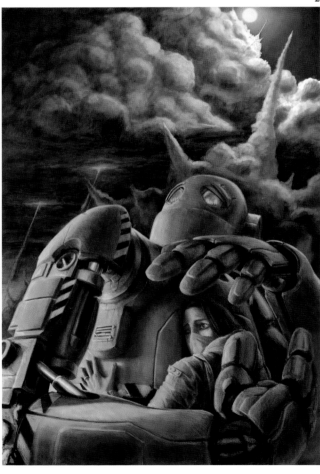

3

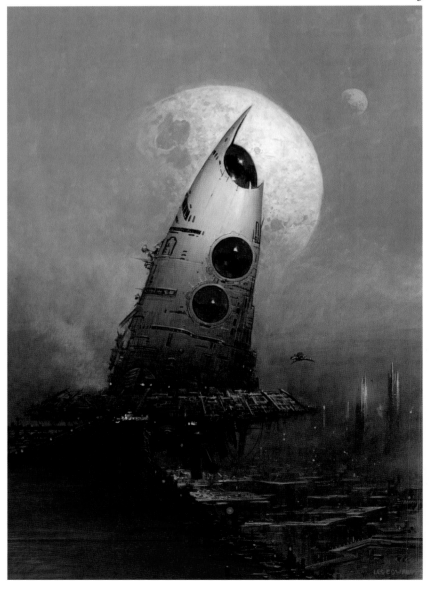

4

Gary Gianni **101**
4616 N Hermitage
Chicago, IL 60640
773-275-2434
ggianni@sbcglobal.net

Thomas A. Gieseke **211**
7909 W. 61st St.
Merriam, KS 66202
913-677-4593
www.artbytom.com

E.M. Gist **193**
760-633-1370
emgist@erikgist.com
www.erikgist.com

Gore Group **119**
www.goregoregore.com

Melvyn Grant **153**
Flat 4, 23 Dane Rd
St. Leonards-On-Sea, East Sussex
UK TN38 0QW
011 44 1424 438014
www.melgrant.com

Gris Grimly **38**
grisgrimly@madcreator.com
www.madcreator.com

David Grove **64**
382 Union St.
San Francisco, CA 94133
415-433-2100

Rebecca Guay **168**
45 Spaulding St.
Amherst, MA 01002
413-253-7999
studio@crocker.com

Elio Guevara **193**
100 Independence Way
Roswell, GA 30075
404-358-2037
www.elioguevara.com

James Gurney **81, 131**
P.O. Box 693
Rhinebeck, NY 12572
845-876-7746
jgurneyart@yahoo.com

Scott Gustafson **98, 134**
4045 N Kostner
Chicago, IL 60641
773-725-8338
scott@scottgustafson.com

Phil Hale **20, 126**
93 Mayola Road
London, UK E5 0RF
011-44-207-682-0139
relaxeder@gmail.com

August Hall **174, 215**
c/o Allen Spiegel Fine Arts
221 Lobos Ave.
Pacific Grove, CA 93950
831-372-4672
asfa@redshift.com

Joshua Hagler **93, 167**
52 Page St. Apt. 3
San Francisco, CA 94102-5925
415-661-3107
joshhagler@yahoo.com

Dominic Harman **27**
c/o Alan Lynch
116 Kelvin Pl.
Ithaca, NY 14850
607-257-0330
alartists@aol.com

Dwayne Harris **68**
620 West First Ave.
Kalispell, MT 59901
dwayne@dwayneharris.com

John Harris **40**
c/o Alan Lynch
116 Kelvin Pl.
Ithaca, NY 14850
607-257-0330
alartists@aol.com

Mark Harrison **66**
353 Ridgacre Rd. Quinton
Birmingham, W. Midlands
UK B32 1EH
+44 (0) 121 6840634
sarah.markus@blueyonder.co.uk

David Hartman **26, 85**
P.O. Box 940863
Simi Valley, CA 93094-0863
www.sideshowmonkey.com
hartman@sideshowmonkey.com

Dan Hawkins **110**
P.O. Box 265
Bulverde, TX 78163
888-456-5046
danhawkins25@hotmail.com

Dan L. Henderson **149**
404-373-8245
www.mindspring.com/~hendall

Linda R. Herzog **197**
1180 Academy Lane
Vista, CA 92081
www.natureartists.com/herzog.htm
lindarherzog@yahoo.com

Richard Hescox **215, 218**
triffid@comcast.net
www.richardhescox.com

Paul Hess **53**
c/o Alan Lynch
116 Kelvin Pl.
Ithaca, NY 14850
607-257-0330
alartists@aol.com

Stephen Hickman **179**
10 Elm St.
Red Hook, NY 12571
845-758-3930
shickman@stephenhickman.com

Mike Hill **220**
3 Beechwood Rise, West End
Southampton, Hampshire
UK SO18 3PW
mike@freefallgraphics.com

David Ho **24, 124**
3586 Dickenson Common
Fremont, CA 94538
510-656-2468
ho@davidho.com

Bruce Holwerda **185**
1205 Crestwood Ct.
Midland, MI 48640
www.bruceholwerda.com
bholwerda@charter.net

Ralph Horsley **38**
18 Brooklyn Terrace
Leeds, W. Yorks
UK LS12 2BX
www.ralphhorsley.co.uk
email@ralphhorsley.co.uk

Brian Horton **124**
104 Sandcastle
Aliso Viejo, CA 92656
949-362-3170
bri_sue@cox.net

John Howe **73**
c/o Alan Lynch
116 Kelvin Pl.
Ithaca, NY 14850
607-257-0330
alartists@aol.com

Mike Huddleston **100, 102**
1000 Washington Ave. #331
St. Louis, MO 63101
mhuddl@hotmail.com

Adam Hughes **86, 87, 100**
P.O. Box 190823
Atlanta, GA 31119-0823
www.justsayah.com
allison@justsayah.com

Matt Hughes **209**
3716 McGuire St
Kennesaw, GA 30144
770-595-1293
matthughesart@yahoo.com

David Wesley Jarvis Jarvis **209**
5260 Lake Margaret Dr.
Orlando, FL 32812
407-228-6698
davidjarvisart@earthlink.net

Jeremy Jarvis **76**
425-260-6643
jeremy@jeremyjarvis.com
www.jeremyjarvis.com

James Jean **69**
www.jamesjean.com
mail@jamesjean.com

Bruce Jensen **44**
3939 47th St.
Sunnyside, NY 11104
718-937-1887
bruce@brucejensen.com

Scott Johnson **72**
701 Stuart Dr.
Carol Stream, IL 60188
www.scottjohnson.com
scott@scottjohnsonart.com

Andrew Jones **23, 144, 145**
842 Flosom St.
San Francisco, CA 94107
512-771-6665
ajones@spectrum.net

Patrick Jones **208**
33 Orchid St. Enoggera
Brisbane, QLD 4051 Australia
+61 7 3855 3456
patrickjjones@optusnet.com.au

Eric Joyner **30**
111 New Montgomery St. #402
San Francisco, CA 94118
415-305-3992
eric@ericjoyner.com

Michael Wm. Kaluta **90, 99**
312 W 92nd St. #5A
New York, NY 10025
212-873-7573
rotvang@earthlink,net

Montgomery S. Kane **158**
P.O. Box 82654
Pittsburgh, PA 15218
monty@planetsaturday.com
www.planetsaturday.com

Ken Keirns **184**
1450 W Chicago Ave. #3F
Chicago, IL 60622
773-236-9876
kencoart@yahoo.com

Steven Kenny **176, 177**
130 Fodderstack Rd.
Washington, VA 22747
540-675-2355
www.stevenkenny.com

Douglas Klauba **82, 156**
9741 S. Hamlin Ave.
Evergreen Park, IL 60805
708-229-2507
doug@douglasklauba.com

Nic Klein **189, 208, 215**
korbacher Str. 54
Kassel, Germany 34134
0049 178 232 9889
me@nic-klein.com

Michael Knapp **95, 134**
308 E 82nd St., 2W
New York, NY 10028
646-358-2965
mike@michaelknapp.com

Viktor Koen **125**
310 E 23rd St. #11J
New York, NY 10010
212-254-3159
www.viktorkoen.com

Michael Komarck **43, 65, 153**
943 Meadow Dr.
Battle Creek, MI 49015
269-964-0593
mkomarck@comcast.net

Cos Knoiotis **77, 138**
102 Hewitt Road
London, UK N8 0BN
0208 340 2545
info@coskoniotis.com

Vance Kovacs **155, 157 hc endpaper**
7072 Cedar Creek Rd.
Corona, CA 92880
951-272-0911
vance@vancekovacs.com

Thomas S. Kuebler **107, 109**
520 Campground Rd.
Selma, NC 27576
tskuebler@earthlink.net
www.tskuebler.com

Anita Kunz **33, 122**
218 Ontario St.
Toronto, ONT M5A 2V5 Canada
416-364-3846
akunz@anitakunz.com

Michael Kwong **161**
17B, Kai Kwong Commercial Building
332 Lockhart Rd.
Wanchai, Hong Kong
852-97301374
michael@locoism.com.hk

Richard Laurent **172**
www.laurentart.com
312-939-7130
richard@rcn.com

Jody A. Lee **75**
www.jodylee.org
jodylee@jodylee.org

Tracy Mark Lee **180**
www.tdg-art.com
www.electrictiki.com

Denise Leite **126**
3 Kandace Ct.
Petaluma, CA 94952
707-762-5867

Nathaniel Lewis **115**
360 Reynolds St.
Kingston, PA 18704
www.nathaniellewis.com
kenman113@hotmail.com

Todd Lockwood **72, 73, 201**
20825 SR 410 E #186
Bonney Lake, WA 98390
www.toddlockwood.com
todd@toddlockwood.com

Jerry LoFaro **172**
58 Gulf Rd.
Henniker, NH 03242
603-428-6135
jerrylofaro@mcttelecom.com

Steven Lord **115**
543 Friedensburg Rd.
Reading, PA 19606
917-609-3945
slord1369@yahoo.com

Travis Louie **185**
18 Echo Valley Rd.
Red Hook, NY 12571
845-758-9460
louieart37@yahoo.com

Robert MacKenzie **53, 78**
341 E 22nd St. #5A
New York, NY 10010
650-504-4853
mackenzieart@yahoo.com

John Mahoney **183**
4421 Kling St. #27
Burbank, CA 91505
818-563-1603
http://johnmahoney.blogspot.com

Don Maitz **164**
5824 Bee Ridge Rd., MB #106
Sarasota, FL 34233
941-927-7206
donmaitz@paravia.com

Emmanuel Malin **199**
5 Rue Léon Dierx
Paris, France 75015
www.mapage.noos.fr/manu_malin
manu_is_malin@msn.com

Gregory Manchess **58, 59, 165**
15234 SW Teal Blvd. #D
Beaverton, OR 97007
503-590-5447
manchess@mac.com

Manchu [Philippe Bouchet] **46**
6 Allee des Erables
Tours, France 37000
(33) 0247371603
philippe.bouchet7@wanadoo.fr

Stephan Martiniere **30, 45, 67, 161**
754 William St.
River Forest, IL 60305
708-488-9937
martiniere@comcast.net

K.D. Matheson **183**
8555 Russell #2019
Las Vegas, NV 89113
www.kdmatheson.com
www.ahorcarte.com

Jonathan Matthews **116, 117**
5326 Halsey Ct.
Louisville, KY 40214
502-379-4635
jonlmatthews@insightbb.com

Chris McGrath **56**
166 W. 75th St. Apt. 306
New York, NY 10023
chrismcgrath@mac.com

Christopher McInerney **190**
P.O. Box 344
Kents Hill, ME 04349
207-522-8213
craftysquid@gmail.com

Dave McKean **50, 51, 133,168**
c/o Allen Spiegel Fine Arts
221 Lobos Ave.
Pacific Grove, CA 93950
831-372-4672
asfa@redshift.com

Scott McKowen **63**
428 Downie St.
Stratford, ONT N5A 1X7 Canada
519-271-3049
scott@punchandjudy.ca

Petar Meseldžija **209**
Kogerwatering 49
1541 XB Koog aan de Zaan
The Netherlands
petarmeseldzija@planet.nl
www.petarmeseldzijaart.com

C.J. Metzger **27**
cjminfo@cjmetzger.com
www.cjmetzger.com

Ian Miller **166**
c/o Worlds of Wonder
P.O. Box 814
Mclean, VA 22101
(703) 847-4251
www.wow-art.com

Wei Ming **194**
China Beijing Dong Cheng District
Gan Yu Hu Tong 33-2-101
Beijing, China 100006
86 10 65257421
i3version@yahoo.com

Steve Montiglio **61**
323-573-7316
www.montiglio.com

Richard A. Moore III **118**
503-706-5721
www.rmooresculptures.com

Lee Moyer **80, 162**
7432 N Kellogg St
Portland, OR 97203
503-737-3344
lee@leemoyer.com

Craig Mullins **80**
www.goodbrush.com

Teresa Murfin **62**
c/o Alan Lynch
116 Kelvin Pl.
Ithaca, NY 14850
607-257-0330
alartists@aol.com

Duane O. Myers **36**

Vince Natale **68**
18 Van De Bogart Rd.
Woodstock, NY 12498
845-679-0354
vnatale@hvc.rr.com

Mark A. Nelson **142, 143**
3738 Coachman Way
Cross Plains, WI 53528
608-798-3783
gdpmark@chorus.net

Jeff Nentrup **56**

Jason Newhouse **204**
701 Pine Apt. 9
San Francisco, CA 94108
415-956-1996
jasonsketchbook@yahoo.com

Painting by Joe DeVito

Artists, art directors, and publishers interested in receiving
information for the SPECTRUM 14 competition should send their
name and address to:

**Spectrum Design
P.O. Box 4422, Overland Park, KS 66204**

Or visit our website for information:
www.spectrumfantasticart.com